cheat AdobeFlashCS3

The art of design and animation

Chris Georgenes

Focal Press is an imprint of Elsevier Linacre House, Jordan Hill, Oxford OX2 8DP, UK 30 Corporate Drive, Suite 400, Burlington, MA 01803, USA

First published 2007

Copyright © 2007 Chris Georgenes. Published by Elsevier Ltd. All rights reserved

The right of Chris Georgenes to be identified as the author of this work has been asserted in accordance with the Copyright, Designs and Patents Act 1988

No part of this publication may be reproduced, stored in a retrieval system or transmitted in any form or by any means electronic, mechanical, photocopying, recording or otherwise without the prior written permission of the publisher

Permissions may be sought directly from Elsevier's Science & Technology Rights Department in Oxford, UK: phone (+44) (0) 1865 843830; fax (+44) (0) 1865 853333; email: permissions@ elsevier.com. Alternatively you can submit your request online by visiting the Elsevier web site at http://elsevier.com/locate/permissions, and selecting *Obtaining permission to use Elsevier material*

Notice

No responsibility is assumed by the publisher for any injury and/or damage to persons or property as a matter of products liability, negligence or otherwise, or from any use or operation of any methods, products, instructions or ideas contained in the material herein. Because of rapid advances in the medical sciences, in particular, independent verification of diagnoses and drug dosages should be made

British Library Cataloguing in Publication Data

A catalogue record for this book is available from the British Library

Library of Congress Cataloging-in-Publication Data

A catalog record for this book is available from the Library of Congress

ISBN: 978-0-240-52058-2

For information on all Focal Press publications visit our website at www.focalpress.com

Printed and bound in China

07 08 09 10 11 10 9 8 7 6 5 4 3 2 1

Working together to grow libraries in developing countries

www.elsevier.com | www.bookaid.org | www.sabre.org

ELSEVIER

BOOK AID

Sabre Foundation

	Forewordv How to cheat, and whyvi Acknowledgmentsviiii How to use this book1	Motion tips and tricks
1	Design styles	Perspective shadow
	Shading 1: line trick	Character animation
2	Transformation and distortion	Lip syncing (nested method). 98 To sync or not to sync . 100 Sync . 102 Hinging body parts . 104 Closing the gaps . 106 Bitmap animation (Jib Jab) . 108 PSD Importer (Jib Jab) . 110 Motion guides (Jib Jab) . 112 Walk cycle . 114 Advanced walk cycle . 118
3	Masking. 50 Rotating globe. 52 Flag waving. 54 Iris transition. 56 Handwriting. 58 Spotlight. 60 Focus. 62 Interlude: A moment of clarity. 64	Anticipation

Contents

	Safe colors	10	Interactivity200
	Keeping it all in sync	10	Event handling
	Interlude: Graphics tablets • • • • • • 148		Pausing the timeline
7	Animation examples 150		
	Super text effect		Interlude: Objects, objects everywhere • • 214
	Smoke with gradients		Going mobile216
	Smoke stylized		Creating a dynamic screensaver 218 Optimization
	Star Wars text		Interlude: Cheap tricks 224
	Vertigo	10	Extending Flash226
	Playing with fire 174 Winter wonderland	12	Introduction to JSFL 228
	Interlude: From the inside out 178		AnimSlider Pro
0	Working		Swift 3D Xpress
O	with sound ₁₈₀		Flashjester
	Recording sounds		Interlude: Pimp my Flash 244
	Sound in Flash	12	Time-saving tips246
	Dynamic sounds (AS3)	13	Keyboard shortcuts
	Working		Common libraries
9	with video		Save workspace
	Importing video		Interlude: Don't go it alone 260
	Interlude: FLV tools and articles 198		Index ₂₆₂
	mechaue. Tev cools and articles 130		What's on the CD268

Foreword

Flash is now a member of the various flavors of Adobe Creative Suite 3, sharing the suites with the likes of Photoshop, Illustrator, After Effects, and Acrobat. This exposes the tool to many new kinds of creative designers and developers, who will likely use Flash in ways the current Flash community hasn't thought of. Whether you're a new or existing Flash user, now is a great time to learn or use the software and get involved with the Flash community online.

Many years ago in a dimly lit basement, I started using Flash to create unpalatable, short, frame-by-frame animations – and discovered Flash was much easier than other tools I had been using to do the same thing. It's hard to believe what Flash has become over the years, from the relatively simple animation program it once was back then. For example, Flash now has a powerful programming language, a bucket full of filter and blending tools, and cross-product integration with tools like Illustrator, Photoshop, and Flex to help you make great animation, applications, or motion design.

One of the nice things about Flash is that it attracts so many different users, from inspiring and creative animators to hard-core programmers, and all sorts of people in-between. You certainly don't need to learn everything there is to know about Flash to be a master at the tool – you can choose to focus your talents on design or development, or challenge yourself from time to time by crossing over between graphics and code. But now that Flash is full of features and capable of so much, the tools can seem rather daunting to learn. But if you have helpful resources at your side, like this book, learning Flash doesn't need to be difficult. I believe the key to learning Flash is to keep it simple when you start out, take it slow, use the available resources (like books), and try to be patient. Learning Flash takes some time, but it is a lot of fun and very rewarding.

Flash is an incredible tool for expressing your creativity, style, and unique ideas. I hope that you use Flash with this book to get inspired, learn valuable new tricks and techniques, and create some wonderful animation. And of course, make sure to have fun with the software while you read and learn all about how to animate!

Jen deHaan Instructional Designer, Web and DVA Adobe Systems Inc.

How to cheat, and why

The truth about cheating

The word "cheat", in most cases, has a negative connotation. To "cheat" implies deception and trickery associated with a fraudulent act. In some ways this book will show you how you can trick your audience, not unlike a magician's "sleight of hand" technique where you can control not only what is being seen, but how the viewer sees it. But this book will certainly not teach you how to be a fraud. To "cheat" in Flash is to find shortcuts to help you work more efficiently and economically. Time translates to money and if you can deliver a great looking project on time, that means you stayed within budget and everybody wins.

My philosophy

At the end of the day, if I didn't have any fun, then it's time to find another job. But I had to learn this lesson the hard way a few years ago while working with an animation company designing a network television series. I was designing the main characters for a show called Science Court (ABC), and there was a conflict between us and the network as to the choice of skin color for one of the characters. I liked green and the network preferred orange. I felt strongly that my color choice was the best and I admit I may have let myself become emotionally charged about the issue. One day I went to lunch with the animation director and we were casually talking about the color issue. It was something he said that changed my outlook on work from that day forward: "We must have pretty cool jobs when the most stressful part of our day is whether or not a character looks too much like a frog." I stopped dead in my tracks, instantly realizing how right he was and how silly I felt about the matter. After lunch we returned to the studio where I immediately changed the character to orange and never uttered another word about it. I even ended up liking the orange more than the green. Since then, my philosophy has always been to have fun no matter how stressful my workday gets. My job, in comparison to all other possible occupations, is the best job even on the worst of days.

Workthroughs and examples

Each workthrough in this book is designed as a double-page spread so you can prop the book up behind your keyboard or next to your monitor as a visual reference while working alongside it. Many of the workthroughs are real-world client projects I have been commissioned to design and animate. Using these projects as examples has allowed me to provide you with a CD containing the source files for you to open

and explore. Each chapter ends with an Interlude in which I talk about everything from my own experiences as a designer and animator as well as some relevant and useful information based on the topic at hand.

Flash terminology

Not much has changed when it comes to terminology in Flash. Symbols have been around since the beginning and so has the behavior any symbol can have (Graphic, Movie Clip and Button). The Timeline is the same and that's a good thing. Nesting pertains to animations within symbols and remains as one of the strengths of Flash animation. Some of the newer terminology consists of Object Drawing, Primitive Objects and Copy Motion. Object Drawing mode allows you to draw shapes as separate objects that overlap without altering their appearance. Primitive Objects are graphic shapes that allow you to adjust their characteristics in the Property inspector. Copy and Paste Motion lets you copy an animation, and paste it to another object.

If you already have a basic understanding of Flash then you will most likely be familiar with all the terminology in this book. If there's anything that you come across that is unfamiliar, try searching the Flash Help docs or the reader's forum at www.howtocheatinflash.com.

What's on the CD?

Lots of cool stuff so check it out! In almost all cases you have the actual FLA file for every tutorial in this book! But I didn't stop there. I have also included as many free extensions as I could find. Most are full versions and some are trial versions with information as to where you can purchase upgrades.

There are a couple of cases where I am unable to provide the source file or some of the content has been removed for copyright and distribution reasons. For full details as to what is included, refer to the chapter "What's on the CD" at the end of this book.

Going further

Visit the book's website at www.howtocheatinflash.com where there's a user forum. You can drop by to say "hi", post a question or offer an answer or two. It is also a great place to exchange ideas and animation with other *Flashers*.

Chris Georgenes

Acknowledgments

Now I finally understand why so many authors dedicate their work to their spouses. With the utmost love and respect, I dedicate this book to Rebecca, who has always supported me and my career of "coloring" things.

I am eternally indebted to:

Bobby, Billy and Andrea for being the greatest characters I have ever helped create.

Mom and Dad for encouraging me to choose my own path in life.

Marie Hooper and Georgia Kennedy of Focal Press for their support and providing me the opportunity to be a part of this wonderful series.

Steve Caplin for all of his knowledge, vision and kindness.

Buck DeFore for his invaluable input and attention to detail.

David Stiller for his friendship and tireless contributions throughout this book and to the Flash community.

Fred Wessel and Dennis Nolan for giving me my greatest tool of all: the ability to draw.

Laith Baharini, Karen Bresnahan, Joe Corrao, Jen deHaan, Mike Downey, Scott Fegette, Warren Fuller, Gary Goldberger, Jarred Hope, Christine Lawson, Shine Lee, Stephen Levinson, Dave Logan, Kirk Millett, Ben Palczynski, Davendra Pateel, Puck, Todd Sanders, John Say, Aaron Simpson, Colin Smith, Evan and Gregg Spiridellis, Ed Sullivan, Urami, Lily Welch, Willo, Lynda Weinman and Vivek.

Adobe Systems Inc., specifically the Flash team for making such a cool product.

Thanks to the following companies for their approval to use their projects as examples for this book:

Abs Ale, Cone Inc., Erain, Euro RSCG Worldwide, Fablevision, Flashjester, istockphoto, Jib Jab Media, Leapfrog Innovations, New Balance, Pileated Pictures and Say Design.

Some of the photographic images used in this book are from the following royalty-free image sources:

Adobe Stock Images www.istockphoto.com

In memory of Max Coniglio.

BETWEEN THE LIONS 2007 WGBH Educational Foundation and Sirius Thinking, Ltd. All rights reserved. Between the Lions, Get Wild about Reading, and the BTL characters and related indicia are trademarks or registered trademarks of WGBH Educational Foundation. All third party trademarks are the property of their respective owners. Used with permission.

BETWEEN THE LIONS is produced by WGBH Boston, Sirius Thinking, Ltd., and Mississippi Public Broadcasting.

How to use this book

I am a digital animator – a *Digimator* if you will. I learned how to animate using a computer. Any animation program can have a mechanical feel to it since we work by selecting options from menus much of the time. The trick I have learned is how to make a software program like Flash feel more organic, as if it were a ball of clay, starting with a basic shape and pushing and pulling it into something unique. If this book teaches anything, I hope it teaches you to think differently as to how you approach Flash. Just because the help docs, online resources or even other books tell you how something can or should be done, don't take that as carved in stone. Take it as carved in clay, meaning, you can continue to expand upon the ways the tools are used, even beyond what you may have read elsewhere.

The first few chapters focus on some of the basics of using Flash in real-world situations. I do not explain the rudimentary features of Flash, such as how to convert objects to symbols and what the differences are between Movie Clips and Graphic symbols. That is what the help docs are for and are simply a keystroke away (F1). You bought this book to learn what goes beyond the help docs and what can only be learned through the span of several years of experience using Flash. For you, this is the true essence of "cheating" because this book condenses those years into about 270 pages.

Any page that includes a CD icon means that the Flash file (FLA) is included on the CD. You can open them and analyze how each file was designed but keep in mind just about all source files are protected by copyright or trademark, preventing them from being used commercially. However, I do hope they will provide a source of education and inspiration for you. All files can be opened in Flash 8 or Flash CS3. Some tutorials will include a "CS3" icon which means that Flash CS3 is required due to CS3-specific features. If you do not have Flash CS3, a free trial version is available from Adobe's website (www.adobe.com/products/flash).

You are not alone either. If you have a question or a technique you would like to share, visit the reader forum accessed through the main website:

www.howtocheatinflash.com

There's no such thing as a dumb question and you may find yourself answering some as well. I am a daily visitor of the forum as well so look for me as I am easily accessible. It's a great way to meet other Flash users and maybe collaborate on a cool animation project.

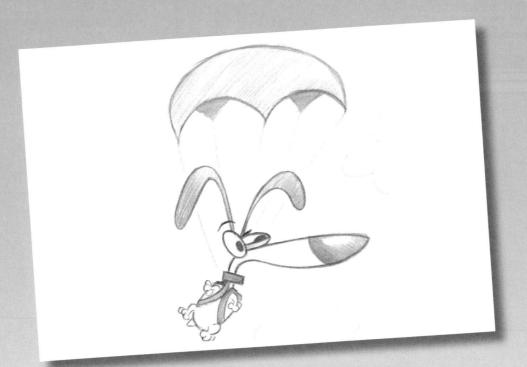

No two snowflakes are exactly alike and the same can be said for artists and designers. A good drawing program will allow this individuality to be expressed without limitation.

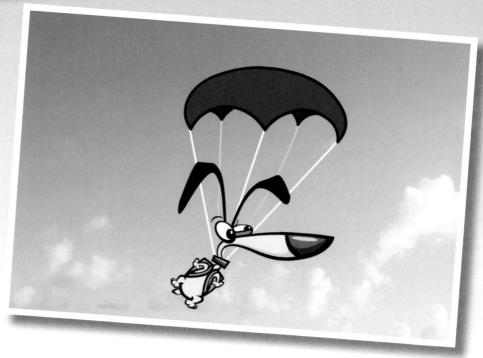

Design styles

THE TECHNIQUES described in this book assume you have a reasonable working knowledge of Flash. In later chapters, we'll discuss ways of working that involve symbols, timelines and various animation techniques. This first chapter will serve as a refresher course on the fundamentals of designing for animation and introduce a few cool drawing techniques along the way.

Later on, we'll go into more detail on how to work with symbols, motion and shape tweening, and the timeline.

Design styles

Drawing with basic shapes

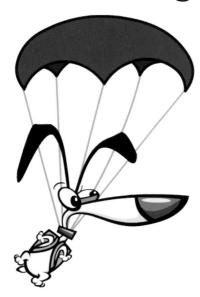

F YOU PLAYED WITH Lego building blocks when you were a kid, you may find this drawing style familiar (or at least intuitive). You'll use several basic shapes and then connect them together. This technique requires breaking down each body part of the character into basic building blocks using the Rectangle and Oval tools. It's a fast and efficient way to simplify the character into manageable sections while achieving a very professional cartoon style.

Here, we will use shapes to cut in to other shapes. This is a very useful technique for cutting holes out of objects as well as altering the edges of shapes. Of course these techniques can be applied to background elements as well.

The key here is using simple shapes to build complex images suitable for Flash style animation, which we will get to in later chapters.

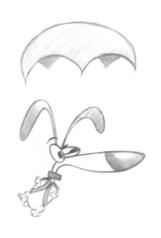

Here is my original pencil sketch that I have scanned and saved as a JPG file. I prefer to start with pencil on paper because I simply like the feel of this medium and the results are always a little more, shall we say, artistic.

After importing the scanned image, insert a blank keyframe on frame 2 and turn on the Onionskin tool. This allows me to trace the image in a new frame while using the original image as a reference.

To achieve the black outline, select the shape, copy it using **HC** and paste it in place using **HShift V**. While it's still selected, select a different color from the Mixer panel and scale it about 80% smaller.

The original shape is still present underneath your new shape. The trick is to position the new shape offcenter from the original to achieve an outline with a varied weight.

Using the Oval and Rectangle tools allows us to quickly achieve the basic forms of our character. The Selection tool is great for pushing and pulling these basic fills into custom shapes based on our sketch.

4 Turn on the Snap option (magnet icon), and drag corners to each other so they snap together. This process is not unlike those Lego building blocks you played with when you were a kid.

5 Next, click and drag the sides of your shapes to push and pull them into curves. This is a fun process as your character really starts to take shape.

HOT TIP

As you complete each individual section of your character, cut and paste them into new layers and lock them. This will prevent them from being inadvertently edited. Better yet, convert them to symbols while you are at it.

The parachute uses a slightly different technique I like to call "cutting in". Let's start with the Oval tool for the parachute's basic shape.

9 You can cut into this shape using different colored shapes such as this blue oval. position it over the area you want to cut into, deselect it, then select it and hit the Delete key **Delete**.

10 Once your shape is the way you want it, you can use the Ink Bottle tool S to quickly add an outline to it.

Design styles

The Brush tool

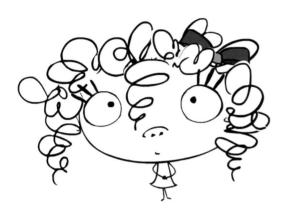

HE BRUSH TOOL is probably the most versatile of all the drawing tools, especially when combined with a pressure-

sensitive tablet. Drawing with the Brush tool is essentially drawing with shapes. It's the tool that

pressure sensitivity and tilt features. Wacom makes a series of popular tablets that work great with Flash. Wacom tablets can work in conjunction with your existing mouse, or replace your mouse completely. Many digital designers use a tablet with any number of graphics editors including Adobe Photoshop and Adobe Illustrator.

feels the most natural due to the support of

When to use the Brush tool is really a matter of style and preference. For this character, I wanted to achieve a loose, hand-drawn feel, so the brush was a perfect choice.

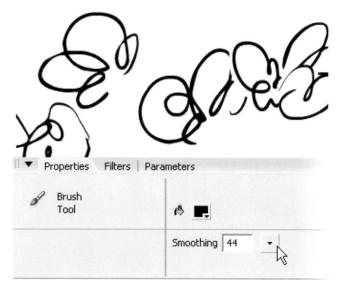

The first adjustment you will want to make when using the Brush tool will be the amount of smoothing you want applied. This option appears as a vertical slider in the Properties panel when the Brush tool is selected. The right amount of smoothing to use depends on personal preference. The higher the number, the smoother the line (and vice versa). For this character, we'll choose a low amount of smoothing to maintain an organic quality to the line work.

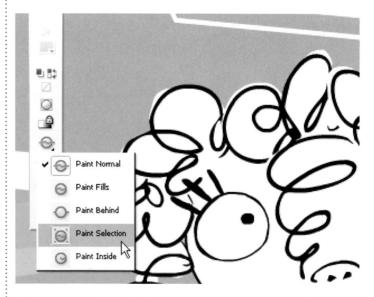

To remain consistent with the loose drawing style, you may want to add a fill color that bleeds outside of the outlines a little. There are several ways to achieve this by painting on a new layer below the outline art or setting the brush to "Paint Behind" and painting on the same layer.

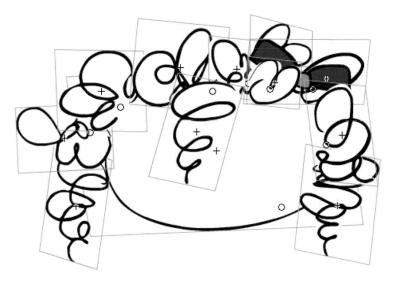

Always design your characters with the intended purpose in mind: animation. Form follows function and the animation style can often dictate how a character is designed. If you are a perfectionist like me, you'll want the hair to look as much like individual curls as possible. To do this, avoid designing the hair as one large flat object. Instead, draw individual sections of curls to keep them as

separate objects so they can be moved independently of each other. Turn on Object Drawing mode (subselection of the Brush tool). Object Drawing mode allows you to draw shapes as separate objects. These objects can be drawn over each other without them being merged together. You can select each Object Drawing with the Selection tool and then convert each one to a symbol.

HOT TIP

Experiment with different stage magnifications when drawing. I prefer to draw on a larger scale and with the stage magnified about 400%. The result is typically a smoother line quality.

4 The final result represents the loose handdrawn style we were after. The line quality feels natural and reflects the imperfections the human hand is capable of. We are not trying to achieve a slick design style here, but rather to convey a looser line quality representative of hand-drawn artwork. This style lends itself well to a child character as the integrity of the line is similar to how a real child would draw.

Mixing colors

OLOR IS POWERFUL. It can be used in a variety of ways to suggest the tone of your graphic design or mood of an entire animated scene. Let's take a look at how to adjust color values using the Color Mixer's HSB sliders. Using the drop-down menu,

change the color mode from RGB to HSB.

Now the sliders next to each swatch can be used to adjust your colors based on their hue, saturation and brightness.

You can convert your colors to gray scale by picking the colors with the Eyedropper tool and then dragging the saturation slider all the way down to 0%. This will lower the saturation but maintain its hue and brightness.

2 Change the hue of your colors by adjusting the amount of hue with the slider. You can also type the value directly into the percentage field if you prefer. If you have several colors to adjust, select the numerical value and copy it to your clipboard. To adjust additional colors all you need to do is select them and paste in the color value.

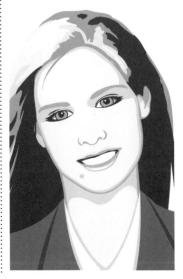

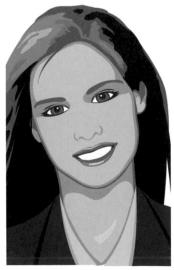

HOT TIP

Remember to convert your color mixer fr

color mixer from **HSB** to RGB and double check that the range of each color is between 16 and 235. If you are not planning on exporting to video, then you do not need to be concerned with the range of your color values. There are also video editing programs such as Adobe After Effects and Adobe Premeire that can force your exported video files to NTSC safe colors. But you might want to retain control by creating your own color-safe palettes in Flash as opposed to allowing them to be converted in post-

Here's another example where the hue for each color has been easily adjusted using the hue color value. This technique can be very effective for providing an overall tone to your website design or matching an existing color scheme.

4 You can experiment by adjusting two or more values to create unique contrasts in color. The lower the saturation, the less contrast there will be between colors. You can achieve that nice "pastel" color scheme by finetuning these values.

5 Adjust the sturation value to create a strong contrast between colors. The saturation will detirmine the intensity of a specific hue.

production.

Using gradients

RADIENTS CAN BE VERY effective when you want to break away from the flatness of solid color fills. They can be used to add a sense of depth and dimensionality to your characters, backgrounds and graphics in general.

Gradients can also work against you due to their ease of use, resulting in generic and often lackluster images. When in the right hands, both linear and radial gradients can contribute to a very effective and sometimes realistic design.

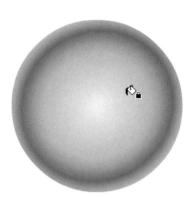

A simple radial gradient is used to fill most of the shapes that make up the monkey. The trick here is providing the illusion of a 3D object in a 2D environment. Four colors are used for this gradient. The critical color for this illusion is the fourth color (far right). It represents a light source coming from behind the sphere, suggesting the sphere is truly round.

4 To make the ear look concave, mix another radial gradient going from darkest in the center to a lighter value on the outer edge. Fill the shape with this gradient and position it off-center so that only half of the gradient is shown. Since darker colors will recede and lighter colors will appear closer to us, this otherwise flat shape now gives us the impression it is concave.

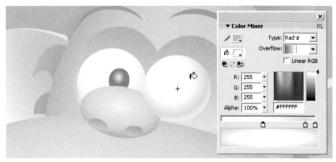

For those classic cartoon "ping-pong" eyeballs, mix a radial gradient the same way using white and gray colors. Color theory teaches us that to show light, you must show dark. Apply this technique to the eyes by placing them in front of a darker shape. This will help add some contrast, making the eyeballs *pop*, thereby adding depth.

Edit the gradient to conform to the shape using the Gradient Transform tool 🖪. Use the handles to rotate, scale and skew the gradient so it is slightly larger than the shape. Select the center control point and drag the entire gradient and position it slightly off-center from the shape.

3 Click and drag the rocal point too. 2 shape and its edge. By doing this you are suggesting that the light source is at more of an angle. Notice the fourth color of our gradient is showing along the bottom and right edge. This implies light wrapping around the sphere from behind.

HOT TIP Experiment with different stage

magnifications

when drawing.

I prefer to draw

on a larger scale and with the stage magnified about 400%. The result is typically a smoother line quality.

The hair is a shape filled with another radial gradient. Most of this shape will be hidden behind other graphics, so you only need to concern yourself with how the outer edge looks when the character is fully assembled.

The hands are really not hands at all. A few strategically positioned spheres with the same radial gradient as the face and body are used to suggest hands.

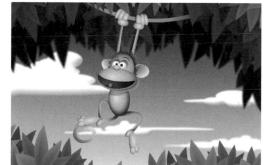

Good designs are consistent in technique. When each element is comprised of the same graphical style, the overall result will typically be consistent and fluid. Don't deviate from your plan, choose a technique and stick with it.

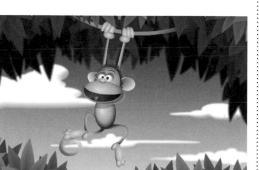

Alpha: 100%

The nose is a combination of spheres filled with radial and linear gradients. To create the nostrils, use a linear gradient and edit it so that the darker color is above the lighter color. By themselves, the spheres are just shapes. But placed against the radial sphere, they become holes.

Adding texture

BITMAPS CAN BE A VERY effective way to add texture to your designs. Since any image could be a potential texture, the possibilities are endless. For this frog character, I wanted a slightly more sophisticated look while still maintaining a cartoon feel. Instead of using solid color fills and some spot color shading, the use of imported bitmap textures added that extra sense of depth and richness.

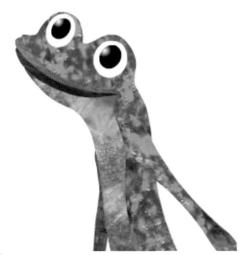

The first task is to design your textures. A digital camera is a very handy device for this purpose. Take a walk around your neighborhood and you'll quickly find an unlimited supply of interesting textures that can be used for your designs. Use Photoshop to adjust the color, add filters and crop your images. Remember to keep the image small enough for web output.

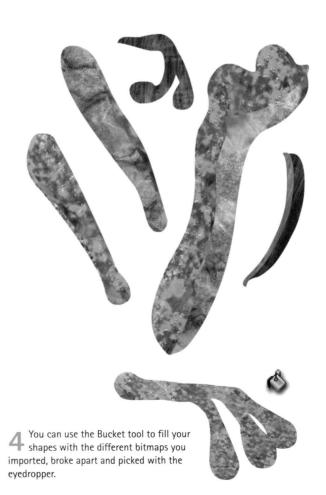

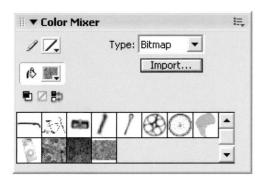

Select the imported bitmap and break it apart # B ctrl B. Click on it using the Eyedropper tool. It will now be added to the Color Mixer as a swatch.

Using the Brush tool, draw your shapes using the bitmap as the fill color.

HOT TIP

You may also want to adjust the properties of the imported bitmap (doubleclick the bitmap icon in the document library) and select "Apply Smoothing". This will apply anti-aliasing to your image and make it appear smoother. As an option, set the quality of your movie to "BEST" by adding one line of code to frame 1 of the main timeline. Your bitmaps will look their best but will demand more from your processor during playback - user beware.

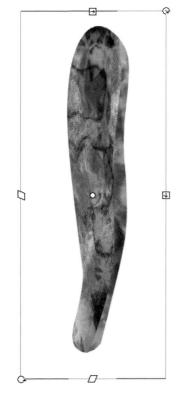

Most likely the bitmap fill will need to be scaled, rotated or repositioned. Select the Free Transform tool **(F)**, and edit your fill using the various handles around the bounding box.

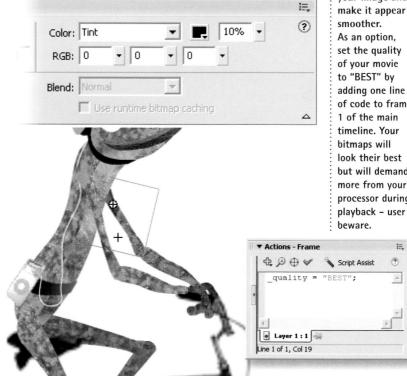

The final step is to convert all parts to symbols and add a slight amount of dark tint to the instances behind the character. This helps separate similar bitmap textures from each other and adds a touch of depth.

Adding texture (cont.)

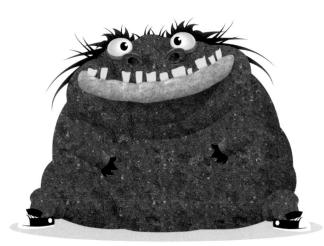

BITMAPS DON'T ALWAYS have to look flat.
Introducing "Grotto", a character made almost entirely of bitmap fills and some carefully placed Flash gradients to provide the illusion of form, volume and, most of all, texture.

Here we'll look at how to give otherwise flat bitmap textures a bit more depth using some basic gradients and alpha.

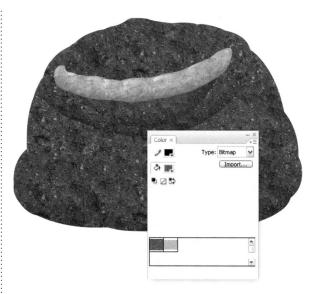

The first step is to create your texture in Adobe Photoshop, import it into Flash, break it apart and then select it with the Eyedropper tool . I created the shape for Grotto's body with the paint brush and the bitmap swatch as my fill "color". Select the body shape and convert it to a graphic symbol.

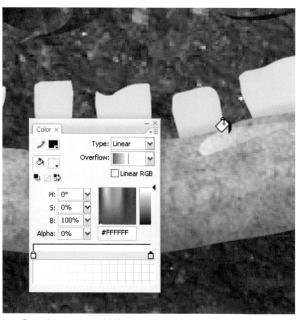

4 Sometimes the devil is in the details, which is evident here with the addition of some subtle highlights to the lip. On a new layer use the Brush tool to paint some shapes and then fill them with a linear gradient containing 30% white to 0% white. Use the Fill Transform tool to edit the gradient as necessary.

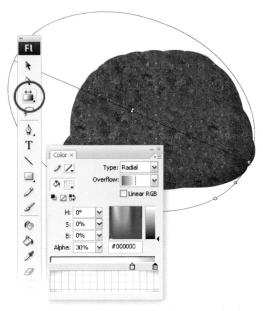

Edit the symbol by adding another layer above the shape layer. Copy (#) (and paste in place (#) (shift) V the body shape into this new layer. Fill it with a radial gradient with two colors; black with about 30% alpha and black with 0% alpha.

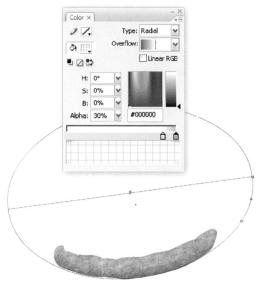

The mouth/lip symbol was made the same way by layering a radial gradient over the bitmap fill shape. Use the Fill Transform tool to position the gradient so it forms a shadow along the bottom half of the shape.

HOT TIP

You may also want to adjust the properties of the imported bitmap (doubleclick the bitmap icon in the document library) and select "Apply Smoothing". This will apply anti-aliasing to your image and make it appear smoother.

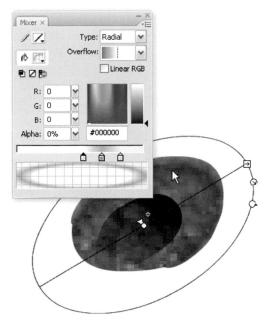

5 The nostril is another example of layering various gradients over the original shape containing the bitmap fill. Here I used a linear gradient for the inner nostril shape and a radial gradient to provide some shading for a more realistic effect.

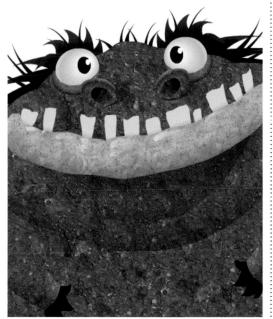

6 When all these subtle details are combined, they can add up to a very sophisticated image. The shapes that make up Grotto are simple yet convincing simply by layering some basic gradients over our textures.

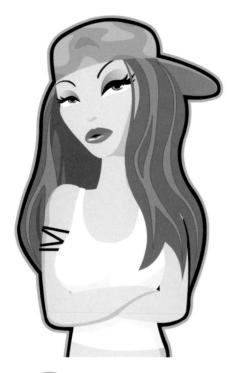

O FAR IN THIS CHAPTER we have looked at several ways of achieving different styles of drawing. From the basics of snapping simple shapes together forming bigger, more complex shapes, to using bitmaps as textural fills. Most of the time the design process demands a combination of tools and techniques to get the job done. For this character design I went from a rough pencil sketch to a fully rendered vector drawing using the Pen tool and basic shapes. The Pen tool, in combination with the Selection tool. offers infinite flexibility when it comes to manipulating strokes and shapes.

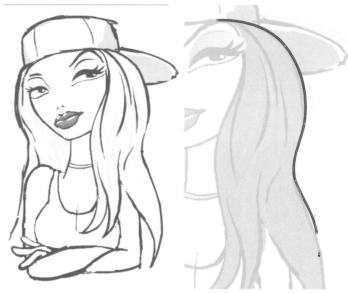

Start with a scanned sketch or draw directly into Flash. Create a blank keyframe on frame 2 and turn on the Onionskin feature. Using the sketch as reference, trace the hair using the Pen tool by clicking and dragging each point as you go. This will automatically create curves with Bezier handles, allowing you to manipulate the stroke each time a point is made.

5 A linear gradient is perfect for the eyeshadow. Choose the color you want for the initial color, and for the second color in the gradient you may want to use the same color used for the skin tone. Then you can blend the eyeshadow into the rest of the face for a soft and seamless effect. You can experiment with various colors to produce different eyeshadow styles.

2 Using the Subselection tool (A), modify the contours of the hair by clicking an anchor point and adjusting its Bezier handles.

Juraw the shape of the face with the Rectangle (a) or Oval tool (a). Use the Selection tool to refine the shape by pushing and pulling its edges.

4 With only a fill color selected in the toolbox swatch, draw irregular shapes to represent a camouflaged hat.

HOT TIP

Go to Edit > Preferences > Drawing and make sure the "Show Pen Preview" option is checked. This will allow you to see a preview of what your lines will look like as you are drawing with the Pen tool. Hold down the Shift key to snap your lines to 90 and 45 degree angles as you draw. To designate a control point as the end of your line, hold down the Ctrl/ Command key while clicking.

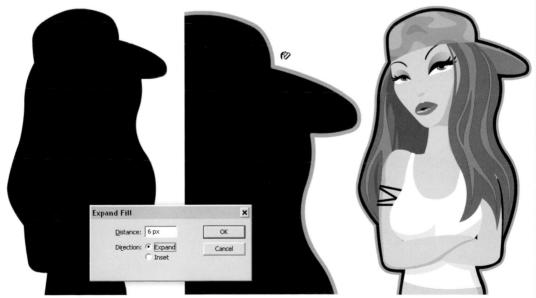

Once the character is completed, unlock all layers and select all **(M)** A copy the entire image to your clipboard using **(M)** Com C and create a new layer. Place this new layer below all other layers. Paste in Place **(M)** Shift V into the new layer. Convert any

lines to fills and fill the entire shape with black. Modify > Shape > Expand Fill will expand the shape's outer edge. Use the lnk Bottle tool S with a different stroke color and click on your shape to add a nice accent of color. Turn on the visibility of all your layers.

Trace Bitmap

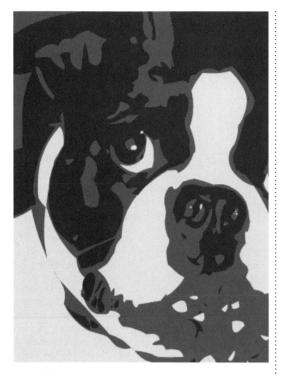

HOTOGRAPHIC IMAGES can be used to add a measure of realism to any Flash project. They can be imported and used in their original state, or they can be simplified for a unique, stylized look. The obvious approach to vectorizing photographs is to import the image into Flash and use the drawing tools to trace it by hand. But that can be very time-consuming depending on the complexity of the image.

The trick here is to average down the amount of colors your image contains, and Adobe Photoshop makes this an almost effortless task. Combine that with the Trace Bitmap engine in Flash, and you won't even have to select one single drawing tool!

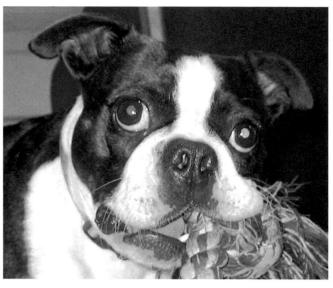

Start with a good quality image that has enough color contrast. Open it in Adobe Photoshop and save it as a PSD file. Now may be a good time to adjust the contrast, saturation, colors or whatever else you prefer to edit.

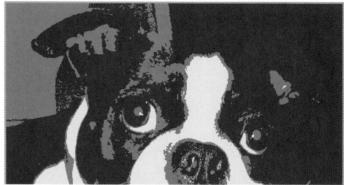

Import the optimized GIF into Flash ***** R** 600 **** Make sure it is selected and go to Modify > Bitmap > Trace Bitmap. In the Trace Bitmap dialog panel, you can adjust individual settings that will ultimately dictate the level of complexity your image will have when converted to vectors. The proper setting will vary depending on your image and personal preference.

Frace Bitmap			
Color threshold:	1		ОК
<u>M</u> inimum area:	1	pixels	Cancel
<u>C</u> urve fit:	Smooth	·	
Corner threshold:	Few Corr	ners 🔻	

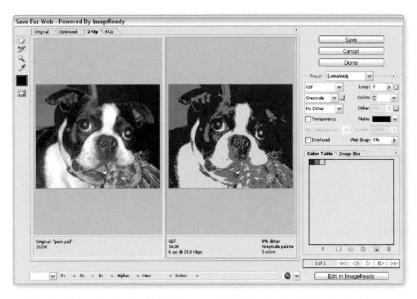

2 Save for Web using **Shift **S ettl Shift all **S and select GIF as the file format.

Select Grayscale from the Color Reduction drop-down menu and limit the number of colors to two or three depending on the image and amount of colors your prefer to keep. Click Save and name your new GIF image.

4 Once the trace is complete, your image will be all vector and fully scalable. The resulting image of this dog is now only 12k but we can get it even smaller by using Flash's built-in Optimize engine. Select the entire image and go to Modify > Shape > Optimize. Use the slider to adjust the amount of smoothing and select "Use multiple passes".

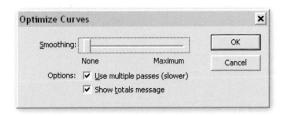

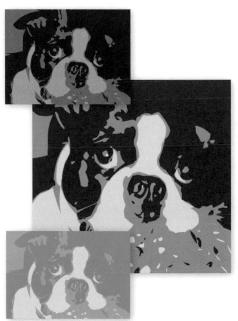

5 End result is an image that is very lightweight for the web, weighing in at only six kilobytes. It is also easy to change its color scheme using the Paint Bucket tool **K** and the Color Mixer.

HOT TIP

When optimizing curves using the Flash optimizing feature, set the stage magnification to 100% or lower. Total optimization may vary depending on the magnification of the stage. Optimization tends to have a greater effect with smaller objects and less of an effect with larger ones. You will have to conduct your own experimention for the preferred ratio between optimization and image quality.

Shading 1: line trick

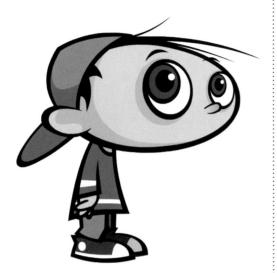

HERE ARE ALWAYS SEVERAL WAYS to achieve the same result in Flash. With all the various tools at our disposal, I am constantly finding different ways of using them to achieve various effects.

Cell shading is commonly referred to as "toon shading". This style of shading is popular with comic book style artwork and classic Disney films. I have discovered four different ways to achieve cell style shading for you to choose from.

1 Start with a basic shape that contains a fill and outline. This technique will work just as well with shapes that have no outlines.

2 Select the Line tool **N** and make sure the Snap to Objects tool is also selected in the toolbox.

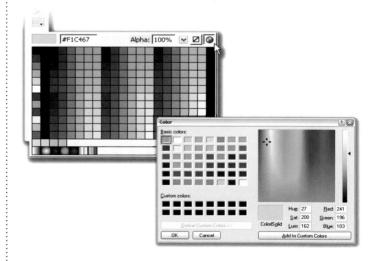

6 An alternative way to mix colors in Flash is to click the color wheel button in the upper right corner. This will open the color palette mixer that is native to your operating system. Mix your new color and click "OK".

3 Draw a diagonal line inside the fill of your shape. Use the Selection tool S to drag each end point of the line so they snap to the edge of the fill.

4 Use the Selection tool to bend the line so that its arc reflects the shape of the oval.

5 With the fill color selected, mix a slightly darker color using the Color panel mixer.

HOT TIP

Cell style shading can be difficult to achieve. You have to imagine that your twodimesional shapes have a third dimension and they are affected by light and shadow. Choose a light source and keep it consistent throughout your design when adding shading.

Select the line and delete it. Easy right? If it still isn't perfect, you can continue to use the Selection tool to edit the edge of the new fill you created.

Shading 2: shape it

ERE'S ANOTHER VARIATION on cell style shading in Flash. This technique involves the Rectangle tool and allows for more complex shading. This may be preferable if your shapes require more complex shadows.

2 Use the Selection tool **S** to pull the corners until they snap to the edges of the shape (make sure the Snap feature is turned on).

5 Let's take this technique one step further by adding more shading for a more realistic effect. Repeat the above procedure using an even darker color inside the shaded area.

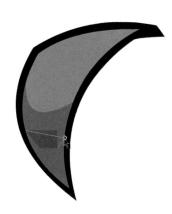

6 Use the Selection tool to pull the corners until they snap to the edges of the shaded shape.

3 Fill the gap area created after snapping the corners to the edge of the shape.

4 Use the Selection tool to bend the edge of the darker fill color so that its are reflects the shape of the oval. Having used the Rectangle tool, you have an extra corner to play around with. This can be useful for creating more complex shading such as with the ear shape.

7 Fill the gap area created after snapping the corners to the edge of the shape.

8 Use the Selection tool to bend the edge of the darker fill color so that its arc reflects the contour of the shape.

9 You can repeat this procedure as many times as you like. The more color values you add, the more realistic the image will be.

HOT TIP

If you would like a cool and easy way to create various hues based on your original color, give Adobe's Kuler tool a try (kuler.adobe. com). You can mix shades of color very easily and then save and download them as ASE (Adobe Swatch Exchange file). Open the downloaded ASE file(s) in Illustrator and then save your new swatch panel as an Al file and import it into Flash. An easier way would be to manually copy the HEX value from the Kuler site and paste into the Flash Color Mixer panel.

Shading 3: paint selected

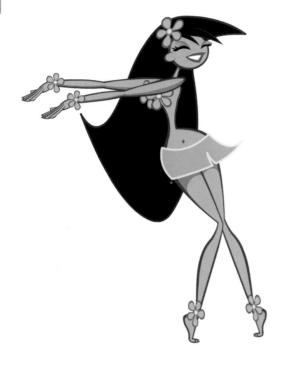

Start with a shape.

Select the Brush tool **B** and then from the brush mode subselection menu, select Paint Selection. This will restrict any paint to selected fills only.

E ARE ALL DIFFERENT and we tend to find different ways of using the same tools. We get used to certain techniques because they become familiar to our workflow and we become comfortable in our own individual habits. Here is yet another technique for creating cell style shading that you may prefer over the previous versions. It lends itself well to the designer who likes a more handdrawn feel to their work.

Next, simply fill the space created by the new fill you just painted.

Voila! Now you've got a convincing cell style shading for the leg.

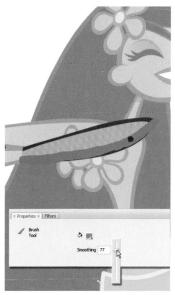

3 Use the Selection tool to select the fill color you'll be adding the shade color to. Now use the Brush tool and adjust the amount of smoothing desired for the shape you'll paint. Next, paint inside the selected fill.

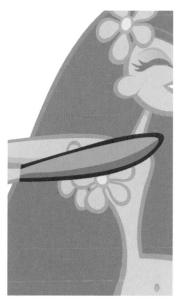

Don't worry about being sloppy.
Once you release the brush, the painted fill will exist only inside the selected area you intended.

5 Sometimes the area may be too large to paint entirely by hand. In this situation, just draw the contour of the edge for the shaded area.

HOT TIP

Consistency is important when it comes to your light source. It helps to limit yourself to one light source if possible and create your shading based on the angle the light source is coming from.

The face shading can be drawn the same way. Remember the direction your light source is coming from and paint a crescent fill.

9 Fill the space created by the new fill and you are done.

10 Cell shading can add that extra dimension to your designs, giving them depth and realism.

Shading 4: outlines

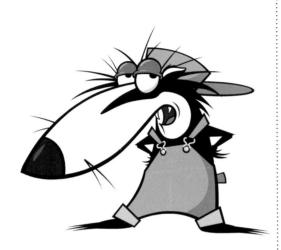

HIS VARIATION ON CELL STYLE shading works well for simple shapes and very complex shapes. If you have line work that is very loose and hand-drawn looking, this may be the technique for you. You will use the lnk Bottle to create a line around your fill. Then you can reposition this line off-center and fill the space created with a darker shade of color.

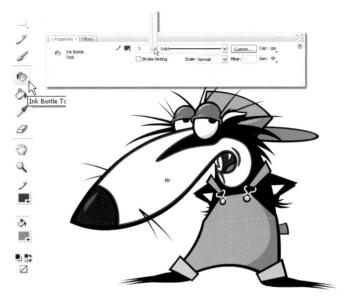

1 Start with the Ink Bottle tool 1 and a stroke color that doesn't exist anywhere in your design. Set the stroke height to around 3 or 4 point. Click anywhere within the fill to outline it with a stroke in the color you chose. Don't worry about how it looks because you will eventually delete this line entirely after you are done.

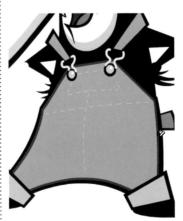

4 For this character's outfit, I applied a stroke outline to the overalls as well.

5 The stroke is selected and repositioned based on the same light source as in the previous example.

2 Select the line by double-clicking on it with the Selection tool. Next, use the arrow keys to nudge it away from the original shape in the direction of your light source. Fill this area created between the stroke and the original edge of your shape with your shade color.

Delete the entire stroke by pressing the **Delete** key. If your stroke has been deselected, select it by double-clicking on it with the Selection tool. Double-clicking the stroke will select the entire stroke while single-clicking on it will select a segment of it if it contains multiple points.

HOT TIP

Set your stroke height large enough to make it easier to work with. A larger value will allow you to select it easier. Choosing a bright color that is high in contrast from your original design will make it easier for you visually.

6 A darker shade of color is mixed and filled to create the illusion of form and realism.

With the stroke still selected, delete it. In some cases, the resulting shape created may need some tweaking.

Use the Selection tool to further refine your shading based on your needs and design sense.

Realism with gradients

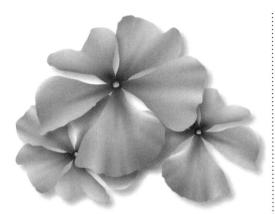

LASH IS MUCH MORE than a tool for designing cartoon characters. Its full array of vector drawing tools is suitable for many styles of illustration. Here we will go step by step creating a realistic flower illustration. Flowers are always appealing to draw and at the same time challenging due to the subtle variations of color they often contain.

The main tools to be used for this example are the Pen tool and Gradients. The Pen tool has been greatly improved in Flash CS3 and if you are familiar with Illustrator's Pen tool, you will notice some similarities. Flash has adopted the core functionality of Illustrator's Pen tool including identical shortcut keys and hot key modifiers – not to mention identical pen cursors as well. Integration is bliss.

One particularly cool Pen tool trick is to hold down the spacebar to redirect the current point while drawing. Another nice feature in CS3 is that the auto-fill when completing an enclosed shape with the Pen tool has been removed for consistency reasons.

The more you experiment with the new Pen tool the more I think you'll like it. In fact, I think it's better than Illustrator's Pen tool.

The first step is to outline the basic shape of the flower's petal with a stroke color that is high in contrast to the original image. Be as precise as you want, but I recommend using the original image as a guide, simplifying where needed along the way.

The Pen tool P is perfect for this task simply because it is quick and easy to manually trace the contour of the petal by clicking and dragging along the contour of the image.

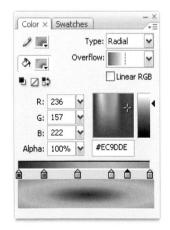

6 The initial gradient will provide the overall hue and tonal range of the flower petal. Flash lets you apply up to 15 color transitions to a gradient.

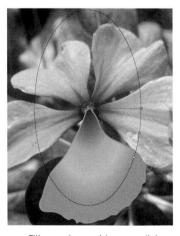

Fill your shape with your radial gradient and then use the Fill Transform tool (a) to edit its size, position and rotation. You can delete the stroke at this stage as it is no longer needed.

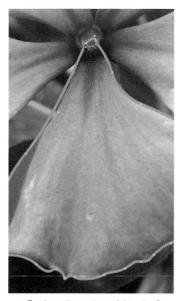

To close the path, position the Pen tool over the first anchor point. A small circle appears next to the Pen tool pointer when positioned correctly. Click or drag to close the path.

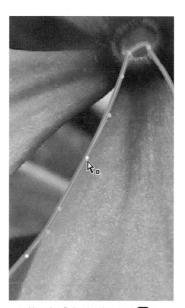

Use the Subselection tool (A) to refine your path if you desire. To adjust the shape of the curve on either side of an anchor point, drag the anchor point, or drag the tangent handle. You can also move an anchor point by dragging it with the Subselection tool.

5 Next we need to mix some radial gradients. Flash's color picker can grab colors from anywhere on your screen if you click on any of the color swatches found in the Color Mixer, Properties panel or the toolbox and drag to the area containing your desired color.

Copy ctrl and Paste in Place me Pl

9 Fill the duplicated shape with your new gradient and use the Fill Transform tool to create the suggestion of subtle undulations within the shape. Repeat the process of copying and pasting in place this shape to new layers for each new gradient.

10 You can manipulate each new gradient using the Free Transform tool to create soft shadows and highlights. In almost all cases, you will only use partial gradients to create subtle transitions of light and shadow.

HOT TIP

To constrain the curve to multiples of 45°, shiftdrag. To drag tangent handles individually, Alt-drag (Windows) or Option-drag (Macintosh).

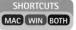

Design styles

Realism with gradients (cont.)

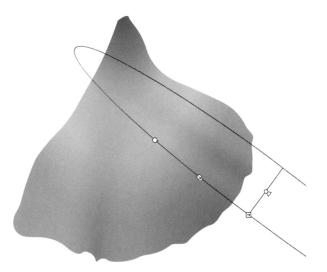

11 It's always convincing to position soft shadows where the edge of the shape contains an imperfection. The combination of gradient colors and irregular contours makes for a very convincing imperfection.

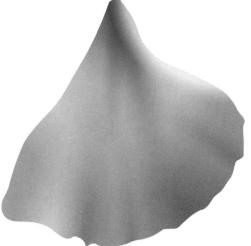

12 This is the end result of using several variations of layered radial gradients, producing beautiful and convincing variations of color.

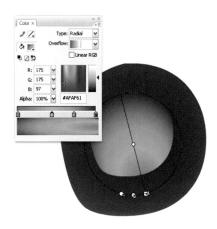

15 To achieve the effect of depth in the center of the stigma, drag the little white arrow in the radial gradient's center to move the focal point towards the edge.

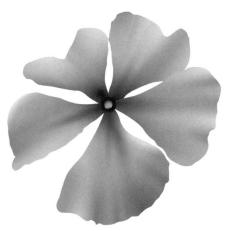

16 Here's what the flower image looks like once all the petals and stigma have been illustrated. But you don't have to stop here. Let's have some fun with Flash's filters. Convert the entire flower to a Movie Clip symbol.

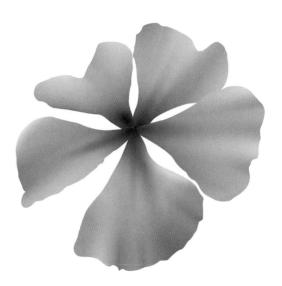

13 Repeat the same procedure for each petal of the flower image. To keep your main timeline layers to a minimum, convert each layer to a goup or an object drawing and convert each petal to a symbol.

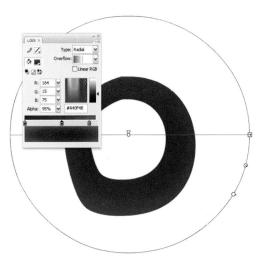

14 The center of the flower, technically named the stigma, was created with a donut-shaped fill containing a radial gradient.

HOT TIP

Set your stroke height large enough to make it easier to work with. A larger value will allow you to select it easier. Choosing a bright color that is high in contrast from your original design will make it easier for you visually.

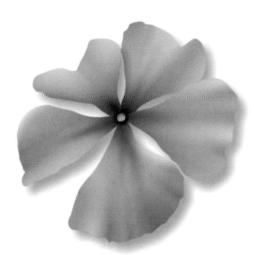

17 From the Filters panel, add a Drop Shadow. Set the blur, alpha and distance to your disired amount. You may want to also add a Blur filter to soften the overall image of the flower.

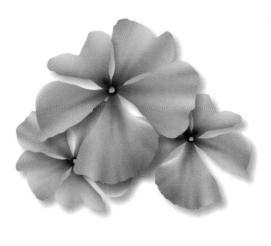

18 Duplicate the instance of the flower movie clip. Scale and rotate them to create an appealing floral arrangement. It's almost hard to imagine this style of illustration can be made entirely in Flash, right?

The new Flash interface

FLASH IS GROWING UP. It started out a long time ago as a simple web animation tool and, for all intents and purposes, has grown to become its own development platform. Most notably, the Flash interface has progressed dramatically from its earliest incarnation. Upon initial inspection you'll notice the look and feel has been streamlined in keeping with the Adobe suite of tools. Icons are now shared across programs and integration has been implemented.

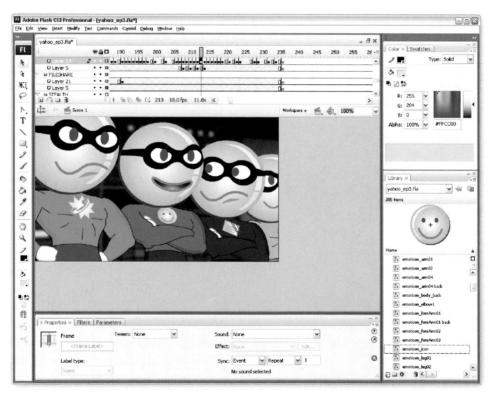

One of the most obvious new features of the UI is how panels can be docked, grouped and minimized. If you choose to dock them to the sidebar, you can then further minimize them until they become icons. Clicking on an icon will open the respective panel or group of panels. There's also a preference to toggle on/off the auto-collapse of the icons when you focus elsewhere in the workspace.

The toolbox can now be customized so that all the tools are aligned in one single column as opposed to two columns. As always, you can customize the workspace and save your layouts. Below is my typical setup, which maximizes the stage area for design work. I prefer to have as much screen real estate as possible for drawing and animating. In fact, I like to set my display resolution as high as possible, which means I do most of my work on a 17" laptop with a 1920 x 1200 display resolution. This allows me to work in a larger format with the Flash stage magnified to about 400%. I have found this to yield more control when drawing with the Brush and Line tools.

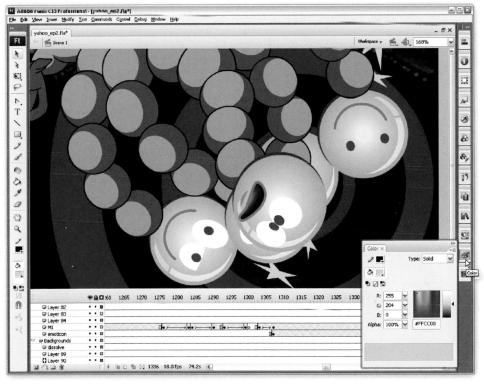

You can save as many different layouts as you like, which is useful if your workflow involves several varied tasks. As you read through the following chapters, you will learn more about the new interface, drawing and integration features Adobe CS3 has to offer.

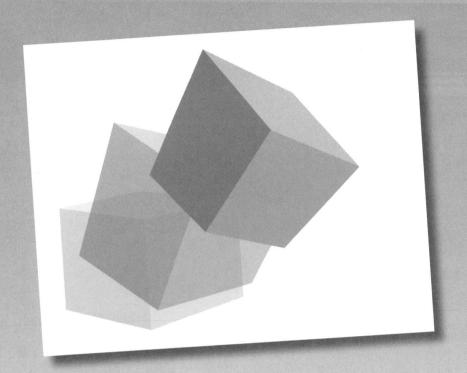

■ The most basic of objects, the cube, can be brought to life using just the Free Transform tool. With a little rotating and distorting, you can easily create an animation that gives an otherwise boring subject some life and personality. The same techniques can be applied to almost any object - including characters.

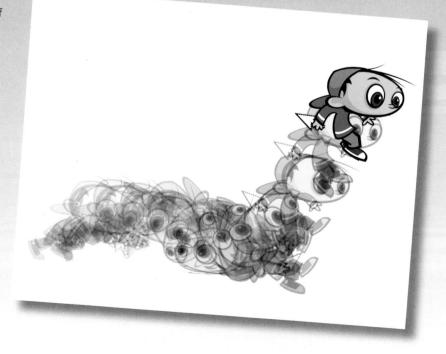

Transformation and distortion

SQUASH, STRETCH, BULGE, warp, distort, rotate, skew, deform - what do all these transformations have in common? Hint: it's not how you felt after that second baked bean burrito you know you didn't need to eat. Answer: it's the Free Transform tool, the single most efficient and versatile tool Flash offers, and it will prove to be one of the most used tools in your daily animation workflow.

The Free Transform tool is truly the Swiss army knife of tools as it allows you to perform a multitude of transformation tasks to raw vector objects, instances of symbols, imported images and broken apart text. This chapter will focus on the versatility of the Free Transform tool and how to apply it to your images.

Distorting bitmaps

S A DESIGNER AND ANIMATOR, one of the most frequently used tools in Flash is the Free Transform tool. It is the most multifaceted tool in the toolbox and will prove to be critical to the transformation and distortion of objects and then some.

Free Transform is the tool to use when you want to scale, rotate, shear and distort your images.
Free Transform is also used to edit the center point of instances of symbols. You can use Free Transform to transform imported bitmaps or graphics created with the Flash drawing tools.

There are a variety of modifier keys to be used with the Free Transform tool that allow you to transform objects in different ways, as we will discuss here.

1 Enter Free Iransform mode by selecting the Free Transform tool in the toolbox or by pressing the keyboard shortcut 2. Let's start by transforming an imported bitmap image.

Preak apart your imported image BB emB before transforming it. If you want you can convert it to a Drawing Object (Modify > Combine Objects > Union).

Position the cursor outside the bounding box between the handles and drag to shear the object. Hold down (2) (a) to shear based on the center of the object.

Hold down # Shift and drag a corner handle to distort the object's perspective equally on both sides. Unfortunately Flash does not distort the image, but rather crops it.

When you drag any of the four corner handles, you will scale the object. The corner you drag will move while the opposite corner will remain stationary. Hold down the Shift key to

scale based on the object's center.

If you grab any of the four center side handles, you will scale the object horizontally or vertically. This is great for squashing and stretching the object.

5 Grab one of the corner handles to rotate the object. Hold down finite to constrain the rotation to 45 degree increments. Hold down all to hinge the object at the opposite corner.

HOT TIP

Some of the Free Transform tool features cannot modify instances of symbols, sounds, video objects or text. If you want to warp or distort text, make sure to break apart the text field into raw shapes first.

Hold down (S) orn to distort the object in a freeform manner. But unfortunately again, Flash doesn't truly distort a bitmap image but rather crops it.

9 Select the Envelope tool (subselection of the Free Transform tool). The Envelope modifier lets you warp and distort objects.

10 Drag the points and tangent handles to modify the envelope. Changes made to the envelope will affect the shape but not the bitmap image itself.

Transformation and distortion

The Envelope tool

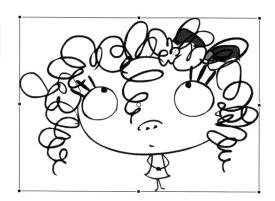

HEN USING THE FREE TRANSFORM TOOL with raw vector objects, the Distort and Envelope subselection tools become available. This is where you can really have some fun warping and deforming shapes as if they were clay. Think of how your reflection looks in a fun house mirror and you'll start to get an idea as to what these tools are useful for.

If you need to be precise with how your images are scaled, rotated or skewed, use the Transform panel to type in your values for the respective transformation.

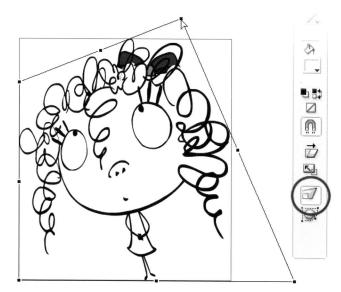

Inter Free Transform mode by selecting the Free Transform tool in the toolbox or by pressing the keyboard shortcut ②. Select the Distort subselection tool at the bottom of the toolbox. Click and drag any of the corner handles to distort your shape.

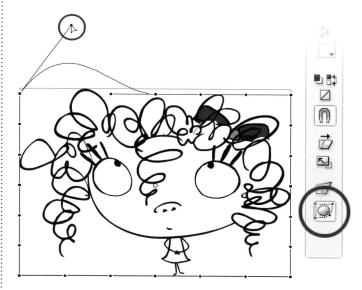

4 The Envelope modifier is great for warping and distorting shape. When you select the Envelope subselection tool, you will notice multiple handles attached to the bounding box. Manipulating these handles will affect the shape contained within. Click and drag a corner handle to start warping your shape.

HOT TIP

Holding down

when dragging a corner point will lock the tangent handles to their current position. Holding down the same keys while dragging one of the side handles will constrain that entire side and all its points.

2 The Distort tool is useful for manipulating the perspective of a shape by clicking and dragging the corner handles.

Hold down the **Shift** key while dragging a corner handle to constrain the adjoining corner an equal distance and in the opposite direction from each other. Think of it as tapering your shape.

5 Drag any of the eight tangent handles to warp your shape in almost any direction. These tangent handles are located at each corner and along both horizontal and vertical sides as well.

6 You can move any of the points to a new location to further warp your shape. But be careful, once you click outside of the selected shape, the transformation will end. You can select it again and continue to warp and distort it, but the previous point and tangent positions will be lost.

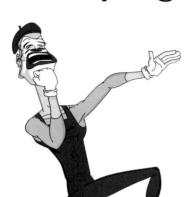

HE ENVELOPE TOOL can help shave some time off your production schedule. In this case, the Envelope tool was used to deform the head of the Evil Mime character to represent the effect of being hit by a self-imposed upper-cut. Sure, the entire head could have been drawn, but not often do we have the luxury of time to start from scratch when a deadline is looming. It was much easier to start with the head already drawn and warp it to suit our needs.

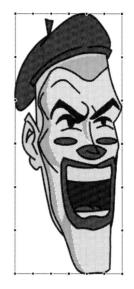

Duplicate the artwork of the head by creating a new keyframe in the head symbol. Select the entire head and the Free Transform tool ②, then select the Envelope subselection tool.

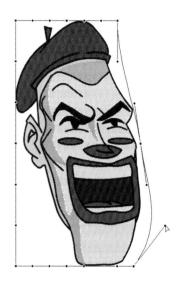

2 Using the Envelope tool, you can move the handles to deform the relative area of the head.

6 Here's the hand drawn in Flash using the Line tool. You may find the need for a variation of this same illustration and need to make it quickly.

7 Using the Envelope tool allows you to quickly distort the drawing into a different shape.

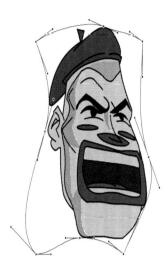

3 Continue to push and pull the Envelope's anchor points and control handles to deform the shape to your liking.

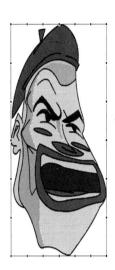

4 You can start the envelope process over by deselecting the artwork and selecting the Envelope tool again. This will reset the anchors and handles which will allow you to further distort your image.

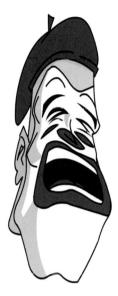

Don't be afraid to manually go back into the artwork and adjust your linework using the Selection tool. Don't rely purely on the tools, often it's your own eye that is the best tool.

HOT TIP

Don't rely on the Envelope tool for everything. In a situation like this, where a complex shape is being warped, you will probably find that upon ending your transformation, you will need to refine your shapes manually by using the Selection tool or any of the drawing tools.

Here's the foot in its default state. Depending on your animation, you may need several feet in different shapes.

9 Once again, the Envelope tool gets the job done, quickly and efficiently.

10 Don't rely completely on the tools. In most cases, they can only go so far. You may want to further refine the details of your image manually.

Transformation and distortion Card flip

POPULAR ANIMATION REQUEST requested on the Flash public forums is how to animate a flat card rotating or flipping 360 degrees. What makes this animation difficult for many to understand is the approach to actually making it. It is easy to assume, since Flash is a two-dimensional program; adding a third dimension simply is not possible unless the object is redrawn manually one frame at a time. But with Flash, it's all in the approach, and it doesn't have to be taken literally. Two dimensions are plenty to work within for this animated effect.

Start with a simple rectangle with no stroke around it. Add a second keyframe on frame 10. Select the Free Transform tool (2) and then the Distort subselection tool.

5 New to Flash CS3 is the ability to apply a shape tween from the context menu in the timeline. So go ahead and apply one.

Let's add some shape hints to correct the problem. Select the first frame in the faulty tween and then go to Modify > Shape > Add Shape Hint & Shift H ett's Shift H.

2 Hold down the **Shift** key and pull a top corner point away from the shape. With the **Shift** key still pressed, pull a bottom corner in the opposite direction.

Now that you have the first half of the animation, you need to create the second half. Select frame 11 and insert a keyframe.

11 Drag the red "a" hint to one of the corners of your shape until it snaps.

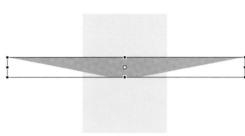

HOT TIP
While writing this topic, I experienced a common

weakness with

Shape tweens

the nature of vectors and how Flash tries to calculate what

it thinks you

want to achieve, sometimes the

tween implodes

An alternative

solution for this

example would

frames 1-10 to keyframes, copy and paste them

in frames 11-20

and then reverse

them.

be to convert

or twists in ways we never anticipated.
Shape hints exist for this very reason and they are easy to learn about in the Flash help docs.

in Flash. Due to

3 Click outside the shape to end the transformation. Select it again, hold down the **Shift** key and drag the bottom middle handle upward. The **Shift** key will constrain the shape vertically.

4 Turn on the Onionskin tool so you can see the previous frame. Position the newly transformed shape so that it is centered over the original shape seen through the onionskin.

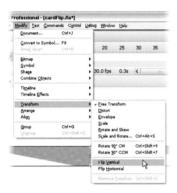

it is centered over the original shape se onionskin.

Modify the shape in frame 11 by flipping it vertically.

Select the keyframe in frame 1 and copy the frame # © ctrl all ©. Next, select frame 20 and paste the frame # © V.

Color ×

2%

分關

• Ø 53

5: 80% B: 67% ha: 100% Apply a shape tween to the latter half of your frames. You may experience a misbehaving tween like I did when writing this topic. Let's fix it.

13 The final visual effect is to mix a slightly darker version of the color of the card and then use it to fill the shapes in frames 10 and 11.

#2263AB

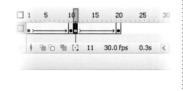

14 The card will not only tween its shape, but also its color from light to dark. This color change makes for a convincing three-dimensional effect.

Transformation and distortion

Squash and stretch

QUASH AND STRETCH is a traditional animation technique that is widely used to give animations more realism and weight. When a moving object comes in contact with a stationary object, it will deform on impact, unless it is completely rigid. One thing that is important to remember is that no matter how much an object squashes or stretches, it always maintains the same amount of volume. The amount of squash and stretch depends on how much flexibility your object should have. Traditional animation usually contains exaggerated amounts of squash and stretch. A good example of this is a bouncing ball. When it hits the ground it actually deforms and gets squashed. It will then become stretched as it propels itself upwards. With a little motion tweening and frame-by-frame animation in Flash, we can achieve convincing realism with relatively little effort.

1 Start with the object in its highest position. Convert it to a symbol and then edit its center point using the Free Transfrom tool. Move the center point to the center of the bottom edge.

2 Insert a second keyframe further down your timeline and position the ball vertically just above the horizontal guide. Apply a motion tween with Easing set to "-100" (ease in).

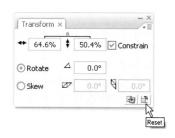

6 Start the ball's ascent by inserting yet another keyframe and removing all transformations. The Transfrom panel has a Reset button to make this a one-click solution.

Copy the first frame and paste it as your last frame. This will position the ball at the end of your timeline in the exact same position as it started. Apply a motion tween and set the Easing to "100" (ease out).

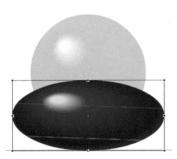

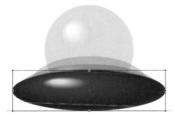

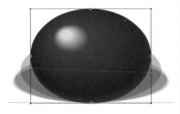

In the next frame, insert a keyframe and turn on the Onionskin tool. Use the Free Transform tool to scale the ball so it becomes wider and shorter. It's important to keep the volume of the ball consistent.

4 Insert another keyframe about four or five frames further down the timeline. Squash and stretch the ball even more. Apply a motion tween and set the Easing to "100" (ease out).

5 Insert another keyframe a few frames down your timeline and transform your ball in the opposite direction. Make sure it still has some deformation applied to it.

HOT TIP

As you create various animation examples from your day-today workflow, it's a good idea to keep them all in a single FLA document. This serves as a great way to quickly reuse animations using the Copy Motion feature in Flash CS3.

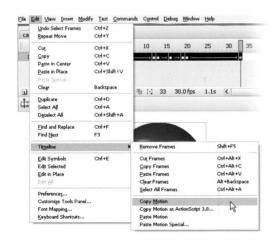

8 Flash CS3 offers a new way to reuse animations. Copy and paste motion lets you copy a motion tween, and paste the frames, tween and symbol information to another object. Select all the frames in your squash and stretch animation. Select Edit > Timeline > Copy Motion.

Insert a new layer and create (or drag from the library) a new symbol to the stage. Select this new symbol and go to Edit > Timeline > Paste Motion. Your additional symbol will now have the same exact span of frames, motion tweens, easing and transformations. Thanks to Joe Corrao for contributing the character above (joecorrao.com).

*

1

1

0

٥.

T

0

Pa

0

×

0

3

a

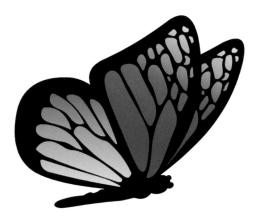

S MUCH AS I DON'T usually rely completely on the tools provided for every aspect of the design and animation, there are some situations where the tools alone get the job done. The butterfly is a perfect example of a relatively simple animation using only Flash's transform tools.

The Distort tool is perfect for changing the perspective of shapes, such as the wing of this butterfly. It also saves time from having to redraw each new angle of the wing by hand. The difference is knowing when to use the right tool for the right job.

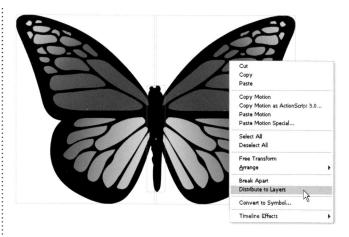

The butterfly was drawn entirely in Flash. It consists of three parts: the body and two wings. The left wing is a flipped instance of the right wing so you only have to draw and animate it once. Select all symbols, right-click over them and select Distribute to Layers from the context menu.

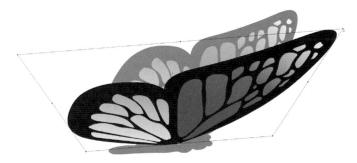

5 Double-click the front wing to enter Edit in Place mode. Insert a keyframe into frame 2. Select the Distort subselection tool and drag the upper left and right corner handles to skew the wing outward and slightly downward.

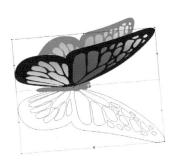

Copy frame 2 and paste it into frame 5. Use the Free Transform tool to flip it horizontally by dragging the middle handle along the top edge.

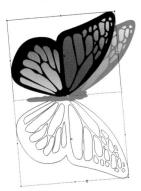

9 Repeat the same procedure by copying frame 1 and pasting it into frame 6. Transform this wing the same way by flipping it horizontally.

BUTTERFLY: MUDBUBBLE

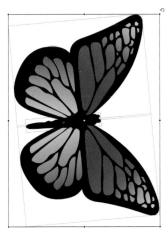

2 Rotate the butterfly 90 degrees using the Free Transform tool. Edit the center point of each wing so they hinge where they connect to the body.

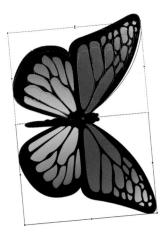

3 Select the bottom wing and, using the Free Transform tool, grab the middle handle along the bullom edge and drag it upwards. This will flip the wing vertically.

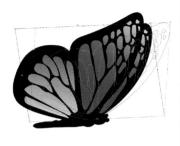

To separate the wings and add some depth to the butterfly, move the back wing to the right a few pixels and skew it slightly. You can also move the front wing to the left and skew that a little also.

HOT TIP

You can nest this entire butterfly into a Graphic or Movie Clip symbol and motion tween it along a guided path. See the topic "To sync or not to sync" in Chapter 5 to learn how to animate along a motion guide.

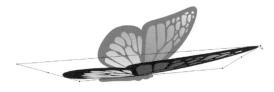

6 Insert a third keyframe and repeat the process of Distorting the wing with the corner handles.

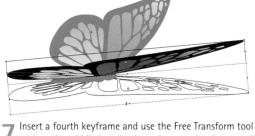

Insert a fourth keyframe and use the Free Transform tool to drag the middle handle along the top edge downward until the wing is flipped horizontally.

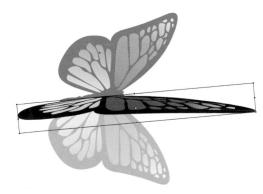

10 You have just animated the wing traveling downward. To make it travel upward, copy frames from the first half of the animation and paste them after your current keyframes.

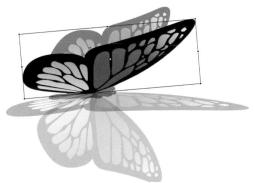

11 A butterfly's wings flicker at a high rate of speed. The fewer the number of keyframes for the wing animation, the more realistic the animation will be. Experiment by adding or removing keyframes based on the frame rate of your Flash document.

Being subtle

ANYONE WHO HAS EVER heard me speak publicly about Flash and what led me to this industry may recognize the term "moment of clarity". As an artist, there have been several of these moments – the most memorable transpired long before Flash was around.

It was spring of 1989 and after four fulfilling years at the Hartford Art School, I was finally about to receive my BFA degree. My drawing style during this time could best be described as hyper-realistic. I was illustrating images that looked like actual photographs. Sometimes the illustrations would fool even a well-trained eye into thinking they were real - at least at first glance. Objects caught in motion as if snapped by some high speed camera shutter, foreshortened as if they were literally flying out from the page and about to hit you sqaure between the eyes. I can only imagine this style represented my excitement as a young artist having this ability to push the limits of light and dark onto a two-dimensional surface, with only the best professors looking over my shoulder. I spent so many hours trying to master this drawing style that I would often have to use my left hand to pry the fingers of my right hand off of the pencil.

Most of my work was large in scale, 18" x 24" and even as large as 30" x 40". A large majority of it was lithographs and etchings that took weeks and often months to create. One afternoon I had a leftover piece of copper plate that I was about to discard. It was small, about 3" x 7", and tiny compared to what I was used to. For no particular reason I drew a rough study of a figure of a woman. I spent no more than ten minutes on the drawing before throwing it in the acid bath so it could be etched. I rolled some ink into it and printed about six copies of it. It was a simple drawing, loose in line style, and very much the opposite of the hyper realistic style I was known for, and for this reason I didn't think it was a very impressive piece. I contemplated tossing the print and the copper plate in the trash and going back to my much larger and more realistic pieces. But something told me to hang on to it, at least for a little while. So I slid it between the pages of a book in my backpack.

Like all graduating seniors, we were celebrated with our own showing in the school's gallery. While setting up my show, I carefully chose my biggest and

most realistic drawings and prints. While hanging the last piece, the small etching of the girl slipped out onto the floor. I reluctantly decided to include it in my show next to the light switch in the darkest corner of the room.

The night of the show was a success and, a few days later, my illustration professor Dennis Nolan, who was unable to attend, asked to see my work before it was to be taken down. He was one of the professors I most admired and to this

day adore his skill and dedication as an illustrator. He quietly perused each lithograph, etching, watercolor and pen and ink illustration. When he finished, he turned to me and asked, "Want to know what is your best piece?" Confident he was going to point to the largest and most realistic piece, I was shocked when he turned and pointed to the small etching next to the light switch. My heart sunk and for a moment I felt as though I might be insane.

He explained to me that its simplicity and essential quality provoked an emotion within him and compared it to Rembrandt or Da Vinci. He told me it was a milestone not only in my career, but in any artist's career to draw like that. It was subtle, and that subtlety made more of an impact than any of the other pieces I had done in my four years as a student. The world of art changed for me that day and, in some ways, the way I looked at life changed as well. It took four years and that very moment for my eyes to be opened as an artist. I was changed forever. It taught me more than I ever thought I would be able to know and it's a lesson I carry with me to this very day. Being subtle is powerful.

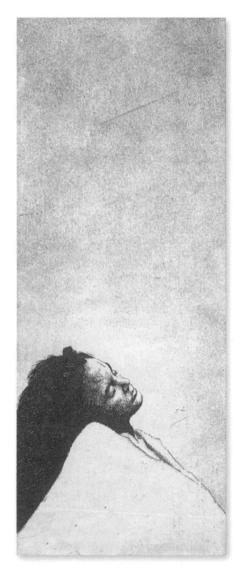

■ The hula hoop appears to be around the hulagirl's waist, or is it? In the original image, above, the hula hoop is clearly in a layer above the hulagirl. By creating a mask for the hula hoop, we can hide that portion of it that overlaps the girl's waist, making it appear to be around her.

Masking

MASKS ARE POWERFUL. They can be used in myriad ways to achieve limitless results. Masks can make your daily workflow easier, less time-consuming and, in most cases, become your most indispensable tool.

Having the ability to control the way two or more layers interact with each other through the use of masks is vital to your abilities as a designer and animator. The coolest thing about using masks in Flash is that not only do they help you to create stunning images, they can also be animated – a very powerful concept that can be mastered quite easily.

3 Masking Rotating globe

Tirst step is to create the continents. A quick online image search will yield plenty of examples. Import the image into Flash and leave it as a bitmap or use the Trace Bitmap feature or manually trace it using Flash's drawing tools. Convert it to a symbol.

HENEVER I WORK WITH MASKS, I feel like a magician. Masks provide the ability for you to create illusions, much like a magician's "sleight of hand" technique. It's all about what the viewer doesn't see and you, as the designer, have the ability to control that.

One of the more popular animation requests from Flash users is how to make a rotating globe. The first thought is that a globe is a sphere and to animate anything rotating around a sphere requires either a 3D program or painstaking frame-by-frame animation. Not so if you can use a mask. Remember, it's not what you see, but rather, what you don't see.

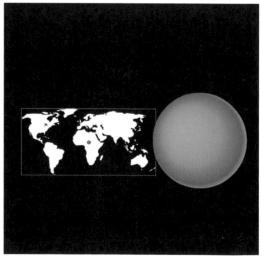

The next step is to create a mask layer using yet another copy of the circle in the bottom layer. Create a new layer above your continents, paste in place the circle and then convert this layer to a mask layer. This will prevent the continents from being visible outside this circle. All you need to do now is motion tween the continent symbol across this circle.

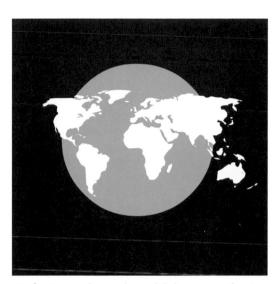

2 Create a new layer and move it below your continents. Draw a perfect circle using the Oval tool • while holding down the **Shift** key. Select this circle and copy it, then paste it in place on a new layer above your continents.

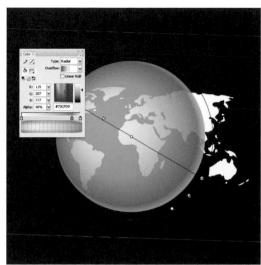

Mix a radial gradient similar to the one shown and fill the circle in the layer above your continents. Make sure to mix enough alpha into each color so the continents will show through. Using the Gradient Transform tool . edit your gradient so that the highlight edge is off-center to one side.

Since the first frame is exactly the same as the last frame, and each frame in between represents a slightly different position for the continents, select the symbol in the last frame and use the arrow keys to nudge it over a few pixels. This will avoid the two-frame "hesitation" in the movement of the continents every time the playhead returns from the last frame to frame 1.

HOT TIP

You can always move your entire animation into a Movie Clip symbol so that it can be easier to position, add multiple globes and/or target with ActionScript. To do this, drag across all frames and layers to highlight them in black. Right-click or Command-click over them and select "Copy Frames" from the context menu. Open your Library and create a new Movie Clip symbol. Right-click or Command-click over frame 1 of this new symbol and select "Paste Frames".

To avoid too much of a delay in the animation between the first and last frames, you can add a new masked layer with a new instance of your continent symbol. The best way to make this looping animation as seamless as possible is to copy the first frame of the continents and paste it in place into the last frame of your timeline. Then work backwards in the timeline and position the continents outside of the circle to the right.

Flag waving

HE WAVING FLAG is a popular "how do I...?" request in the Flash community. To be honest, it plaqued me for quite some time as to how best to achieve this animation. My initial reaction was to use shape tweens and frame-by-frame animation - but that proved time-consuming and with unconvincing results. Then one day, out of the blue, it hit me: if I slide the right shape across a masked area, I could create the illusion of a flag waving without having to kill myself animating it in a traditional way. It suddenly became so easy anyone can do it.

You will begin by making a nice long repeating ribbon shape. Start with a simple rectangle with any color fill and no outlines. Make it a little wider than it is taller.

Repeate step three by pasting your new shape and flipping it vertically. Then attach it to the side of the shape again. See the ribbon pattern taking shape? But your ribbon is a solid color and lacking some depth, so let's continue by adding some shading.

7 Create a mask layer above the ribbon layer. Using the Rectangle tool, make a shape big enough to cover a section of the ribbon as shown. It helps to use a high contrast color.

Test your movie using all enter to see the effect of the flag waving as it passes through the mask. But let us not stop there. Let's animate the mask using shape tweens to further emphasize the left and right edges of the flag waving. Use the Selection tool to bend the left and right edges. Create a keyframe further down the mask layer.

2 Use the Selection tool **S** to bend the top and bottom edges slightly so they have a nice arc to them. You will want to repeat this shape to create a pattern, so select it and copy it.

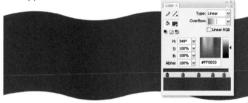

5 Mix two colors and add them to the Swatch panel. Mix a linear gradient with several color pointers alternating between these two color values. Fill your ribbon shape with this gradient and edit it so that the darker tones are in the concave sections of the ribbon shape.

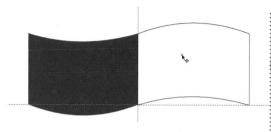

Paste your shape and then flip it vertically. Use the Selection tool to drag it so that it connects to the original shape. Once these shapes are joined together, select it and copy it.

Once you have the ribbon the way you want it, select it using A. copy it using O. cul O and then paste it using V. cul V. Align it edge to edge with the original shape to essentially double its length. Convert it to a symbol.

Next, create a keyframe somewhere down the timeline and reposition the ribbon to the left of the mask shape. Apply a motion tween.

In this new keyframe, bend the left and right sides of the mask shape in the opposite direction. Apply a shape tween. Repeat this procedure until the last frame is reached. The animated mask adds an extra animated touch to the overall flag waving effect. Presto! You are done.

To create a seamless loop of the ribbon, copy and paste in place a new instance to a second masked layer (using the same mask). Motion tween it so that it follows the original ribbon shape without creating any gaps.

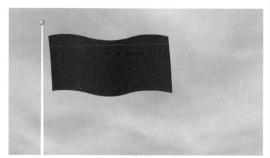

12 Don't forget to add a flag pole and sky background for an even more convincing illusion. Try placing this animation in a Movie Clip symbol and drag a few instances of it to the stage. Scale them and arrange them in perspective for the ultimate flag waving effect.

HOT TIP

This is a looping animation. For best results make sure the first and last frames are identical. To do this, use copy frames – paste frames or copy the object in the first frame and paste it in place in the last frame.

Iris transition

HERE ARE USUALLY SEVERAL WAYS to go about creating the same animations and effects in Flash. Whether it be animated on the timeline or dynamically generated using actionScript, it allows us as users to work within our own comfort zones. A simple iris transition is an example of an effect that could be done several different ways. I personally wouldn't know where to begin coding this kind of animation, but give me a timeline and some keyframes and I am in my element. Using a mask for this example provides us with even more options; we can easily control the direction and focus of the iris itself, where it starts and where it ends. This can be a nice touch to your storytelling if you want to focus the viewer's attention to a very specific area of the screen.

First step is to create a simple circle using the Oval tool

The fill color is insignificant. Hold down fill while dragging to constrain its proportions. Do not convert this shape to a symbol, but rather convert the layer to a Mask layer.

4 Add a new layer and drag it over the mask layer so it becomes linked to it as a "masked" layer. This is the layer where your content will reside. If your content requires multiple layers, then make sure they are all masked or move all content into a new symbol and drag an instance of the symbol to the masked layer.

In frame 1, scale this circle as small as possible.

Open the Scale and Rotate panel using all S

orn all S, type in a percentage and click OK. Use the Align panel using K orn K to center the circle to the stage.

Create a new layer (not masked) below all the other layers and create a black rectangle the size and shape of the stage. The color can be anything you choose, but black typically works well for this type of effect. At this stage you can reverse the animated mask by copying keyframes in reverse order and applying another shape tween.

Create a keyframe a few frames down your timeline in the same mask layer. Scale the circle so that it is covers the stage completely. Convert the shape to outlines so you can see the stage underneath it. Apply a shape tween so the circle grows from small to large, filling the stage completely.

Since you are creating the iris effect with an animated mask, you can easily control what area of the stage the iris focuses on. In the last keyframe, position the circle in the last frame over the character's eye. When the animation plays, the iris will animate and close in on the eye – a typical technique used in several cartoons.

HOT TIP

Feel free to experiment with colors other than black. **Sometimes** radial gradients can add some fun depth to this transition effect. It is easy to substitute different colors or textures by changing the background layer art to whatever you want.

3 Masking Handwriting

HIS IS ONE OF MY **FAVORITE ANIMATED** EFFECTS because I am asked frequently how it can be achieved, yet it is quite simple in technique. Every time I demonstrate how to make text "write" itself, the reaction is almost always the same: "Oh wow! That's all there is to it?" The example here uses another animated mask which yields a very small file size, ideal for large blocks of text. There is another method that is a bit more involved technically, but the result is a more realistic writing effect at the expense of a larger file size. I'll discuss that technique later on in Chapter 10. For now let's look at the easier, smaller approach.

Hand writing

The first step is to type some text on the stage. It doesn't matter what it says, just choose a font and start typing. By default, text fields in Flash are set to Dynamic. In some situations this may be fine but when an effect is added to the text field, the text may not render correctly in the Flash player. Such effects include masking, alpha, rotation and scaling. If you need to use Dynamic tesxt, embed the font outlines.

Hand writing

Add a new layer above your text layer and convert it to a mask layer. The text layer will automatically be linked to it as a "masked" layer. In frame one, draw a rectangle just to the left of your text, making sure it is as tall as the text itself.

Hand writing

5 Now just apply a shape tween in between these two keyframes. Lock all layers and play your movie or test your movie to see the effect of your text writing itself.

2 If you choose to change the behavior of your text field to Static, the font will be embedded in the compiled SWF and the Flash player will render it correctly – even with an effect added to it. Another option is to break apart the text until it becomes raw shapes. This will insure the text renders correctly but also creates a larger file size and it will be harder to edit the text if need be in the future.

4 In this same layer, create a keyframe further down the timeline and scale the shape horizontally so that it spans the entire width of your text.

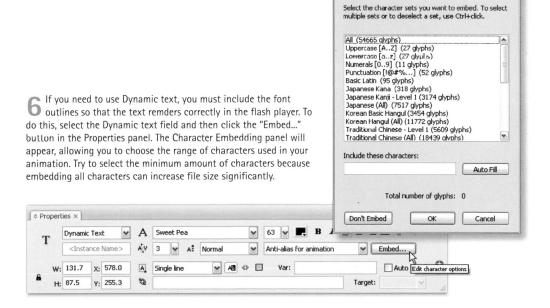

Character Embedding

HOT TIP

If you want a more realistic technique to make text look like it is writing itself, check out the frame-byframe method in Chapter 10.

3 Masking Spotlight

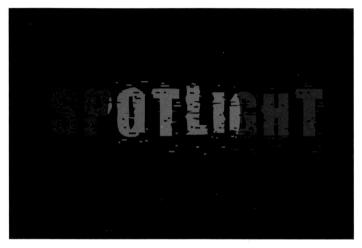

NIMATED MASKS, as we've seen, can provide an interesting dimension to your animation. It really doesn't take much effort to create various visual effects using an animated mask, such as this spotlight effect for a client's logo.

The first thing you need is some text or other image to "shine" a spotlight on to. Convert it to a symbol. The background should be dark if not completely black. In order to show light, we first need to create darkness. This technique wouldn't have the same effect if the background was very light.

2 Create a new layer above your image layer and convert it to a mask layer. The image layer will automatically be linked to it as a "masked" layer. Draw a shape using the Oval tool while holding down the shill key to constrain its proportions. Convert it to a symbol.

Add a keyframe further down the timeline and position the mask shape to the opposite side of the image. Apply a motion tween so that the mask shape passes across the image.

The key to making this technique convincing is to copy and paste in place the image to a new layer below the original layer. Make sure it is a normal layer (not masked). Select the symbol and tint it to a dark color. This layer will not be affected by the mask.

Test your movie to see your animated mask pass over the original image layer while the darker instance remains unmasked and visible throughout the animation.

HOT TIP

Don't be afraid to add more keyframes in your mask layer and position the mask symbol in various positions relative to the image it is revealing. You can also animate the mask getting larger and smaller by scaling it. Be creative and change the shape of the mask to say two circles side-by-side to suggest we are looking through binoculars.

NE OF THE MOST EXCITING NEW FEATURES in Flash CS3 is the PSD and Al importer. We finally have wonderful integration between Photoshop and Illustrator alike. For this example we will edit an image in Photoshop, save it as a PSD file and import it into Flash via the PSD Importer wizard.

We will also add a slight touch of ActionScript for some added interactivity. If you suffer from ActionScript-phobia, don't panic, this will be painless with only a couple of lines of simple code. If I can do it, you can as well. The code simply will hide the cursor in the Flash player and allow us to drag a movie clip around the stage. The trick here is the mask itself, allowing us to see the sharper image through the mask shape only. Open wide and say "Ahhhh". This won't hurt a bit.

First you need to start with an image, of course. This might be a good time to browse your hard drive or grab your digital camera. It doesn't have to be a raster-based image or even a photograph. It can be vector art drawn in Flash or imported from a different program. Whatever image you choose, you will need two versions, the original and a blurred version of the original.

Once the import process is complete, your Flash document should contain both images on different layers. Make sure the blurred image is below the sharper image.

Create a new layer above the sharper image and convert it to a mask layer. The image layer below will be automatically linked to it. Draw a shape in your mask layer and convert it to a Movie Clip symbol. Lock these two layers to see the mask work.

2 Open your image in Photoshop and duplicate the layer it is on so you have two copies of the same image. Apply a Gaussian Blur to one of your images. Save the file as a PSD file.

In Flash, import the PSD file you just created. The PSD import wizard will appear and prompt you with a variety of options. The left panel will display all the layers of the PSD file. Click on them to display options for each. You will also want to convert layers to Flash layers, place layers at original position and set your Flash stage to the same size as your Photoshop stage.

6 You are almost done! Lock all layers to see the effect. It works but it is pretty boring as the mask just sits there. Time to add some functionality.

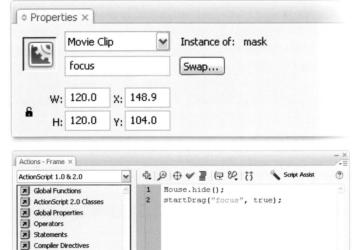

Use the Selection tool sto select the Movie Clip symbol containing the mask shape. In the Properties panel, type in an instance name. I chose "focus" for this example. With the Movie Clip still selected, open the Actions panel and type the following ActionScript exactly:

▼ Constants

ActionScript 1.0-2.0: Mouse.hide(); startDrag("focus", true);

For ActionScript 3.0: Mouse.hide(); focus.startDrag(true);

HOT TIP

The shape of your mask doesn't have to be a circle. It can be as simple or as complex as you wish to make it. Experiment in Photoshop with Image effects beyond blurring. There's enough to choose from to keep you busy for a while. I particularly like the Glass filter (Filter > Distort > Glass...).

A moment of clarity

I REMEMBER THE MOMENT WELL, AS I SHOULD since it was the moment when I realized what I needed to do as an artist to make my mark on the world. What I wasn't sure of was how big a mark I could make. What made the moment even more significant was that it took me over 6 years to figure it out. It began in 1989 when I graduated from the Hartford Art School (Connecticut) with a major in printmaking with a minor in Art History. I took enough Illustration classes to constitute a double major. The result: a portfolio filled with static lithographs, etchings and a multitude of illustrations of varied mediums. Animation didn't exist in the curriculum and therefore was never an option. I never considered animation as a skill I would even be good at. After graduating, I pounded the pavement with portfolio in hand, knocking on as many doors as I could. With the exception of a handful of interviews, having no experience did not get me very far. The internet didn't really exist back then - at least not as we know it today. The term "home PC" wasn't invented yet. and I was stuck with a book filled with analog images that represented 4 hard years as an artist - and hardly anyone to show it to.

After 6 years of countless random jobs (Jeep mechanic, restaurant manager, Boston Water & Sewer Collections Dept, etc...), I became aware of a local education software company that was producing a new animated series on Comedy Central. On a Monday morning I walked in the front door of this software company, gave my portfolio to the receptionist and told her I'd be back on Friday to pick it up. I turned around and walked out the door.

A month later, they hired me to work on an animated pilot for Dreamworks. At that time, the company used an old DOS-based animation program called Animator Pro (Autodesk) that soon became obselete. We turned to Flash and little did I realize the impact it would have on my career. Initially we were using Flash to animate for broadcast shows. We didn't have a clue how to use it for the web - until we got a deal to produce an animated series for shockwave. com (now atomfilms.com). I was put in charge of this project and had to ramp up my knowledge of Flash very quickly. During this time, my contact at shockwave asked if I could speak at the Flash Forward conference in New York

City. I agreed without knowing exactly what that meant.

I drove the 3 hours from Boston to NYC the day of my session. I shared the stage with two brothers, Gregg and Evan Spiridellis, who had just started a small company in NYC called Jib Jab (ever heard of it?). We became fast friends and remain so even to this day.

That evening was the Flash Forward Film Festival, held in a huge theater with a very large screen that displayed the best use of Flash in several categories.

Awards were being given and the excitement in the air was palpable. I never anticipated that a software program could generate such a buzz. I was witness to a culture being born, an entire society of Flash users who shared a common bond as if it were some secret handshake or cryptic language. And there I was, standing in the middle of their nest, surrounded by the frenetic buzzing and energy derived from this

the frenetic buzzing and energy derived from this program.

It was my first experience seeing the best of the web being celebrated on a huge stage and it suddenly all made sense to me - why I was there, what I was involved with, and what I had to do. It was my first moment of clarity.

To descibe the image of me standing in the back of the theater, watching this phenomenon transpire, recall the scene from The Blues Brothers film where John Belushi is in the church chanting "The band!" as he is struck by a holy beam of light through the church window. That was me. I knew from that moment on what I needed to do. I drove home as my head was spinning with ideas about how I was going to display my art with Flash for the world to finally see. It was a 3-hour drive and I never even turned on the radio the whole way.

■ The Yahoo! Super Messengers, in a classic superhero pose. The above version is a bit lackluster if not completely boring. Below is the same shot with the help of some simple motion effects. The difference is an animation with a bit more punch (sorry, pun intended).

Motion tips and tricks

LET'S FACE IT, Flash is about motion. In some cases, the more motion, the better. Motion can emphasize the intensity of an action sequence and can add a measure of realism to your animations. Whether it is making text fly around a website or animating a character in an action sequence, providing convincing motion effects can be critical to their success visually.

In this chapter we will look at a few of what I consider to be the most valuable motion effects that you can use in your everday life as a Flash designer and animator. Motion tips and tricks

Basic shadow

HADOWS CAN ADD depth to your project. This is the most basic way to add a shadow to an animated character. Its simplicity does have its limitations, however. In this chapter you will learn more advanced shadow techniques with greater flexibility - but some may not be supported in older versions of the Flash player. Depending on your target audience and your client's technical requirements, you may need a technique that will allow you to publish to older player versions. This is one such technique.

For the best result, place your character animation inside a symbol – this is commonly referred to as "nesting". The next step is to simply copy the symbol of your character using **C ctr** C. Create a new layer and move it below the character layer. Paste the copy of the symbol using **V ctr** V into this new layer.

4 With the Free Transform tool **Q** still selected, click and drag horizontally outside the bounding box in between the handles to skew the shadow.

2 Next, apply a tint to the symbol instance you just pasted. The tint needs to have a strength of 100% to completely hide the character's details. The color of the tint should also be a darker color value than the background.

3 Position the shadow instance and with the Free Transform tool, scale it vertically to suggest some perspective of it being cast against the ground.

HOT TIP

This technique works great when your entire character animation resides in a symbol. Using a duplicate of this symbol for the shadow serves a dual purpose: since you are reusing a symbol, your movie will be efficient in terms of file size. Another advantage to using a duplicate symbol is when you revise or add more animation to the original symbol. Since both instances reference the same symbol in the Library, the shadow instance will be updated as well.

5 You may want to scale your shadow slightly smaller to suggest more depth. Play around with its position relative to the original character for the best results. Because the shadow symbol is a duplicate of the original animated character symbol, it will also animate in sync with the character. This will result in a convincing shadow effect. Since you have not used any special filters, this shadow effect is supported by all versions of the Flash Player.

Motion tips and tricks

Drop shadow

SEPARATION BETWEEN CHARACTER and background can be critical to the overall impact of your animations. There are several ways to approach adding shadows for characters but, with animation, the approach can seem a bit daunting at first. Flash CS3 makes this as easy as possible with the use of Filters.

For this example we will take a look at the Drop Shadow filter in its purest form. The technique that follows this one will provide a cool way to use the same filter that adds more depth and perspective.

2 Create a new Movie Clip symbol from the Library panel. Select the first frame of this symbol and, from the right-click context menu, select Paste Frames.

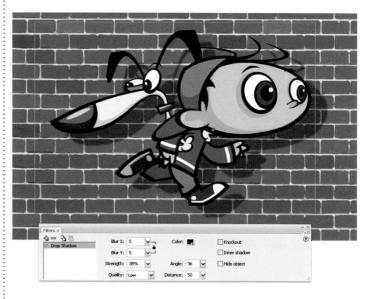

5 If you have a complex background, set the opacity to around 30–40%. This will allow the background values to show through the shadow itself for a realistic effect. I usually spend most of my time adjusting the angle and distance of the shadow relative to my light source. Test your movie to see the Movie Clip and shadow animation.

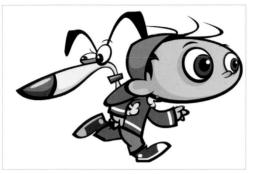

Drag an instance of this Movie Clip to a new layer on

3 the main timeline. Delete all the original frames and

Shadow filter.

layers as they are no longer needed. Select your new Movie

Clip instance and with the Filters panel open, select the Drop

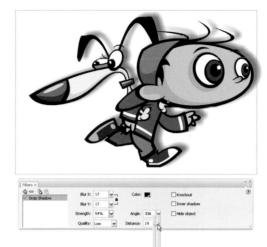

Adjust the amount of blur, opacity, angle and distance to achieve your desired results. You can also select the color of the shadow by clicking on the swatch color.

Knockout

☐ Inner shadow

✓ Hide object

HOT TIP

Adjust the strength of the shadow to suggest more or less contrast between our character and wall. Less strength (less opacity) will suggest a softer light, such as an overcast day. Higher strength (more opacity) will suggest a stronger light, such as a very sunny day.

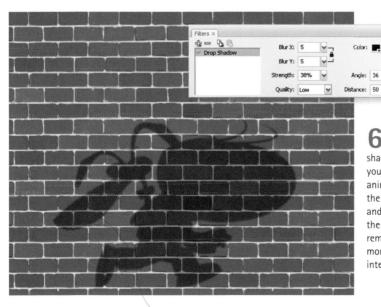

Select the Hide object feature 6 to hide the Movie Clip. The drop shadow will remain on stage. Test your movie to see just the shadow animation. Experiment with some of the other options, such as Knockout and Inner shadow. You can also click the little lock icon next to blur to remove the X and Y constraint. Apply more blur to X or Y for even more interesting results.

> **SHORTCUTS** MAC WIN BOTH

Motion tips and tricks

Perspective shadow

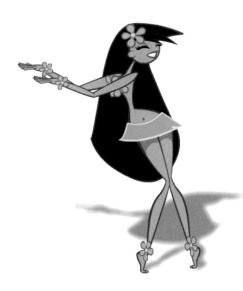

So far we've looked at how to add a drop shadow filter to an animated character using a movie clip and the filters feature. But the drop shadow can be a little limiting in some situations. To place a character in an enfironment that has more depth and perspective to it, the drop shadow will not work very well since it tends to flatten the perspective. You may need a shadow that provides the illusion of perspective and depth.

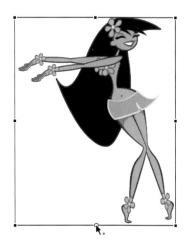

Select your Movie Clip instance and copy it using ** G cm/G.

Create a new layer below it and paste it in place using ** Shill V cm Shill V.

2 Lock the top layer to avoid editing it. Select the instance in the layer below it and, using the Free Transform tool ②, edit its center point so that it is positioned on the bottom edge.

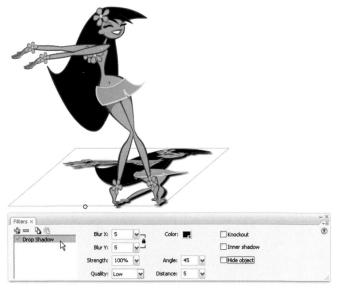

With the symbol still selected, apply a Drop Shadow filter to it.

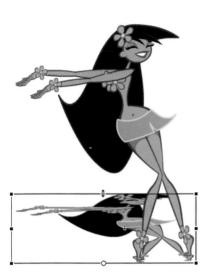

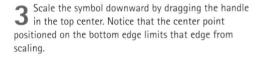

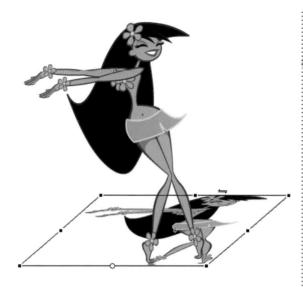

4 Next, skew the symbol by dragging in between the handles outside the top edge.

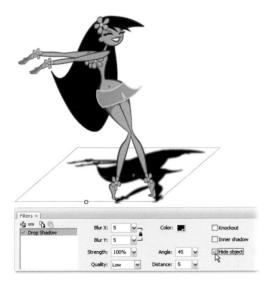

6 The "cheat" to this technique is to select the Hide object feature. Now all you'll see is the shadow filter itself.

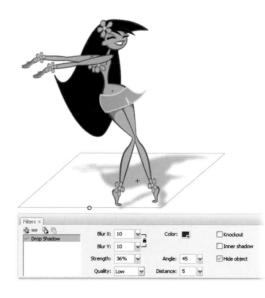

Play around with the options provided. You can adjust the amount of blur, opacity, quality, angle and distance. You can even change the overall color of the filter itself.

HOT TIP

Filters were introduced in Flash 8. Therefore the oldest player version to support filters is Flash player version 8. You cannot publish to Flash player version 7 or older and expect any filter effects to be included. Flash will warn you if your publish settings are set to a player that does not support filters. Plan ahead as much as you can. If your client requires an older player, then avoid filters.

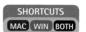

4

Motion tips and tricks

Blur filter

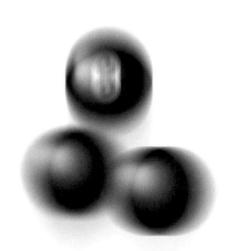

HE BLUR FILTER is a very handy tool for creating a more realistic motion blur compared to just a linear gradient. Filters can only be applied to Movie Clip symbols, so you will need to plan ahead if vour animation relies on several nested animations that need to be in sync with each other. With a combination of motion tweens and some basic ActionScript, you can control what each movie clip does and when they should do it - not unlike the director of a movie.

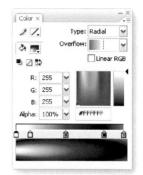

The billiard ball is simply a circle with a radial gradient. The trick is mixing the gradient using five colors: highlight, midtones, shadow and then a lighter value to the far right. This is the most critical color as it suggests light coming from behind the shape, creating the illusion that it is three-dimensional. Use the Gradient Transform tool to edit the center point as well as the scale and rotation.

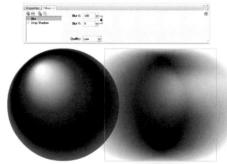

To add a realistic blur effect to the ball as it is motion tweened across the stage, select it and in the Filters panel drop-down menu, select the Blur option. Since the ball is traveling horizontally, we do not want any vertical blurring. So click on the little magnet icon to unlock the blur constraint. Set the amount of blurring in the X dialog. The Y dialog box should be set to "0".

When two or more balls collide, then you must target each instance and tell them what to do. On the main timeline you can control what they do with keyframes and motion tweens. The nested animations must be targeted with ActionScript since a movie clip's timeline is independent of the main timeline. Both movie clip timelines are controlled with one line of code each. The nested animations then play until they reach a stop action.

2 Convert your sphere to a Movie Clip symbol. All of the ball animations are nested in this symbol, consisting of a starting roll, rolling to a stop and a continuous roll. Check out the source file on the CD to see how these animations were made using a mask and motion tweening the symbol "8" across the sphere.

5 The technique is to use motion tweens and the Blur filter to provide the illusion that these balls are moving at an extreme rate of speed. Once a ball makes contact, its speed is dramatically reduced, at which point the Blur filter is removed by adding a keyframe and clicking the "-" symbol in the Filters panel.

3 Copy and paste, or drag multiple instances from the library, of this symbol to the stage – each on its own layer. Select them one at a time and type in a unique instance name in the Properties panel. This will allow you to target them individually.

●●□1

6 To synchronize the nested animations to the main timeline, add a blank keyframe where you want to target your movie clip(s). Make sure the keyframe is selected and with the Actions panel open, type in the Movie Clip instance name you want to target, then tell it what to do. Here the movie clip "ball1" is being told to go to the frame label "rollstop1" and play.

HOT TIP

Locate the file named "8ball. fla" from the CD included with this book. Double-click one of the ball symbols to see how it was animated using motion tweens and a little masking. You can add to this timeline by creating additional ball rotations. The illusion here is that the ball never rotates at all, the white circle with the number 8 inside it is what actually moves across the surface of the circle shape. For similar illusions made with masks, see Chapter 3.

You can use _currentFrame to start or stop the ball on whatever the current frame happens to be. This is particularly handy when the timing of the animation changes on the main timeline and you don't want to constantly have to update the nested animations. When this script is called, whatever the current frame is inside the targeted movie clip, its playhead will simply stop.

Motion tips and tricks Flying text

REMEMBER THE FIRST time you learned to use a mouse? Or to tie your shoes? These tasks seem so simple now, but some things are just plain easier after someone shows you how. It's the "not knowing where to start" that can be frustrating.

Well, consider this your start. I'm going to show you how simple it is to achieve some basic cool motion effects in Flash CS3 - effects that look really difficult to build, but, once you know how, are not so hard to create. Specifically, you'll make objects appear to move very fast using an animation effect known as motion blur.

Tirst, you need to create the two objects used for this effect: text and a linear gradient. The linear gradient should have at least three colors, the middle color should be a value similar to the main color of the object and the left

and right colors should be the same color as your background. If you have a complex background, mix these two colors with 0% alpha so the blur blends into the background.

About three to five frames down your timeline, add a new keyframe (F6). Holding down the Shift key, use the right arrow key to move the gradient across the stage. Position it wherever you like, just make sure it remains on the stage entirely (do not position it off the stage).

5 This effect is not limited to a horizontal format. Rotate the gradient 90 degrees.

6 Align the text below (or above) the gradient using the Onionskin tool to help guide you.

2 To create the animation for this effect, convert the linear gradient to a symbol and place it about halfway off of one side of your stage. You might want to start the animation on a frame other than frame 1 to provide a moment for the viewer to anticipate the action.

4 Apply a motion tween to make the gradient symbol move across the stage. Next, create a blank keyframe in the frame after your second keyframe and drag your text symbol to the stage from the Library panel ** 🗘 🗘 Turn

on the Onionskin tool so you can see the previous frame and where the linear gradient is positioned. Align your text to the right of the gradient. Play back your animation.

Repeat the same procedure as you did for the horizontal effect. Motion tween the gradient vertically from outside the viewable stage area. Then, in the frame after the tween, add a blank keyframe and position and align the text below the gradient. Reverse the procedure to make the text fly out and off the stage. I'm sure you will have a lot of fun with this effect as it is one of the easiest to master - yet it looks so good!

HOT TIP

This technique works quite well with objects other than text. Balls, bullets, superheroes, cars, just about any object in action that requires a high rate of speed will work with this effect. You will likely want to play around with a combination of frame rate and the length of your motion tweens depending on your project. The advantage with this effect is you do not need a very fast frame rate (although it does help). You can achieve the same results with a lower frame rate as long as the number of frames in the motion tweens are fewer than compared to a higher frame rate.

4

Motion tips and tricks

Combining effects

HERE ARE SOME ANIMATED EFFECTS that look so advanced, it's difficult to detirmine how they were actually made. It is often assumed the skill level necessary to create such advanced motion graphics is well out of the reach of the average Flash user.

Not true in most cases. When we watch animated motion graphics, if the frame rate is fast enough, the human eye may not be able to see everything that is happening. As a result, our mind fills in what may not even be there. The good news is, we can use this natural shortcoming of the human eye to our own advantage when creating "advanced" motion effects. In my experience I have discovered that the most visually appealing animations are a combination of multiple techniques happening at the same time.

BECOME A KEYFRAMER

1 Type out your text using the Text tool. This particular font is pretty complex and already suggests movement. Your text, however, can be hand-drawn graphics depending on the style of project you might have.

With every letter still selected, right-click over one of them and select Distribute to Layers. This will create a new layer for every letter and each letter will be placed into its own layer for you. A true time saver if ever there was one. Now is a good time to convert each letter to a graphic symbol.

HEYFRAMER

keyframer_banner.fla*		
	∞ a□ {	0 85
₽ ∃	<i>○</i> • • □ □• >→•	T
ΦE	• • ■ □• >→ •	
□ C	• • • • • •	
□ ○	• • □ □• >→•	
D M	• • □ □ □ • > → •	
₽E	• • □ □• >→ •	
DΑ	• • □ □ □ → •	
□ K	• • ■	
ΦE	• • □	
ΦY	• • ■	
□ F	• • □ □ □• → •	
□R	• • □	
ØΑ	• • □ □• → •	
□ M	• • □	
ØΕ	• • □	
□R	• • □	•
9 4 9	□ ♦ 🛅 🔁 💽 79 30.0 fps 2.6s 😮	
Scene 1		
CHANGE IS GOOD	BECOME A KEYFRAMER	1

5 Next, to create the effect of each letter fading in one after the other, you will stagger each motion tween to overlap the one below it. Starting with your second letter, select the range of frames in the motion tween, then drag them down the timeline a few frames. You can also select a frame before the tween and press F5 (Insert Frames) to push each motion tween down the timeline.

BECOME A KEYFRAMER

With the text field still selected, break it apart using (C) once. This will split the text field into individual text fields per letter. This retains the properties of the font and you have the ability to edit each letter as such. If you wish, you can break it apart one more time to convert the font into raw vector shapes.

4 On each layer, add a keyframe about three to four frames down the timeline. Now go back to the first keyframe containing your letter, select the letter symbol on the stage and apply some alpha via the Properties panel. Drag the alpha slider all the way down to 0%. Repeat this procedure for every letter. Apply a motion tween for every letter so that they all fade in when you play back your timeline.

HOT TIP

Check out the "Extending Flash" chapter to learn about JSFL and how vou can create your own commands for repetitive tasks such as applying a motion tween. Once something is an actual command, you can then create a custom key shortcut for it. This will save you about two clicks every time you need to apply a tween. That can add up quickly over a period of days, weeks and months. Every minute saved is a minute earned in this industry.

6 The final step is to select the first frame of each animation and use Shift while pressing the left arrow key. This will position each letter with 0% alpha to the left and on playback will create the motion of each letter flying into position while fading in at the same time. Once again, there is nothing particularly difficult about this effect. All you have done is used motion tweens with some alpha fades. This is still a very basic Flash animation technique. The only difference is the timing of each letter relative to each other. Throw in a slight amount of movement and suddenly you have what looks like an advanced animated text effect.

Motion tips and tricks

Blur filter

OMETIMES YOU MAY NEED a blur effect that is more realistic than the linear gradient method. The Blur filter is perfect for creating realistic blurs - even animated ones. Filters were introduced in Flash 8 and to create the same blur effect in older versions, we had to export the object from Flash as a PNG file, open it in Photoshop (or any graphics editor of choice) and apply the motion blur. Then we would have to export from Photoshop as a PNG file and import back into Flash. Thankfully, those days are long gone with the ability to not only apply filters, but to animate them as well.

1 It is usually a good idea when creating animated effects to work backwards. Start with the final frame, insert frames to extend your entire timeline and then add keyframes to the last frame.

3 In frame 1, select a Movie Clip symbol on the stage and apply a Blur filter from the Filters panel. Click on the small black magnet icon to unlock the blur constraint. Use the slider to adjust the amount of blur for the X axis only.

5 For objects that fly in vertically, limit the amount of blur to the Y axis. Remember to use your Shift and arrow keys to maintain alignment between keyframes – unless of course you want to have your object travel at an angle.

2 Go back to frame 1 and begin the animation process by positioning the objects that will animate into view off the stage. Hold down the **Shift** key while pressing the

arrow keys to maintain alignment and move the object incrementally ten frames.

4 Drag the keyframe in your last frame closer to the first keyframe and apply a motion tween. The symbol will animate from outside the stage into its original position. The Blur filter will also be motion tweened from the amount of blur in the first frame to no blur in the last frame.

6 Objects that appear as if being focused from thin air use an equal amount of blurring for both the X and Y axes. Did you know you can set a blur amount beyond what the slider allows? The slider taps out at a value of 100, but you can type in your own value up to 255.

Be careful about the number of filters you apply to objects. The playback performance of the Adobe Flash Player may be affected if too many calculations are needed to render each of the filtered effects, Each filter has a quality setting: Low, Medium and High. If you are unsure about the processor speed of your target audience, use the Low setting to insure maximum playback performance.

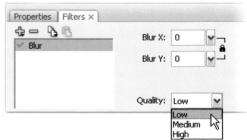

Motion tips and tricks Selective blurring

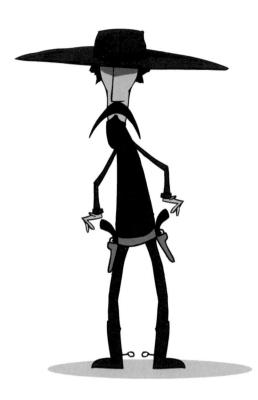

ERE'S ANOTHER COOL TRICK to suggest movement between two keyframes. Open the "cowboy.fla" from the included source CD and play back the animation. The technique being used is basically a mixture of frame-by-frame animation with a variation of blurring and stretching. Look closely at the movement of his arm when he reaches for the gun. There's only two frames where this effect is used and at 24 fps it's almost impossible to see. Yet the effect is still visually effective as it really smooths out the motion of his arm through the gesture of reaching and drawing his weapon.

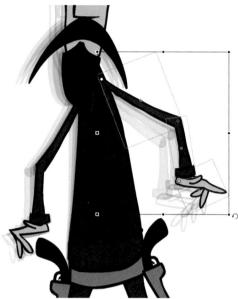

The first step is to add a little anticipation (refer to the "Anticipation" topic to learn more). Rotate the arm into a position that suggests he is about to grab something (refer to the "Hinging" topic to learn more about rotating body parts based on a custom center point). I also added some "itchy-finger" animation to build up the anticipation and focus the attention on his hand.

4 The next frame is similar to the previous frame. I used the Brush tool again to draw new shapes using the same colors. Turn on the Onionskin tool to see the previous frame as a reference.

2 Replace the arm with some very simple shapes drawn freehand style with the Brush tool. The fill for the arm is a mixture of black and about 30% transparency. The fill that represents the hand is the flesh tone mixed with some transparency as well.

3 You can mix in a little alpha by typing in a percentage manually or using the handy slider bar. Add this new color to your Swatch panel using the upper right corner dropdown menu.

6 When a gun is fired, the resulting action is referred to as "recoil". We have Sir Isaac Newton to thank for showing us that every action has an equal and opposite reaction. This law of physics is critical for us to understand and, when necessary, incorporate into our work.

HOT TIP

The selective blurring technique works best when it is barely seen. If it stays on stage long enough for the viewer to notice it as an object, it has performed a disservice to your animation effect. In essence, this technique should enhance the motion as a whole, not introduce an additional component to it. It should be subtle and used sparingly for a greater overall effect.

Motion tips and tricks

Background blurring

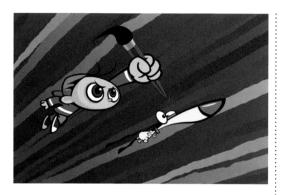

F YOU WATCH animated shows on television then I'm sure you've seen the motion blur technique, where the characters remain relatively still while the background is being blurred. This provides the illusion that the character is flying through air at incredible speed. Visually it's a very dramatic effect and can be used in myriad ways during an action sequence.

The illusion here is that the background is actually moving through the shot – but in fact it doesn't have to be and in most cases never really moves at all. In this example the shapes that represent the motion simply wiggle slightly in a very short loop. What makes this effect convincing is a combination of color, line work and of course the character itself.

1 Start with a radial gradient as the undertone of your shot. Use the Gradient Transform tool to position the gradient in the lower left corner. It is where the character will fly in from and helps provide some needed depth to the scene.

4 Select all lines and convert them to a graphic symbol. Edit this symbol by adding several keyframes on the same layer. This will duplicate the lines for each added keyframe. Select all lines in each keyframe and click the "Smooth" tool (Crush subselection tool) a few times. Make sure the amount of smoothing is different for each keyframe. The idea is to create an oscillation between frames.

2 Create a new layer and use the Line tool **N** with a stroke color high in contrast to your gradient colors. Draw some lines to use as directional guides.

3 Create a new layer above your guidelines and using the Brush tool **3** and a large brush size, hand draw some thick lines that taper slightly towards the lower left corner.

5 On the main timeline I added some random shapes flying through the shot in the same direction as the background lines. This helps emphasize the speed and direction the character is moving.

6 The final touch is to add your character. This effect works best when your character is drawn in a way that reflects the speed and wind resistance they would encounter.

You can emphasize the dramatic effect by motion tweening the character from off the stage into its final position. Combine this effect with some of the motion blur effects previously learned in this chapter and you'll have a killer action sequence.

HOT TIP

With the background as a nested looping animation, you can easily reuse it for other similar shots that need to imply very fast motion. As a symbol you can transform it by scaling, skewing and even tinting it based on the design of your shot.

Learning to be simple

ONE OF THE MOST DIFFICULT challenges for me as an artist was to learn how to simplify my drawing style. Early in my career my work consisted of large scale lithographs depicting weeks of painstakingly complicated imagery. Spending days and often weeks on each print wasn't uncommon for me. But if you asked me to whip up a simple cartoon character, I wouldn't even know where to start.

Fact is, simplifying my drawing style didn't come easily. I was literally thrown into the world of cartoon animation when asked to join an animation

team at a local production company. They already had an established series on a popular cable network channel (*Dr. Katz, Comedy Central*), and my job was to design and animate a pilot for Dreamworks. It was a nice way to get thrown into the world of animation, resulting in a very diverse artistic direction for me. I embraced the challenge.

The next several years provided me the experience of designing and animating several successful television series and animated content for the internet. We used Flash for everything, including storyboards, animatics, character and background design and, of course, animation. We

were a paperless studio and Flash was our Swiss army knife of software tools. As Flash matured with each version, my skill level using it was maturing also.

Strict deadlines and cut-throat delivery dates meant working fast. Working fast meant keeping the drawing style simple, which I became very good at through practice. Not unlike a classical musician ending up performing children's pop music, it was my fine art training that helped pave the road to cartoon animation.

Ironically today, I am considered a cartoonist and character animator as

opposed to a fine artist. The ability to draw with simple shapes and lines did not come easy to me. Admittedly, I continue to find it a challenge creating graphics that are iconic in style. To break down an image into a few simple shapes and have it still be appealing and even the least bit amusing is a daunting task. Sometimes I can nail it in a few minutes of sketching, other times it can take a few hours of pushing and pulling shapes until I think they work together. All too often my efforts get tossed aside and spend the rest of their lives stored onto a cold and dark back-up hard drive. Being asked to author this book has granted me the opportunity to choose some of the more successful designs as feature topics for the sole reason that they help make the book more visually appealing. What you don't see are the hundreds of failed attempts and design blunders I have created to reach this level in my career. There does exist an island of misfit characters where the majority of habitants are the result of my own handiwork.

Michelangelo was once quoted as saying "I saw the angel in the marble and carved until I set him free." As modest as he may have been, his perspective on design is timeless. Apply this thinking to your own approach when designing anything from a character, logo, background or even a website. All the best details are there in front of you, it's everything else that needs to be removed.

From concept sketch to finalized animated body parts; just how does a Flash animator get from point A to point B? What is the workflow when it comes to animating characters in Flash? This chapter looks at several real world examples of actual characters and how they were built, and why.

Character animation

IT IS TIME to get down and dirty. In previous chapters we looked at how to achieve a wide variety of design styles, transformations and motion effects. But the concept of how to bring all these techniques together to create a successfully animated character can remain a mystery. When is it advantageous to nest certain animations and why? How can swapping symbols be effective? What exactly does the Sync feature do? What is the most effective way to synchronize a character's mouth and lips to a voice-over soundtrack?

These questions and more are explained in the following pages. So roll up your sleeves and get ready for a fun ride into the world of Flash character animation.

Character animation

2.5D basics

WEENING IS A GREAT WAY to add quick and simple animation to your Flash movie. But what if you could push the tweening method to its limits and give more realism to your character? What if you could harness its simplicity and make it work in ways not too many other Flash users have thought of? What if you have learned everything there is to know about tweening, go back to the first 10% of that knowledge, and take a left turn? Where would that take you?

In this example, I'm going to reveal a truly killer Flash animation technique that will actually create a 3D optical illusion that has fooled even the most discerning eye. The cool thing is you never leave the Flash environment and remain in the 2D realm. You are now in a dimensional limbo. If it's still 2D but looks like 3D, then what exactly is it? Welcome to what is commonly referred to as "2.5D animation".

Let's start with a few basic shapes that resemble eyes and a mouth on a face. You can add some horizontal and vertical guides to help keep these objects aligned with each other. Before you start editing these shapes, insert keyframes a few frames down the timeline across all layers. You will see why this is useful later.

4 Move the other eye over as well but scale it slightly wider as it gets closer to the middle of the head. This is where, if it were truly mapped to the surface of a three-dimensional sphere, it would be at its widest - the point where it is closest to us.

Next, move the mouth over in the same direction and scale its width slightly smaller like you did for the first eye. You might want to push the mouth closer to the left edge to provide more space between the mouth and the right eye. This will help make it feel as if the mouth is truly wrapping around the head like the left eye is starting to do.

2 Insert keyframes across all layers between the first and last frames of your timeline. Start with the head symbol by skewing it with the Free Transform tool. Since you will be creating the illusion of the head turning to the left, skew this shape by clicking and dragging just outside the bounding box in this direction.

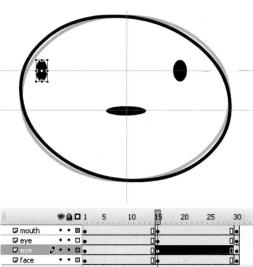

Next, select the left eye symbol and position it close to the left edge of the head shape. Use the Free Transform tool to reduce its width slightly, creating the illusion of the eye moving away from us around the surface of the head.

000

4 % % [1] 15 30.0 fps

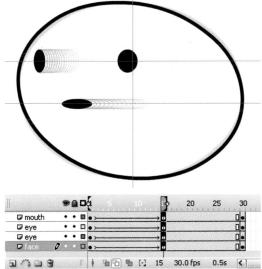

6 Now all you have to do is apply motion tweens to all the layers. Drag across all layers to select them and apply a motion tween from the context menu or Properties panel. Remember when you added keyframes to the final frame in step 1? Now all you need to do is apply motion tweens to the latter half of your timeline to return the head to its original position.

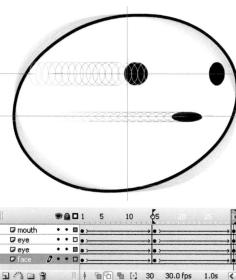

Repeat the same procedure but in the opposite direction to make the head appear to turn to the right. Experiment by making the head move from left to right by removing the keyframes in the middle of the timeline.

HOT TIP

Don't be afraid to push the limits of this technique. I see my students attempt this style of animation and all too often they hardly move the features across the face enough to make the illusion convincing. Play back your animation frequently to test the overall effect. You can always add or remove frames if the animation is too slow or too fast. Add a little easing to make it look even more realistic.

Character animation

2.5D advanced

ET'S APPLY THE SAME technique, as explained in the previous example, to a more sophisticated character. This character is comprised of several individual objects, all of which were designed and composed with this animation technique in mind. The spacial relationship of each object to each other is important as they will all need to move, skew and scale together, but at varied amounts. The effect is based on the whole being greater than the sum of its parts. There's nothing overly sophisticated about creating this technique but the result can look very complex on the surface.

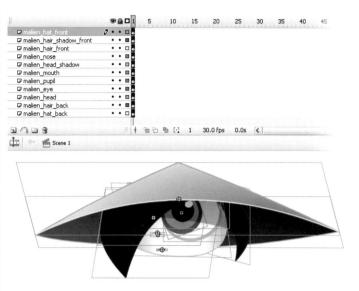

The first step is to make sure all objects have been converted to symbols and you have edited their center point to your desired location (check out the "Edit Center" topic in Chapter 2). For this technique to be successful, it's often useful to design your characters in three-quarter view as opposed to a profile view or facing us directly.

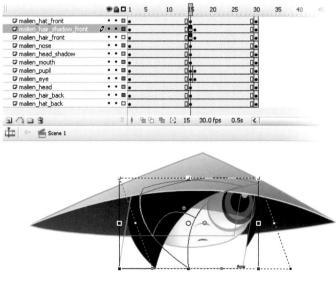

A Next, skew the hair to the right from its bottom edge. Since you want to convery this object coming around the front of the character's face, move it over to the right and scale it horizontally to make it slightly wider than it is in the first frame. This creates the illusion that it is moving not only across the face, but also slightly towards us as well.

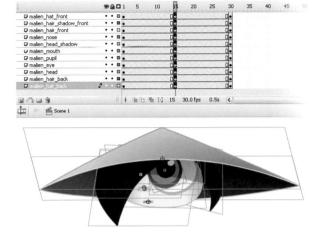

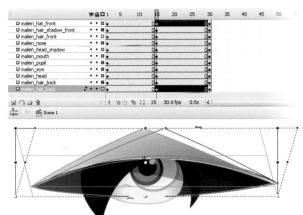

2 If you want to create a seamless loop by making the head eventually return to this same exact position, select a frame (across all layers) somewhere down the timeline and add a keyframe (F6). It pays to think ahead because you have avoided having to copy and paste the keyframes from frame 1 later. Select another frame (across all layers) an equal distance between your first and last keyframes.

This middle frame is where you will edit your character. Start by using the Free Iransform tool to skew the symbol instances. Here I have skewed the hat, which is comprised of two separate symbols, a front and a back. Selecting and skewing them together insures that they remain aligned which each other. It's helpful to lock all other layers temporarily while you do this.

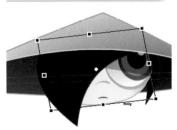

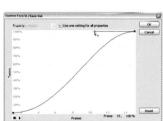

HOT TIP

Character design is critical for this effect to be successful. Keep it simple and stylized because the more anatomically correct your character is, the harder it will be to animate in this style.

SHORTCUTS MAC WIN BOTH

Repeat this process for each object, combining various amounts of skewing, caling and positioning. The smaller symbol representing the hair on the right side is the only symbol, in this example, that gets positioned to the left. Moving it behind the head emphasizes the illusion that the head is a sphere that objects can seemingly "wrap" around.

Character animation

2.5D monkey

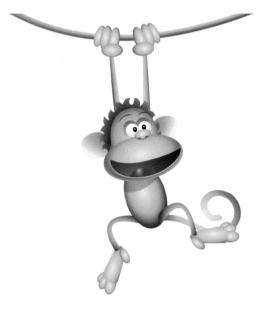

HE KEY TO REALISM lies within the shading. The same 2.5D animation technique is being used here, but this time the graphics are drawn using gradients to promote an even more convincing faux three-dimensional effect.

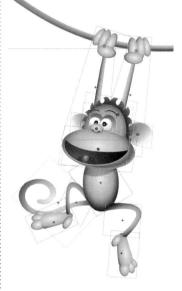

Start with the character at a threequarter angle in frame 1. Let's call this "point A".

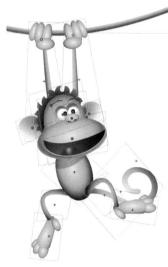

2 In your last frame, create what we'll call "point B". The challenge is getting from point A to point B through the use of tweens.

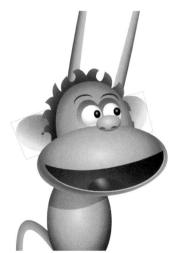

6 The ears play a pivotal role in this effect. At this new angle, we can see more of the left ear and less of the right ear.

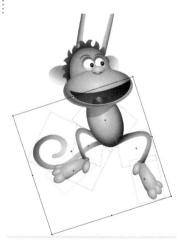

7 Once the head symbols are transformed and positioned where you want them, lock their layers, select all the body parts and rotate them.

8 Next, adjust the legs and tail individually by selecting and rotating them.

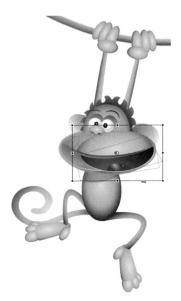

3 Using the Free Transform tool, rotate, skew and move each symbol into it's "point B" position. Here the mouth symbols are transformed first.

4 Next, trasform the nose, eyes, pupils and eyebrows. Pay close attention to the spacial relationship between each of these objects and our perspective at this new angle.

5 The head and hair symbols are rotated and positioned accordingly. At this angle, we see more of the hair from the left side and less on the right.

HOT TIP

Check out the "Using Gradients" topic in Chapter 1 to learn how to create and edit the radial gradients used in this example.

9 Select everything except the arms and hands and move the monkey over using the right arrow key. Hold down Shift to move in ten-pixel increments.

10 Rotate the arms so they align with the monkey's new position. Their center point is positioned where the hands grab the vine to make this even easier.

1 1 Apply motion tweens to each layer and play back your animation. Final adjustments are usually necessary at this stage.

Character animation

Lip syncing (swap method)

IP SYNCING IS AN ART form in its own right. It is the art of making a character speak to a pre-recorded vocal soundtrack. This technique involves the creation of various mouth shapes and matching them to the appropriate dialog. This technique can also be very time-consuming, especially if your dialog is very long. You can be as simple or as complex as you want. There's a big difference between South Park and Disney style animation when it comes to matching mouths to sounds. There are two basic methods of lip syncing in Flash which we will look at here.

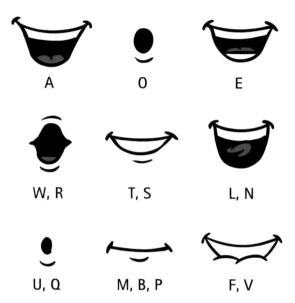

Here are the standard mouth shapes to use as a guide. Each shape corresponds to a specific sound or range of sounds. Each sound is noted below each shape. For most animation styles, you do not need to create a different mouth for each letter of the alphabet. In most situations, certain mouths can be reused for a variety of sounds.

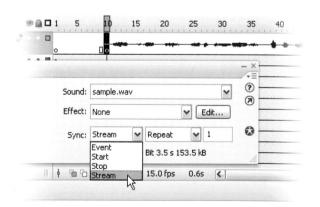

The next step is to import your sound into Flash. Sound formats supported are WAV, MP3, Aiff and AU. Go to File > Import to Stage and locate the sound file on your hard drive. Once imported, create a new layer in your timeline and select a frame. Using the Sound drop-down menu in the Properties panel, select the sound you just imported. Next, set the sound from the default "Event" to "Stream".

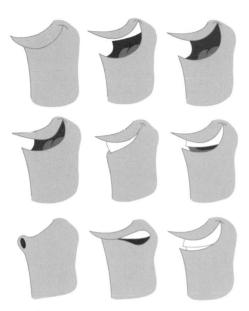

2 Using the standard mouth shapes as your guide, draw your character's mouth shapes, taking into consideration the design and angle of your character. After drawing each mouth, convert each one into a Graphic symbol.

Bascd on the design of your character, you will likely want to have your mouth symbol on its own layer. This makes it easier to edit it for animation.

HOT TIP

When you name each mouth symbol, include a description of what dialog sounds it should be associated with. This simplifies the process of choosing the appropriate symbol by allowing your eyes to scan down the list of names in the Library without needing to select each symbol to see the thumbnail.

5 On the main timeline where your character resides you can animate the mouth talking by creating keyframes and using the "Swap Symbols" method via the Properties Inspector. The Swap Symbol panel will open, allowing you to scroll through your Library.

6 Click once to preview each Library item and click OK to replace the instance on the stage with this symbol. It helps to name your mouth symbols starting with the same three letters as they will be sorted by name in the Swap Symbol panel, making it easier to find the mouth you want.

7 Click OK to swap the symbol instance on the stage with this new symbol from the Library.

5

Character animation

Lip syncing (nesting method)

HROUGH YEARS OF ANIMATING in Flash, I have developed what I think is an even better and faster way to lip sync a character. A few years ago I was working in a full production environment with teams of animators producing several series for television and the web. Most of these episodes were 22 minutes in length with several characters and plenty of dialog. Lip syncing quickly became the most dreaded of tasks. Using the Swap Symbols method is certainly a useful approach, but when you have 22 minutes of lip syncing to do and only two days to finish it, finding a faster method becomes a production necessity. The Swap Symbols method requires a minimum of four mouse clicks for each swap.

- 1. Select the symbol instance.
- 2. Click the "Swap" button.
- 3. Select the new symbol.
- 4. Click "OK".

Over the course of thousands of frames and symbol swaps, those clicks can add up to an enormous amount. Shaving off just one click per mouth shape can, over time, save valuable production costs (not to mention an animator's sanity).

This is where "nesting" really shows its strength and versatility. By nesting all your individual mouths into a single symbol, you can control the instance of this symbol with the Properties panel. This method eliminates the need to swap symbols and also saves time.

The first step is to place all your mouth shapes into a Graphic symbol. I recommend editing an existing symbol on the stage to help you align your additional mouths to the character on the main timeline. Double-click the mouth symbol on the stage to enter Edit Mode. Create a blank keyframe for each additional mouth. If your mouths already exist as symbols, open your Library (Ctrl + L) and drag each mouth to its own keyframe. Use the Onionskin tool to help align each one.

5 The convenience of nesting is obvious when you transform (rotate, flip horizontally or vertically, etc.) your character; all nested assets are transformed as well.

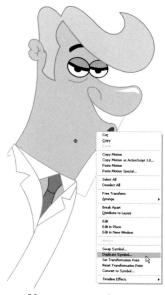

6 Often you may need a custom mouth animation - for example, a mouth that whistles. Right-click over your mouth and select Duplicate Symbol. Give it a descriptive name.

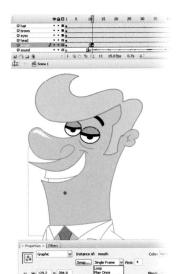

2 Back on the main timeline, open the Properties panel (Ctrl + F3) and select your "mouth" symbol containing all of your mouth shapes. As a Graphic symbol, the Properties panel will allow you options to control the instance.

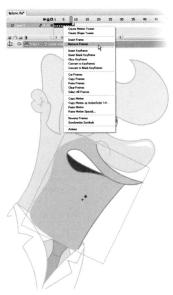

Remove the unneeded symbols by selecting them and choosing "Remove Frames" from the right-click context menu. Keep the symbol that closely represents a "whistle" shape.

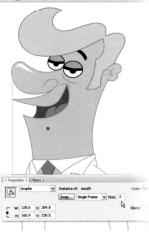

Ad a keyframe to the mouth layer, select the mouth instance and in the Properties panel select Single Frame. In the Frame input box, type in the frame number that corresponds to the mouth shape needed.

Animate the whistling mouth as a short loop. Here I used the Envelope tool to distort my original mouth shape after breaking it apart.

4 Scrub the timeline (drag the playhead back and forth) to hear the next sound. Repeat the same process by adding keyframes, and typing in the corresponding frame number for the mouth shape needed.

9 On the main timeline, add a keyframe and select the "whistle" symbol containing your new animation. In the Properties panel select "Loop" from the drop-down menu.

HOT TIP

When designing your character, it's important to conceptualize how the character's features may work. Some mouths are designed so that they are independent of the jaw and nose, while other mouths are an integral part of these features. So ultimately your mouth may be drastically different in terms of design, yet follow these basic standards.

To sync or not to sync

O SYNCHRONIZE A NESTED ANIMATION inside a Graphic symbol with the main timeline, select the Sync option in the Property Inspector. Sync is a feature that is available when a motion tween is applied. Select a keyframe with a motion tween to find the Sync option in the Properties panel. What this means for nested animations is that the nested frames will be synchronized with the main timeline.

Here's where Flash makes the Sync feature somewhat mysterious: If you apply a motion tween by applying the tween from the drop-down menu in the Properties panel, then Sync is UNCHECKED. If you apply a motion tween via the rightclick context menu, then Sync will be CHECKED. The Sync feature is indicated on the timeline when a keyframe is followed by a vertical line.

So when would you use Sync? When would you want to avoid it? Let's first take a look at a situation where Sync would not be useful.

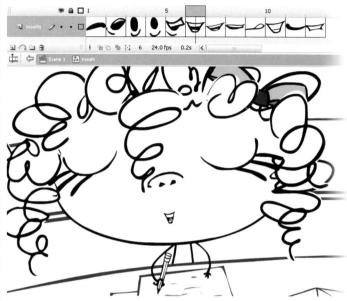

In order for you to see the effectiveness of the Sync feature, you need a nested animation to work with. A mouth symbol with several mouths on different keyframes will do just fine. Thumbnail views of each frame was selected using the Frame View drop down menu in the upper-right corner of the timeline panel (to the right of the frame numbers). This is a handy way to see the contents of each

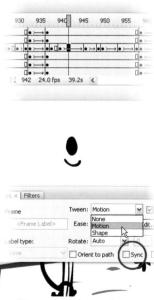

When you apply a motion tween using the Motion drop-down menu in the Properties panel, the Sync feature is, by default, not selected.

If you apply a motion tween using the right click context menu, by default, the Sync feature is selected. Confusing? Sure is.

The Frame View drop-down menu offers several choices for you to customize the way your timeline looks. My personal favorite is the "Short" setting, which lowers the overall height of each layer.

In the timeline, the top image indicates a keyframe with Sync turned on. The bottom image indicates a keyframe with Sync turned off.

You can take lip syncing a bit 3 You can take lip syncing a oil further by tweening the mouth on the main timeline. This adds a second layer of animation since this mouth symbol contains nested mouths as well.

Having the ability to assign a specific frame number is critical for lip syncing. If Sync is selected, you will not be able to edit the current frame number.

Using the Free Transform tool, 4 Using the rice transcended scale and/or skew the mouth depending on the vocal sound and apply a motion tween. The Sync option becomes a factor when motion tweens are applied.

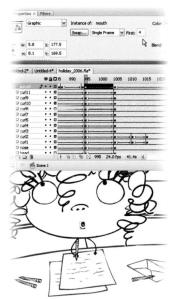

Once Sync is turned off, then you are free to change the frame number pertaining to the nested animation.

HOT TIP

Check out the "Extending Flash" chapter, specifically the AnimPro Slider by Warren Fuller. It is a very useful extension for controlling nested graphic symbol animations and, personally, my favorite tool for Flash.

5 Character animation Sync

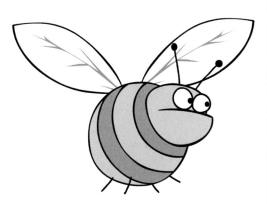

NE DAY THE CLIENT ASKS for you to animate their company's character logo across their website splash page. You use several keyframes and motion tweens to animate their character (nested inside a symbol) along a motion guide and deliver the final version to your client and await their feedback. Unfortunately the client changes their mind and asks if you could change the bee character to a dog with a jet pack instead. Do you have to do the entire animation over again? No, because you can always swap out the bee symbol for another symbol. But you have to swap out each instance of the bee for every keyframe you made in the animation. What a drag! The more keyframes on the timeline, the more monotonous and frustrating this task can be.

Sync to the rescue!

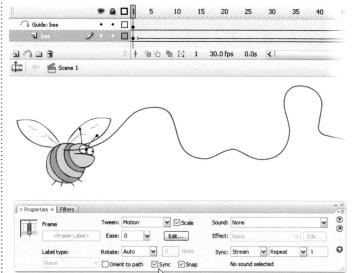

1 Let's start with a simple animation involving a nested character animation in a graphic symbol motion tweened along a guided path. Apply the motion tween using the Tween drop-down menu in the Properties panel so that the Sync option will be turned on by default. Nothing too complex going on here. The bee symbol contains some nested animations (wings flapping, eye movements and the bee sneezing).

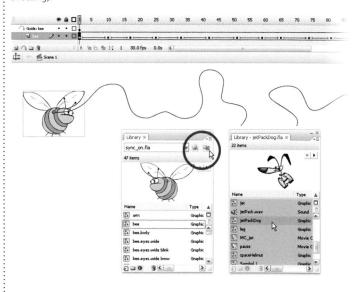

4 You just about finish the animation when the phone rings and your client informs you that they want to change the bee to a totally different character. Thanks to Sync, your time and hard work will not be wasted. Go to File > Import > Open External Library and navigate to an FLA containing the replacement symbol and click Open. A new Library panel will open displaying the symbols and assets contained in the selected FLA. Click and drag the preferred symbol from the external Library to the Library of your current document.

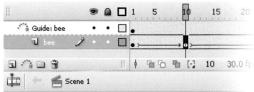

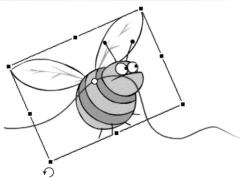

2 Insert a keyframe somewhere in the motion tween. Use the Free Transform tool ② to rotate the symbol. Feel free to scale or skew the symbol as well. Because the first keyframe is "Synced", all subsequent keyframes will have Sync turned on by default as well.

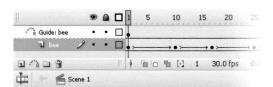

5 Select the bee character in the first frame of your motion tween. In the Properties panel click the Swap button and locate the new symbol you just added to your Library and click OK.

Continue to insert keyframes every few frames and transform your symbol by rotating and scaling. The idea here is to make this simple motion tween relatively complex for the example purposes.

6 Since every keyframe in the motion tween has the Sync option selected, your entire animation will be updated across all keyframes. Crisis averted, go and make yourself another cup of coffee, catch up on your email overflow and get back to your client in a little while. Make sure to sound out of breath when you call them to tell them the changes have been made (just kidding).

HOT TIP

Use the Sync option to control different symbols within the same motion tween. Turn off sync for certain keyframes if you want to swap to another symbol for that keyframe. Turn on Sync to keep the same symbol in sync with the main timeline. This method will not work with Movie Clip symbols. Use only Graphic symbols because only Graphic symbols can be synced to other timelines. Movie Clips have timelines that are independent of all other timelines. Sync does not apply to them.

URPRISINGLY, Flash lacks what most animators consider a "must-have" animation feature: Inverse Kinematics. IK is a feature commonly found in 3D and in a handful of 2D animation programs. This feature allows for parent-child linkage relationships and articulation between objects. So how can we simulate IK in Flash? Once again it is the Free Transform tool to our rescue - but keep in mind, this is not truly an IK solution. With Free Transform we can edit the center point of a symbol instance, thus editing the point on which the symbol rotates or "hinges" itself. Any simulation to IK is purely coincidental.

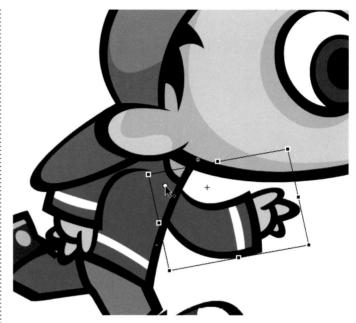

Select the Free Transform tool ② and then click on one of your symbols on your stage. The center point of the symbol is now represented by a solid white circle. Simply click and drag this circle to a new location. In my example, I moved the center point of the arm to where the shoulder is (approximately).

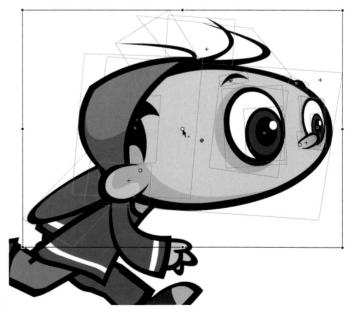

4 You can select multiple symbols across multiple layers and hinge them as if they were one single object. With the Free Transform tool still selected, hold down the **Shift** key and click on multiple symbols on the stage. The center point will now be relative to the center point of all the symbols selected.

With the same tool rotate the arm symbol. It will "hinge" based on its new center point, making it easier to position each arm movement in relation to the body symbol.

This can be very useful for hinging the head of a 5 This can be very userur for imaging character which may contain multiple symbols (eyes,

mouth, nose, hair, etc.).

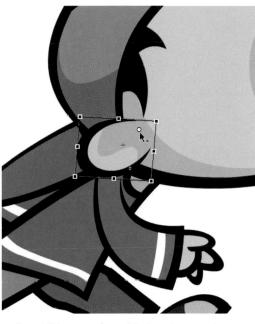

Repeat this process for each body part you want well. Now you can start animating by creating additional keyframes and apply motion tweens throughout your timeline.

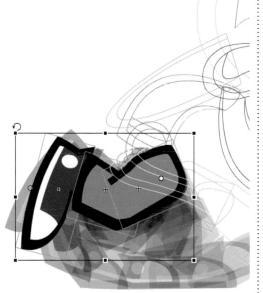

The center point for each individual symbol will be retained but the center point representing multiple selected symbols will not be remembered once they are deselected.

HOT TIP

To select multiple objects, it is often easier to click and drag with the Selection tool across the objects on stage. Make sure you set the center point for each symbol on frame 1 of your timeline. If the center point is different between keyframes where a motion tween is applied, your symbol will "drift" unexpectedly.

ORM FOLLOWS FUNCTION in Flash. The more stylized the design, the more flexibility you will have when it comes to adding motion. On the other hand, the more anatomically correct your character is designed, the less you can get away with when it comes time to animate it.

Sometimes a project comes along where the design style demands realism. As a result, the animation technique demands attention to detail, which can be limiting to a certain degree. One particular issue is bending arms and legs at their respective joints, and the unsightly gap between them that is often created. The solution: "caps". At least that's what I like to call them. An elbow cap for the arms and a knee cap for the legs can solve the dreaded gap problem.

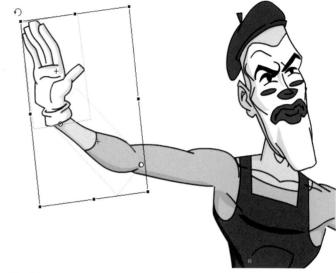

The Evil Mime character for the Yahoo! Super Messengers project was designed in a very anatomically correct style. This caused some problems during the animation process – specifically the joints between limbs. When the arms or legs are in their original positions (as they were drawn originally), there's no gap.

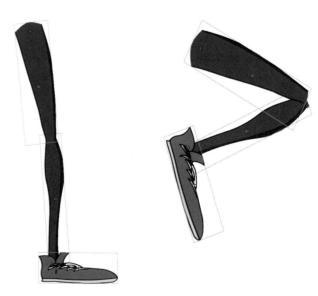

5 The leg, like the arm, works quite well when in a straight position. The upper thigh blends perfectly into the calf and shin.

6 The problem arises when these body parts are pushed to their anatomical limit when rotated and bent at the knee (or lack thereof).

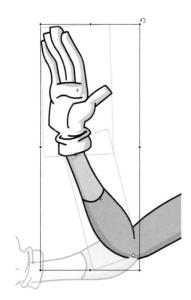

2 Once the arm is bent, the gap appears between the forearm and upper arm symbols. This is a problem inherent with this style of line work.

The solution is to add a new symbol in the form of an elbow. This new "cap" can be used as "filler" to hide that ugly gap between limbs when rotating.

4 Use the Free Transform tool to skew the cap symbol so it aligns with both arm symbols - bridging the gap between them, so to speak.

HOT TIP

For a more realistic IK method in Flash, check out the IK' motion extension featured in Chapter 12.

7 Once again, adding a knee cap symbol solves this problem quite nicely.

Position the knee cap in between the upper and lower leg symbols and align as necessary. Use the Free Transform tool ② to skew and scale the knee so that it fits properly.

It may seem like a lot of work to add elbow and knee caps, and subsequently more layers to your Flash document. But in the end, the results of your hard work and attention to detail will not go unnoticed.

Bitmap animation (Jib Jab)

IB JAB MEDIA gained widespread notoriety for its election year shorts "This Land" and "Good to be in DC", which featured George W. Bush and John Kerry during the 2004 Presidential campaign and were viewed online more than 80 million times.

The Jib Jab team uses both Photoshop and Flash to create the majority of their animation, and the process involves sketching, photography, photoshop collage and, of course, Flash animation. In this tutorial, you'll be instructed on how to make a President Bush dance cycle. You'll need a photo of President Bush's head, a camera and an understanding of tweens, guide layers and the basics of character animation.

Special thanks to Aaron Simpson, Gregg and Evan Spiridellis for their generous contribution to this book. This is Flash animation gold.

1 For this type of animation, you should define the proportions and the action your character will be executing. Start by drawing the first pose for your character.

2 Sketch the second pose and when you're finished, you should have a clear idea of the photos you'll need to animate with.

6 You should only build one arm, as we'll flip these assets and reuse them on the opposite side. Here the arm was cut out using another Quick Mask.

The arm looks too thin on the shoulder area. Press # [17] to enter Transform mode and click the Warp icon, then manipulate the Bezier handles to give it a cylindrical shape.

3 Photograph a front view of a jacket, shirt and tie and then a separate photo of a fist. In this situation, you can reuse the arms as legs, and create a vector foot.

4 Open your photograph file in Photoshop. Press ② to enter Quick Mask mode and, using a hard edge brush, select the area you want to animate separately.

5 Here's the body section after cutting it out with the Quick Mask feature. Make sure the background is transparent.

HOT TIP

Check out
Steve Caplin's
How to Cheat
in Photoshop
CS3 for some
of the best lips
and tricks for
how to extend
your Photoshop
knowledge.
it's a great
companion book
to have next to
this one.

Next, select a circle where you want the elbow joint to be and save that selection in a new channel.

9 Here is the lower arm graphic after being cut out from the overall arm.

10 Here the upper arm receives a little more transforming with the Warp tool for good measure.

PSD Importer (Jib Jab)

NE OF THE COOLEST features in Flash CS3 is the new PSD Importer. You now have the ability to import PSD files straight into Flash! This is a huge workflow breakthrough and a great feature that integrates Photoshop and Flash.

Here is how the layers look in the Photoshop file. Many of the images have transparent backgrounds. Transparency is one of the many features preserved when importing.

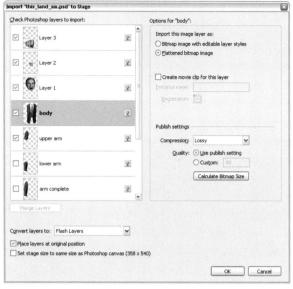

In Flash go to File > Import and navigate to your PSD file. The PSD Importer wizard will launch automatically. Besides having a convenient thumbnail preview of each layer, you can also select or deselect which ones get imported. Other options include maintaining editable layer styles, conversion to movie clips, compression and how layers are distributed in the timeline (layers or frames).

6 The shoulder should rotate where it meets the torso, and the forearm should rotate at the elbow.

The image of President Bush is easily found by doing an image search on the web. Assets like the hands can be shot with your own camera and edited in Photoshop.

Reuse the arm assets for the legs by copying and pasting them to new layers. Then scale and stretch the copied version and align it to your character as the thigh and calf.

Flash also offers a PSD Importer preference panel that allows you to set your own defaults for each option. Just go to Edit > Preferences and click on the PSD File Importer category in the left column.

4 You may prefer to convert your images to symbols after importing. Keep your library organized by using symbol names the same as the names of your images.

5 Fdit the center point of each symbol using the Free Transform tool **Q**.

HOT TIP

Besides File > Import, you can also drag and drop a PSD file onto the Flash stage to invoke the PSD Importer wizard. Always maintain RGB color values in Photoshop to preserve their consistency when importing into Flash.

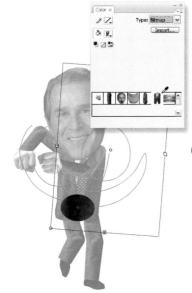

9 The pelvis area was created with a shape and a bitmap fill from one of the imported bitmap images. Use the Gradient Transform tool (a) to scale it to show only the blue fabric.

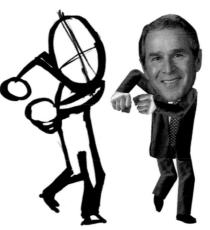

10 In frame 1, pose your character based on your initial sketch. You can choose to have your sketch to the side or directly underneath your symbols. Whichever way you prefer, the main objective is to position your character in this same gesture. In your second keyframes, pose your character in its final state using your sketch as a guide. You can't flip your symbols horizontally or you will ruin the motion tween.

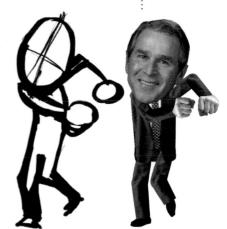

Character animation

Motion guides (Jib Jab)

OTION GUIDE LAYERS let you create paths along which you can tween instances of symbols, grouped objects, or text blocks. You can link as many layers as you want to a Motion Guide layer and have multiple objects follow the same path. A normal layer that is linked to a Motion Guide layer becomes a guided layer.

Motion guides are useful because, without them, a normal motion tween is linear, meaning it moves in a straight line only. If your object needs to move along a curve, a Motion Guide is necessary.

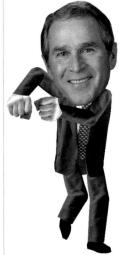

1 Create a Motion Guide layer for the left hand by selecting the hand layer and clicking the Motion Guide layer button in the Timeline panel.

	9001	10 15	
à Layer 1		а	
☐ univ001F_Hands01Rt	· · · · · ·	$\longrightarrow \bullet \rightarrowtail \bullet \rightarrowtail \bullet$	
& Guide: bush_forearm	• • •	0	
□ bush_forearm	· · · · ·	$\longrightarrow \bullet \rightarrowtail \bullet \rightarrowtail \bullet$	
à Layer 60		0	
□ univ001F Hands0190.	· · · ·	0. 0. 0.	
☐ Bush_01	· · · · · ·	\longrightarrow • \longrightarrow • \mapsto •	
□ bush_shoulder	· · · · · ·	$\longrightarrow \bullet \rightarrowtail \bullet \rightarrowtail \bullet$	
& Guide: bush_forearm		0	
D 4 D 3	N P To	白 物 [1] 5	15.0

6 Add a motion guide for each additional object you need to animate along an arc and draw the appropriate path needed.

2 The hand layer will automatically be linked as a guided layer. Draw your desired path using the Pencil or Pen tool.

			8		1		5	d	10	15	21
à Guide: bush_forearm	-	•	٠	0							
□ bush_forearm	0	8	æ	0	•>	-	• >-	—	-	• >> •	l
à Layer 60		•	٠	0						- [
☐ univ001F_Hands01Rt		٠	•	0	•>	-	• >-	-			1
☑ Bush_01		٠	•	-	•>	-	• >-	-			1
□ bush_shoulder		•	•			-	• >-	-		• >> •	
& Guide: bush_forearm		•	•				010			- [
□ bush_forearm		•	٠		•>	-,	•>-	-	· > ·	• >> •	
□ bush_shoulder		٠	•		• >	-	• >-	→ •	2	• >> •	
3/108					4	1	Pa	45	[2]	9	15.01

Using a combination of motion guides, paths, transforming and tweens, you can animate any object along in any direction you prefer.

		9	2		1				10)	1	5	20	25
& Guide: univ001F_Hands01Rt		•	•	0		igg.		Ď			THE	d		
O terimization in production.	0	ĸ	×	B	•	0		0	•	D-	0			
D bush_forearm		•	•	8		399		0	•	Sour	0			
univ001F_Hands01Rt		•	•	-	•	LE.		0	•		0			
Ø Bush_01		•	•			411	112	0	•		0	Ŀ		
□ bush_shoulder		•	•		•	318	183	0	•	THE P	0	L		
□ bush_forearm		•	•		•		100	0	•		0	Ŀ		
□ bush_shoulder		٠	٠			103	10	0	•		0	Ы		
003					14	9		d	b.	(i)	5		15.0 fps	0.35

		9 8		1	5		10	15	20	25
& Guide: univ001F_Hands01Rt			8				1000	0		
U univ 001F_HandshitRt	0 .	8				0		_ [] •		
□ bush_forearm				•		0		0.		
☐ univ001F_Hands01Rt				•	Mrs. Hr	Di-	1((1))	0.		
Ø Bush_01	•		0		NERUDIA	0		D.		
□ bush_shoulder	•					0		0.		
□ bush_forearm	•				THE	Q.		D.		
□ bush_shoulder			0			D.		D.		
3/103				(4)	旗边	3.5	1:1	9	15.0 fps	0.54
± ¢ € B		I								

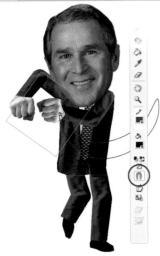

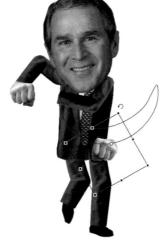

3 Make sure Snap is selected (magnet icon) and drag your symbol until it snaps to your motion guide.

Add additional keyframes as
4 Add additional keyframes as necessary and snap your object to
the path. Use the Free Transform tool
to rotate your symbol as well.

5 In your last frame, snap your symbol to the end of your motion guide and add your final transformation.

	9	91	0	1	5	-	10	15	20
□ bushTorso	•	•	8	• >-	- · ·		>	• >> •	
□ bush foxesm	0.	•	0	• >-	++>	+1	·		
□ bush_shoe	•	•	8	• >-	+ • >-	→	-	• >> •	
□ bush_shoulder	•	•		• >-	+ · >	- ·	-		
□ bush_forearm	•	•		• >-	+•>	- •	>-	• >> •	
□ bush_shoe	•	•		• >-	+ • >-	→	>	• >> •	
□ bush_shoulder	•	•	8	• >-		→ •	>	• >> 1	
bushPelvis		•	0	• >-	→ • >-	→ •		• >> 1	
9/198				+	a a	Pa	[2	9	15.0 f
中令各	🚹 bush cycle0								

8 The legs and feet do not need to be guided along a motion path since they only move in linear directions.

9 The final step is to place your character in its intended environment by adding a background. The American flag shown here was edited in Photoshop and imported into a layer below all the other layers.

HOT TIP

Test your
work often by
using Ctrl +
Enter. Flash
will generate
an SWF file
and play it for
you within the
Flash authoring
environment.
This SWF can
be found in the
same directory
where you saved
your FLA file.

5 Character animation Walk cycle

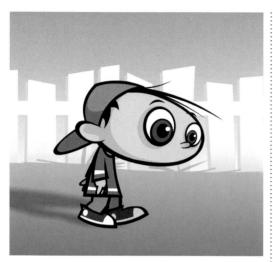

eventually going to be faced with the task of making somebody or something walk. For whatever reason, newcomers to animation regard walk cycles as being extremely difficult. Why? I won't lie to you, they are. Well, in an anatomically accurate way, they can be very challenging. As an animator, you will find it nearly impossible to avoid the walk cycle, so it may be best to face your fear head-on right now. You just might learn that walk cycles aren't all that difficult to accomplish. There are several ways to make the task of animating a walk cycle very difficult or relatively easy. Let's examine the easy way.

The best way to create a walk cycle in Flash is to animate the character walking in place, as if on a conveyor belt. The main idea here is to drag an instance of this looping walk cycle animation to the stage and use a motion tween to animate the character walking across the scene. We'll get more into that after we tackle the actual walk cycle.

Design your character in three-quarter view. At this angle the character is simply easier to animate - especially when it comes to walk cycle animations. Next, convert your entire character and all its parts into a Graphic symbol. You will be working entirely inside this symbol to create your walk cycle.

Let's concentrate on just one leg for now. In fact, turn all other layers off so only one leg of your character is visible. This character's leg is made up of three different symbols: an upper thigh, a lower leg and a sneaker. This is a straightforward setup with enough flexibility for a simple walk cycle.

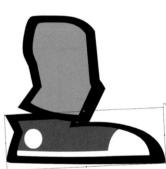

A Notice that I didn't use the same sneaker for every frame. Depending on the position of the leg, I duplicated the original symbol, gave it a new name and edited its shape to reflect its new position. This is the type of detail I love to add to my animations and I really feel, as subtle as it may be, it adds a lot to the overall look and feel of the character's movements.

Feel free to experiment with the amount of frames between each of your leg positions. You can have more frames for when the foot is sliding back along the ground (so it travels slower) and less frames while the leg is off the ground (so it travels quicker), returning it quickly to its initial position. This can create the illusion that the character is heavy, or perhaps carrying something heavy, If you do the opposite and have the foot slide quickly across the ground and slower when off the ground, it may suggest your character is on a slippery surface, such as ice.

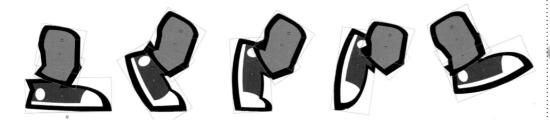

Position the leg into several major walk positions using keyframes. Start with the leg planted firmly on the ground. The next position is the foot still on the ground but bent so the heel is up off the ground. Then create another keyframe and position the leg just before it is lifted off the ground. Next, position the leg completely off the ground and in its most rearward position. The final keyframe shows the leg is in its most forward position off the ground. Use the Free Transform tool to rotate each leg symbol until they

are in the desired position. Notice there are several slightly different shapes to his sneaker based on the amount of weight (or lack of) being placed upon it. When it is fully compressed on the ground its bottom edge is flat. Just before it's lifted off the ground, it is bent just after the toe. When it is entirely off the ground, its bottom edge is slightly rounded. These may seem like very insignificant details, but in the grand scheme of things, they can make all the difference.

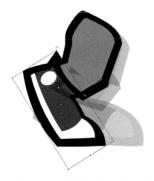

5 Turn on the Onionskin tool and adjust the playhead brackets so you can use your established leg positions as references. Create keyframes across all layers that contain your leg symbols.

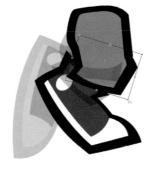

6 Use the Free Transform tool ② to rotate and move each leg symbol into an intermediate position relative to the keyframes you already created. The number of frames between the major leg positions will determine the characteristics of the walk cycle.

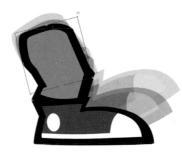

7 Experiment with the frames between each leg position. Adding more frames when the foot is sliding back along the ground will create the effect of the character gripping the surface. Add fewer frames while the leg is returning to its initial position.

HOT TIP

Before you start, it may be a good idea to put down your stylus and go for a walk. I'm sure the fresh air won't hurt, but the intention is for you to study how your body moves during the act of walking. As an animator you will find that studying from real life will be your greatest resource. Notice your right leg and left arm move in the same direction with each other. Same thing happens with your left leg and right arm. It is details like these that your animation will benefit from.

9 Play back your animation constantly so you can get real-time visual feedback as to your process. This type of animation work is trial and error and depends on your personal animation style to get the walk cycle to look and feel good to you. Don't get frustrated, it simply takes practice. Sometimes it helps to not think of it as an actual leg. Try to imagine it's not a leg at all but some kind of mechanical assembly like a basic pulley or lever system. This thought process

can make animating less daunting and a lot more fun.

Open the "leg_simulation.fla" from the included source CD. This FLA contains an example of a walk cycle experiment. I made it to show how a walk cycle can be thought of in mechanical terms. It was a fun experiment because it removes the intimidation factor that is associated with animating a walk cycle.

SHORTCUTS

MAC WIN BOTH

Character animation

Walk cycle (cont.)

NCE YOU ARE FINISHED creating enough keyframes and leg positions, and you are satisfied with the movement of your leg, we can now move on to the other leg. Since you already animated one leg, there is no reason to start from scratch with the second leg (unless the other leg is designed differently). Therefore, delete the other leg entirely from the stage. Seriously, go ahead and delete it. We don't need it any more. Trust me.

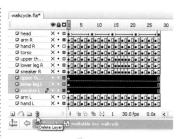

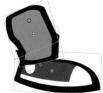

10 Hold down the **Shift** key to select multiple layers and drag them to the trashcan icon or click on the trashcan icon to delete them from the timeline.

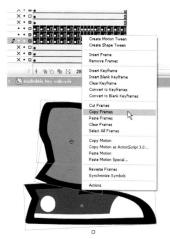

11 Select the entire range of frames and layers of the leg you previously animated. Right-click (Control + click) over the highlighted area and select "Copy Frames" from the context menu.

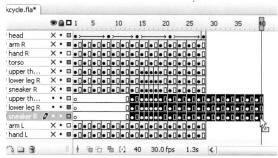

15 Select this entire range of frames and layers by clicking and dragging across all of them.

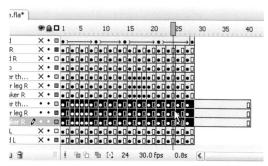

16 Click and drag this entire range of frames and layers to the left until they start on frame 1. Remove the residual frames by selecting them and "Removing" them from the right-click context menu.

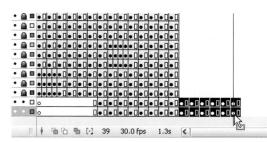

20 As we did with the leg animations, animate just one of your character's arms and then copy and paste its keyframes into a new layer(s) to achieve the second arm. Select the first half of your arm/hand animation and place it after the latter half of the animation.

21 Select and drag the entire arm/hand animation so it starts again on frame 1 and remove the residual frames that are left behind.

12 Add a new layer below your existing leg, select the entire range of frames, right-click over them and select "Paste Frames" from the context menu.

13 Lock all layers except these three you just copied and pasted. Select the first half of this duplicated leg animation by clicking and dragging across layers and frames.

14 Click and drag the entire section of highlighted frames down the timeline and place it after the latter half of the animation.

17 Using Edit Multiple Frames, select the new leg symbols and use the arrow keys to nudge them to the right and up slightly. This will help separate the two leg assemblies.

22 Turn on Edit Multiple Frames again and select this entire range of arm/hand symbols. Click on them once with the Selection tool and apply the same color tint as the legs.

18 Apply a color tint to the leg symbols using black with approximately 30% strength. This gives the illusion the back leg is in shadow and helps create a sense of depth.

23 With Edit Multiple Frames still turned on, use the arrow keys to nudge them up and to the right slightly.

19 Animate the arm and hands by rocking them back and forth. You can use frame-by-frame or motion tweens depending on your needs.

24 You can add to your walk cycle animation by adding some motion to its head and body. It comes down to personal preference and your individual animation style.

HOT TIP

Be careful when using the Edit Multiple Frames feature. Make sure only the layers you want to edit are unlocked and all other layers are locked to avoid accidents.

Advanced walk cycle

是是是是是是是是是是是是是是是是是是是

Contributed by Ben Palczynski www.hiylea.com

HIS IS AN EXAMPLE of a traditional walk cycle animation where each frame is drawn completely by hand. What makes this particular animation "advanced" is that it requires not only drawing skills, but a sense of rhythm and timing. Ben makes it look easy, but with some dedication and practice, you can achieve great results.

One of the most well known and highly praised resources for character animation is *The Animator's Survival Kit* (Richard Williams). Williams explains everything you could ever want to know about all kinds of walk cycles and it's a reference no animator should be without. Its one of those books that should be next to your workspace at all times.

Pick a starting point to draw.
The initial step as the front foot contacts the ground will do. It helps to use a horizontal guide to help keep things aligned and level.

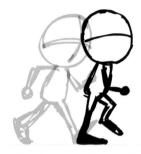

2 Now draw the halfway position where the standing leg is straight and central. Turn on the Onionskin tool to use the previous drawing as your reference for scale and alignment.

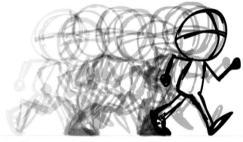

5 Turn onionskinning on over the whole animation so you can look for the arcs of motion to check that things are generally lined up. If something is jittering in your animation this can help you spot where it is.

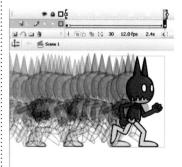

8 Drag this nested walk cycle to a new layer on the main timeline and motion tween it across the stage.

9 The head "turn" uses the same "globe" technique as shown in Chapter 3 (Masking).

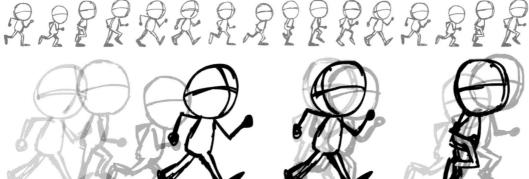

Continue drawing the key main poses using the Onionskin tool to reference your previous keyframes.

Next, center the drawings so you can create a nested loop. Combine any layers you have for each frame, turn Edit Multiple Frames and span all keyframes using the Frame Indicator brackets. Use the Align panel to center them all.

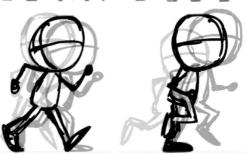

Now do the poses in between these positions. The more keyframes and poses you add, the smoother and slower your animation will be. Experiment with frame rate and number of keyframes for your walk cycle.

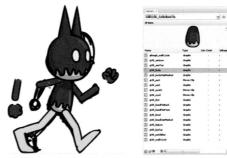

Place these keyframes in a symbol if they aren't already. Draw your character or drag pre-made body parts from the Library into a new layer above your walk cycle. Align each body part according to each sketch for each keyframe.

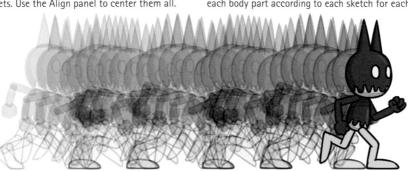

To prevent your character's feet from slipping along the surface as it walks across the stage, set the symbol to graphic and playback to loop. Turn on the Onionskin tool and make sure that the feet overlap fully when they're placed on the ground. The advantage of having the walk cycle nested in a single symbol is the ability to scale the walk cycle quickly and easily. You can also flip the walk cycle horizontally to make the character walk in either direction.

HOT TIP

When animating a walk cycle, it's sometimes a good idea to start off by animating the character literally walking across the screen - one image positioned after another like the thumbnails along the top and bottom of these pages. This might help you fine-tune the overall mechanics and the ryhthm of your walk cycle.

Character animation

Anticipation

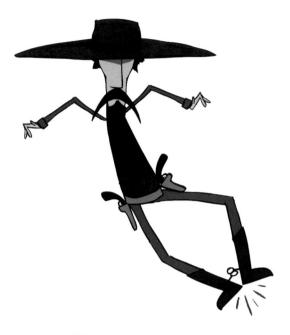

By DEFINITION, anticipation is the preparation for a particular action or movement. It can also be used in animation to attract the viewer's attention to a specific event that is about to occur. An example of this would be an archer pulling an arrow back along its bow or a baseball player raising his arm to throw a ball. Anticipation can also be used to build suspense in a scene. It tells the viewer something is about to happen, and the longer the anticipation is, the more suspenseful it can be.

Anticipation is critical to making believable animation. Without anticipation, your animation may appear too abrupt and unnatural. It is important as an animator to study from life and notice how we move and react anatomically.

Here the character is in its initial position. Not much going on in terms of action but we can assume he might do something due to the slight tension in his stance and his hands being in close proximity to both holstered guns.

4 The first step shows the character still on one foot but also leaning back a little further and crouching lower with all his weight on this one leg. This is obviously not a comfortable gesture that could be held for very long. Hence the anticipation that something is about to happen.

2 To anticipate the action, animate the cowboy in the opposite direction he will be moving. Make a new keyframe across all layers where the next position change will occur and use the Free Transform tool ② to rotate and position your character. Apply a motion tween and some easing out to imply physical tension within our character.

5 Here I am pushing the envelope by adding even more tension in the character's overall gesture. There's no doubt he is about to react in a very physical way.

3 Sometimes an animation requires more than one keyframe position to achieve the right movement and gesture. For this particular animation I used four different gestures for the anticipation animation, each with a motion tween and some easing applied.

6 Sir Isaac Newton showed us for every action there is an opposite but equal reaction. In keeping with this law of motion, animate the character moving in the opposite direction and ultimately performing the anticipatory action.

HOT TIP

Refer to the topic in this chapter on "Hinging body parts" to help you rotate symbols based on a customized center point.

Drawing upon oneself

Contributed by Laith Baharini
www.monkeehub.com
www.lowmorale.co.uk
www.jcbsong.co.uk

HE MOST COMMON TECHNIQUE I USE to make a character or an object appear as if it's drawing itself into the scene is purely frame-by-frame animation anyone can achieve. Although the effect can be guite labor intensive, it can also be visually effective if you want to achieve a very organic hand-drawn effect. The basic principle involves starting with a finished drawing, then over a series of keyframes, cut away bits of the drawing with the Lasso tool. You will work backwards starting on what will eventually be the end keyframe of the animation. When you play back the animation from frame 1, the drawing will appear to draw itself. The same effect can be achieved by using a mask to reveal the character or object. I find this works best on areas of color as opposed to lines. Let's look at how you can incorporate both techniques to animate a chicken character appear to draw itself.

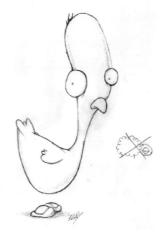

The first step to animating the chicken character is to spend decades studying and sketching this wonderful species of bird. As you can see I skipped this part and just scanned in the first chicken I drew. Resize the scanned sketch into a workable and desirable size in Photoshop and then import it into Flash.

2 With the scanned sketch imported and on the stage, convert it to a movie clip. This will be the drawing guide and this is how I do a lot of my characters. Adjust the alpha of this "guide" to about 50% so the contrast of the lines you draw over it will be clearer.

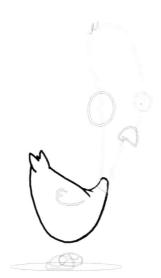

6 Now lock all the layers, then unlock just the body outline layer; doing this helps ensure you only work on the appropriate area. Insert a keyframe in frame 2. Select the Lasso tool and cut away a small portion of the line.

Repeat this procedure of adding keyframes and removing small portions of your line work until they are completely removed. Select the entire range of keyframes, right-click over them and select "Reverse Frames" from the context menu. Repeat this process for all other outline layers.

Build the chicken character up in layers, keeping individual parts on separate layers. The techniques of splitting a character up are fairly universal and logical – head/hody/arms/legs/eyes/mouth (or in this case beak). Create a new layer (above the guide) and, using the Paintbrush tool, draw the outline of the chicken's body.

When you've drawn the body outline, fill it with a color. Next click on the filled color area to select it, cut it using *** \(\mathbb{R} \) \(\mathbb{R} \)

5 Create the head and other parts in the same manner. Add a new layer for each new body – errr – chicken part, keeping them all separate. Remember to cut and paste each color fill to individual layers as well. If you are familiar with character animation, then you are already used to working with multiple layers and layer folders.

HOT TIP

Instead of using the Lasso tool to select and delete a small portion of your line work, you may want to try using the Eraser tool or the pressuresensitive eraser on the opposite end of your stylus (if you have one). In terms of style and pacing it's worth keeping in mind that if you cut big pieces away at each keyframe the line will appear quickly and could look a bit jumpy.

To create the effect of each color fill being "drawn" in, add a new layer above the body layer and convert it to a mask layer. In this layer create an irregular shape and convert it to a symbol.

9 Insert a keyframe in the mask layer in a frame at the end of your timeline. Position the symbol containing your shape so it completely covers your fill color for the chicken's body. Apply a motion tween to animate the mask so it "reveals" this color fill.

10 Add a mask layer and create new mask shapes for each color fill. Motion tween each one into position to reveal each chicken part. Lock all layers or publish your movie to see your animation effect

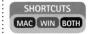

Contributed by Kirk Millett www.kirkmillett.com

ACKGROUNDS ARE CHARACTERS TOO. They can often take on personalities all their own and be brought to life just as much as a character (with eyes, a mouth, arms, legs, etc...) can. Backgrounds are also a classic way of complementing a character's actions within its environment. Remember Fred Flintstone's marathon runs through his own living room? Even though we'd see the same lamp and hanging picture pass by over and over, we remained focused on the action and story. An effective background loop will allow your viewers to do the same. The illusion is created by repeatedly tweening background art across the stage. The art has matching left and right edges so multiple copies can be seamlessly stitched together. A greater sense of depth can be achieved when individual background elements are placed on separate layers and moved at different speeds.

The key to a seamless looping background is creating graphics that can be joined together seamlessly. The rock formation art is only slightly wider than the stage. By duplicating it and aligning its left edge with the right edge of the original, you can double its width.

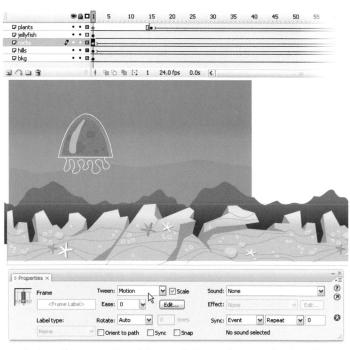

3 Apply motion tweens to each layer so that a new instance of each symbol starts at the same point as the previous one in the last keyframe. The trick here is the ability to "tile" your background graphics so they seamlessly align with each other when positioned horizontally.

Join and group multiple art copies on each layer. The back layer should have shorter art and use more duplication than the foreground layer. This will allow the back layer to move more slowly than the foreground layer, even though their tweens will use the same amount of frames. This is commonly referred to as a "2.5D" effect since it creates the illusion of a third dimension (Z-axis), but you never leave Flash's two-dimensional environment. That third dimension simply doesn't exist except in the viewer's mind as they watch the foreground and background elements move across the screen at different rates.

In the last keyframe of your 4 motion tween, position the background graphic so that it aligns perfectly with the instance in the first keyframe. It's good practice to check the alignment of these graphics by tesing your movie several times.

The central character or object should also show movement. The squash and stretch motion of the jellyfish clip completes the illusion, even though it does not move around the stage.

Adding a foreground element can add a convincing sense of depth to the overall scene. Because the plant is closest to us in relation to the other elements, it moves at a faster rate of speed.

HOT TIP

Draw your background art, then drag a copy off to the right by holding down the Shift alt Shift keys. Modify the right edge of the original art to match the left edge of the copy. Delete the copy. Your remaining art now has matching edges and can be seamlessly tiled.

Character animation

Tradigital animation

HE FUSION OF TRADITIONAL AND DIGITAL ANIMATION has given us "tradigital" animation. I don't know who invented the term but the effect was first shown to me by Ibis Fernandez (www.2dcgi.com), a well known and talented animator who blew me away when he sent me a sample of this technique a few years ago. Up until that point in my career, I had been using Flash for four years and thought I knew every trick in the book. It was clear to me I had more to learn.

Tradigital animation is the result of traditional animation techniques translated by the use of digital tools. The end result may look traditional, but the process is very different and less time-consuming. When a client deadline is looming, traditional animation goes out the window. A common argument among traditionalists is that tweens are too easy to use and often become relied upon for every aspect of an animation. This may result in your animation looking very mechanical and stiff. So where do you draw the line (sorry, bad pun)? What technique should you use? Motion tweens? Shape tweens? Frame by frame?

Answer: All of the above. Don't limit yourself to just one technique if you don't have to. Use the technique that the action calls for, even if it means combining two or more techniques. What is so impressive about this particular technique is the fluidity of the movement you can achieve. Draw image "A" and then image "B" with the Line (or Pencil) tool, then with each line segment on its own layer, shape tween from "A" to "B". Merge all your layers, clean up your lines, add some fills and shading - voila! You're a "tradigitalist".

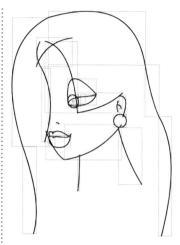

1 For this technique to be a success, you need two different drawings of your character or object. Object Drawing mode is highly recommended here as each stroke will remain as a separate object that can still be edited. It is also critical because you will later distribute each stroke to its own layer.

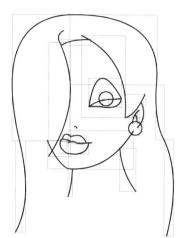

2 Insert a blank keyframe (F7) in a new frame (frame 30 will do), and draw the new angle of your character or object. The trick here is to use the same number of strokes as you did in the first drawing. You could also choose to insert a keyframe (F6) and edit the same strokes to reflect your new angle.

6 Make sure you have the Merge Layers extension installed (see Chapter 12 and the source CD). Make sure all layers and keyframes are selected and go to Commands > Merge Layers. This will run the JSFL command that will compress all keyframes and layers to one single layer for you. The time you just saved will allow you to grab another cup of coffee.

You can delete all the old layers as they will all be empty after the merge. Go to File > Save As and save this file with a new name. This is important because you may decide to make some changes to your image at some point in the future. After all layers are merged, this becomes very difficult.

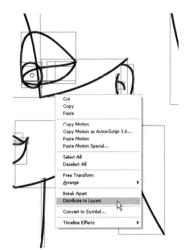

For both drawings, select all of your strokes, right-click over them and select Distribute to Layers from the context menu. Since this will create a whole new set of layers for each drawing, you will need to select all the keyframes for one drawing and drag them to the other drawing's layers.

	* ≜□1	10 15 20 25
D Layer 1		
□ Layer 2		
D Layer 3		
□ Layer 4		Consta Motion Tusses
□ Layer 5		Constru Chassa Tourses
□ Layer 6		Contract Con
D Layer 7	• • •	Insert Frame
D Layer 8		Insert Frame Remove Frames
□ Layer 9		Insert Keyframe
D Layer 10		Insert Blank Keyframe
D Layer 11		Insert Keyframe Insert Blank Keyframe Claw Keyframe Convert to Keyframes Convert to Blank Keyframes Covert to Blank Keyframes Out Frames Copy Frames
D Layer 12		Convert to Keyframes
□ Layer 13		Convert to Blank Keyframes
D Layer 14		Convert to Blank Keymarnes
D Layer 15	• • •	Cut Frames
D Layer 16		Copy Frames
U Layer 17		Paste Frames
D Layer 18		Clear Frames
D Layer 19		Select All Frames
□ Layer 20		Select All Frames Copy Motion Copy Motion as ActionScript 3.0 Paste Motion Date Motion Search
□ Layer 21		Copy Motion
D Layer 22		Copy Motion as ActionScript 3.0
D Layer 23		Paste Motion
D Layer 24		Paste Motion Special
☑ Layer 25		Reverse Frames
☑ Layer 26		Synchronize Symbols
D Layer 27		
□ Layer 28		Actions
□ Layer 29		
☑ Layer 30		
D Layer 31		
☑ Layer 32		
D	0 0.	

4 Drag across all layers, right-click and select Create Shape Tween from the context menu, Previous versions of Flash didn't offer this option in the context menu. If you are using an older version of Flash, apply the shape tween using the Properties panel or drop-down menus. Now is the time to add easing if preferred.

5 Next you need to prepare your layers for merging. Drag across all layers and frames, selecting them all in black. Hit the F6 key to convert all the shape tweens to keyframes. While selected, remove the shape tween using the Tween drop-down menu in the Properties panel. Go to File > Save and save your work at this point.

HOT TIP

Flash doesn't have a built-in "Merge Layers" feature. Not sure why this feature was never considered but with JSFL (JavaScript Flash), we can make our own features. David Wolfe has created a "Merge Layers" extension for Flash that is available on the source CD in this book. Techniques like the "tradigital" topic would take at least five times longer to create without the use of a Merge Layers extension. So make sure you check out how to use this handy extension in Chapter 12 and install it before attempting the technique on these pages.

Next, you need to break apart strokes from the Object Drawing mode. Why? Because if you have overlapping strokes and want to add color fills to your image, it needs to be flattened one step further for editing. Turn on the Edit Multiple Frames feature and adjust the frame indicator brackets to span all keyframes. Break apart (Ctrl + B) to merge all strokes.

9 Use the Selection tool while holding down the Shift key to select all unwanted strokes and delete them. In this situation it is simply a fact of life that, as an animator, eventually you will have to perform the tedious chore of cleaning up after yourself or, even worse, someone else's work.

As tedious as the last step was, here's your reward - a very slick looking animation that looks like it was made using three dimensions. But it gets even better when you add color and shading.

Continued...

Tradigital animation (cont.)

1 1 Once all your strokes are connected and cleaned up, mix your colors and start filling. You will need to apply all color fills across all keyframes by hand. Flash has no automatic way of doing this for you.

12 Occasionally you may find an area of your image will not accept the fill color. Usually the cause for this is a gap between strokes that is hard to see. Make sure Snap is turned on and use the Selection tool to drag their end points until they "snap" together.

13 Let's take this effect to the next level by adding shading. Add two new layers above your animation and draw two shapes in each new layer. Use the color black mixed with about 30% alpha. Make sure the brush has Smoothing set to 100. The fewer vector points the better.

17 Turn on the Edit Multiple
Frames feature and make sure
the Frame Indicator brackets span all
keyframes. Select all (Ctrl + A) and
break apart (Ctrl + B) all Drawing
Model objects to merge all the strokes
together.

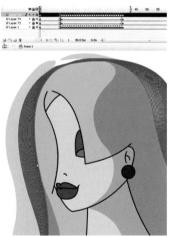

18 Copy all frames of your outline from the previous step and past frames into a new layer above your shading layers. Make sure all other layers are locked, turn on Edit Multiple Frames, select all strokes and change their color to bright red or something in contrast to the character itself.

19 Turn off Edit Multiple Frames, and unlock the two layers containing the shading animations. Select all frames across all three of these layers and go to Commands > Merge Layers to compress them down to one layer. Delete the remaining empty layers.

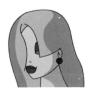

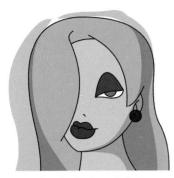

14 Insert a keyframe in both layers in your last frame of your animation. Move the left shape about 20 pixels to the left and the right shape the same distance to the right. Use the Selection tool to bend their outlines to reflect the new contour of your character and apply shape tweens.

Remember the previously saved version of this animation?
Open it and find the layers containing the outline strokes of your character.
Select them and Copy/Paste Frames, into a new document. You will use these strokes to "cut" away the shading you will not need.

16 Select all frames and layers and convert them all to keyframes (F6). While they are still selected, remove the tween from the Tween drop-down menu (Properties) and merge all layers using the Merge Layers JSFL extension (Commands > Merge Layers).

HOT TIP Shape tweening

in Flash is a "Voo-doo" science. Results can often be unexpected depending on the amount of vector points the object(s) is comprised of. The biggest tip is to keep your shapes as simple as possible if you need to tween them. This is why in step 14 I chose to insert a keyframe and work with the same exact shapes from frame 1. I know they will have the same exact number of points and increase the chances of my shape tween being successful. If any of the shapes "implode" during the shape tween, you may have edited them a bit too much.

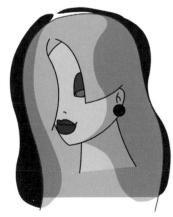

20 Use the Selection tool to click anywhere outside the shapes to deselect them. Select the shaded area outside of your character's outline and delete it. Repeat this procedure for every keyframe.

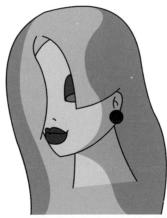

The final step is to double-click the red stroke (double-clicking selects all segments in the stroke), and deleting it. Repeat this for every keyframe until you are left with just the shading shapes inside the contours of the original character.

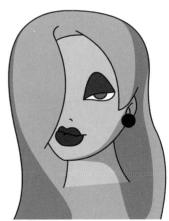

22 Next, test your movie and sit back to enjoy the fruits of your labor. This technique is great when you want to add some realism and drama to your shot. But remember to plan ahead carefully to avoid having to spend more time making revisions.

How did 1 get here?

I SPEAK AT MANY CONFERENCES, schools and user groups throughout the country. It's a very fun thing to be able to do as it allows me to not only share tips and tricks, it also connects me with other designers and animators on a personal level. Don't get me wrong, email, chat and phone are great ways to communicate, but they are no substitute for sharing the same physical space with other developers, designers and animators who all share the same interest.

Being able to travel to conferences in various cities and connect with users from all over the world has given me the ability to tap into the pulse of the culture that surrounds Flash. I hear first hand the thoughts, opinions, gripes and questions users have about this industry. There is always one particular question I am asked by students, teachers and fellow users: "How did you get to where you are now?" Now, I am very well known for dragging out even the shortest of stories and the answer to this question is lengthy to begin with. With limited space on these pages I will give it my best shot to provide you the abridged version.

The road that led me to where I am now was, to say the least, full of twists, turns, roundabouts and in some areas, U-turns the lead to dead ends. It was hardly eight lanes of traffic-free straight aways with clear signs with arrows pointing me away from hazzards and obstacles. But somehow, throughout the journey, I still managed to make all the correct turns, even when I didn't know where each one would eventually take me. I was somehow able to remain on course, towards the direction that led to me to where I am now. Ten years ago if you told me I was going to be a successful freelance animator, I would have laughed. Even the realization of it now makes me chuckle to myself.

I first started using Flash in 1999 and had never seen anything like it. At that time I was a Creative Director for a small animation studio in the Boston area and we turned to Flash as our main animation program. Most of the content we created was for broadcast television and my understanding of how to deliver engaging content for the web was minimal at best. That was all about to change. Shockwave contracted us to create an animated series for their site www.shockwave.com. I was already a fan of Shockwave, which made this project particularly exciting. It became a crash course on how to use

Flash to create animation optimized for the web that also had a fully functional game incorporated into a preloader for dial-up users. As a company we had no experience developing for the web. As an individual, this was a brave new frontier. To make it even more interesting, I had strict deadlines to meet, which all but eliminated the research and development portion of the process. I was smack in the middle of all this unfamiliar technology, directly between the Shockwave producers and my own bosses. All eyes were on me to figure out the artistic and technical issues involved with delivering engaging and interactive content. Funny thing was, I was very new to vector-based animation and my skill level with ActionScript was not too much beyond a gotoAndPlay command. Despite my technical shortcomings, I embraced the challenge. Ask me if I was under-qualified and I would answer "yes", but not without the confidence to deliver the project complete and on time. It just meant I needed to roll up my sleeves a little further.

The series was a success. I managed to fulfill every technical and artistic requirement and delivered it on time. None of which would have been possible for me without the help of the Flash community. I frequented the Macromedia

Flash forums and various online resources such as www.moock.org, www.were-here. com and www.ultrashock.com, where I found an endless community of users willing to provide a helping hand. The most important aspect of this experience wasn't about the amount of learning I achieved, but rather the community and its selflessness to help others. My community involvement became a daily ritual, and over time, I found myself providing more answers than questions. Not only did I advance quickly, I made many

friends and networked myself into a few high-profile freelance gigs. I started to specialize in animation and motion graphics for the web. I was hooked.

It was an exciting time to be a Flash user as the internet was literally bursting with dynamic and engaging content. It was the beginning of the "dotcom" boom and little did I know just how much of an effect it would have on my career.

(...cont.)

A couple of years later, Macromedia announced the creation of the "Team Macromedia" program and soon after a Macromedia employee suggested that I personally submit my application. I wasn't sure exactly why but decided to fill out the application anyway. To my surprise, I was accepted into the TMM program. I was now officially recognized as a member of the Flash community by the company that makes Flash. This was so cool! I was now one of "those" guys. Since the Adobe/Macromedia aquisition, this program continues under the name Adobe Certified Experts, which I guess makes me not only a "team" member but also an "expert" too. But as far as I'm concerned, I am just a user of Adobe's products, still working in the trenches just like everybody else, exactly where I want to be.

My community affiliation has provided many opportunities to be a featured speaker at various conferences and user groups. These experiences have given me an up close and personal way to network with peers from around the world, not to mention how much fun it is to be amongst hundreds and sometimes thousands of users who share the same excitement and passion as I do.

Aside from populating the online Flash forum with technical answers, I found myself delivering live Flash technical presentations via Adobe Connect

and what is commonly referred to as "Tech Wednesdays". One such presentation has been overwhelmingly popular, (http://adobe. breezecentral.com/p46515568/) This was my very first recorded Breeze presentation and it has been one of the most popular resources for Flash character design and animation on the web. The surprising aspect of this presentation was that I was merely filling for the original presenter who had to cancel last minute. With no time to prepare

anything, I simply demonstrated what I do on a daily basis for clients and sometimes for self-amusement. It was just another day at work for me, but this time I had the world looking over my shoulder. Luckily it was a topic that many users were very interested in. Due to its popularity I was asked to host more online presentations, all of which were recorded and featured on Adobe's website. This is one of my most rewarding community experiences due to the number of users who continue to benefit from these recordings.

Ask me how I ended up here and I will tell you it was the result of hard work, a little luck and the generosity of the Flash community. Ask me why I volunteer so much of my time helping others, and I will tell you, because I remember how precious the help was from others when I needed it most. I am proud of my accomplishments as a Flash user and when there's an opportunity to pass along this knowledge to others, then we can all benefit. It's what makes the community vibrant and alive for the benefit of all who wish to get involved. Flash is just a tool, but it is the community that surrounds this tool that transforms it into a culture.

http://my.adobe.acrobat.com/p46515568/ http://www.adobe.com/devnet/flash/articles/design_character.html http://www.adobe.com/devnet/flash/articles/adv_char_anima.html http://www.adobe.com/devnet/flash/articles/tween_macrochat.html

One day your client may request that their online content be repurposed for video. They may look to you for answers as to how possible this process is. Rest assured, Flash to video is widely produced for a variety of broadcast content. The line between online and offline Flash content is officially blurred.

Flash to video

FLASH IS EVERYWHERE. Not only is Flash developed for online and offline movies, websites, games and applications, but also for DVD and broadcast television. In fact, my first years as a Flash user were spent authoring Flash content for several broadcast animated series. Exporting from Flash to video formats (QuickTime and AVI) to be imported and edited in an Avid workstation was my only authoring requirement of Flash. I had no knowledge of Flash for the web, including ActionScript, optimizing, preloaders and even buttons of any kind. It was analog Flash at its purest and that was the Flash world I lived in.

Flash to video

Document setup

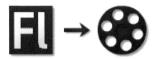

OME OF THE MOST POPULAR Flash to video questions I am asked are: What Flash content can be and cannot be exported to video?

Why do some animations play in video format while others do not?

What frame rate do Luse?

What is NTSC?

What is PAL?

What is the resolution for a 16:9 screen?

What is the correct stage size?

Should I be concerned about color correction?

What video format should I export to?

Do you export the audio from Flash?

Are you getting enough sleep?

(OK, that last one was from my mother, but you get the idea.)

This entire chapter is devoted to the topic

of getting your Flash project to video format. Sounds simple enough but there's a lot to know, so let's boogie.

Let's start with the basics and open a new Flash document. Open the Document Properties panel using # otr/ or click the "Size" button in the Properties panel. Here you can determine the width and height of the movie and its frame rate. But before we change anything we need to decide what aspect ratio we are authoring to.

NTSC doesn't use square pixels; they are rectangular. A problem arises when you develop content for video on your computer because you are creating square pixels to be displayed as rectangular pixels. That means your video will look slightly stretched. To compensate for this, adjust the width of the movie so that the aspect ratio is 720 x 540.

PAL (Phase Alternating Line), the predominant video standard outside the Americas, also uses the 4:3 aspect ratio but uses a 720 x 576 pixel aspect ratio. The frame rate is 25 fps. PAL has a greater resolution than NTSC and therefore has a better picture quality. Its higher color gamut level produces higher contrast levels as well. But the lower frame rate, compared to NTSC's frame rate, will not be as smooth.

Standard Television 4:3 NTSC (National Television Standards Commission), the

video standard used in North America and most of

South America, uses a 4:3 aspect ratio, which essentially

means the width and height of a standard television set.

To break it down in even simpler terms, 4:3 means that for

Widescreen Television 16:9

every four units wide, the picture is three units high. Apply this formula to a 16:9 screen and you'll get 16 units of width for every nine units of height. Simple arithmetic so far but it's about to get tricky.

HOT TIP

Using a videobased aspect ratio for the web is always a good idea. You never know when the client might ask you to convert the web-based Flash movie into video format to be burned onto DVD to be shown at their next big company summit meeting.

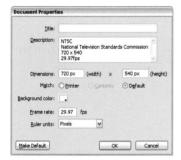

NTSC uses a frame rate of 29.97 fps. You can export Flash movies that have different frame rates such as 12, 15, or 24 fps and convert them to 30 with video editing software, although a movie converted from 12 to 30 fps will not look as smooth as a movie originally authored at 30 fps.

You can save your NTSC Flash document as a Template if you plan to create multiple files (File > Save as Template...). You can also create your own template categories by creating new folders in the "Templates" folder on your local hard drive where Flash CS3 is installed.

	уре:	Animation			
			Data Rate		
24 🗸	fps		Data Rate:		
Current				Restrict to	kbits/sec
8 10 12 15 24	24	frames	Optimized for:	Download	
29.97		•	Preview		
	Current 8 10 12 15 24 25 29.97 30 30 \$59.94	Current (8 24 10 12 15 24 25 29.97 30 30 35 59.94	Current	x 24 v fps	x 24

Film uses 24 fps, which is also a popular frame rate among animators. Although you can use 24 fps in your Flash project, when you export it to video, you will need to convert the frame rate as well. This is easily done during the export process by specifying the appropriate frame

rate for the video format to which you are authoring (PAL or NTSC). Keep in mind that this does not speed up your animation, rather it simply will not appear as smooth. Since film and PAL have nearly the same frame rate (24 and 25 respectively), there will be hardly any visual difference.

Flash to video

Title and action safety

ELEVISIONS DO NOT generally display the entire width and height of your movie. In almost all cases, televisons will show a smaller portion of the true display size. Using a visual guide that represents the potential stage area in danger of being cropped will help guarantee that what you create in Flash shows up in its entirety on a variety of television sets.

There's nothing worse than finding out too late that the title sequence you labored over for ten hours appears on most televisions with several characters cropped, or is even completely invisible. To prevent this, you need to define which area is considered the safe zone within the dimensions of your movie. There are two safe zones to consider: the actionsafe zone and the title-safe zone.

2 The title-safe zone is smaller than the action-safe zone because it is much more important to ensure that all titles are clearly legible without any chance of a single letter being cropped. For this reason, the title-safe zone lies 20% in from the absolute edge of the video. When you add titles to your movie, make sure they are positioned entirely within this safer title-safe zone to avoid being cropped.

The action-safe zone lies 10% in from the absolute edge of the video. You can assume that everything falling within this zone will appear on a television screen. Anything outside this zone can be potentially cropped and not visible. Compose your scenes based on the area within the action safety zone, assuming this will be the only area not cropped by the majority of televisions.

Place the title-safe zone in your Flash project on its own layer above all other content. When you are ready to export to video, delete this layer to prevent it from being included in the video file. If you don't want to delete it from your document, just convert the layer to a guide layer. Guide layers will not be included in your final export.

View > Pasteboard 5 will allow you to see the work area beyond the stage dimensions. This is useful for working with graphics that extend beyond the width and height of the stage. Having the title safety visible will indicate where the stage is in relation to your artwork. This is particularly useful for simulating camera moves such as panning and zooming.

HOT TIP

Flash CS3 introduces the "Export Hidden Layers" option. Go to File > **Publish Settings** > Flash tab to locate this feature. When this feature is turned off, all layers with visibility turned off will not be exported. The advantage here is not having to delete the layer from your timeline. You just need to remember to turn off its visibility before exporting.

Flash to video

Safe colors

N PREVIOUS VERSIONS of Flash, support for video export was lacking in several areas. Dynamic content such as ActionScript, button symbols and movie clips could not be exported to a fixed-frame video format. These types of Flash objects could only be supported in the Flash player during runtime. Any animations nested inside a movie clip would not render beyond their first frame and any ActionScript in the movie would cause the export to video to fail and generate errors. Dynamic content and rendered video have always been two different animals never meant to play well together.

Welcome the new Flash
CS3 QuickTime Exporter. You
now have the ability to export
dynamically created Flash content
including effects generated with
ActionScript.

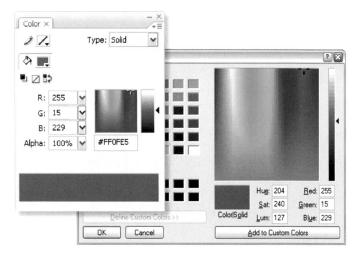

Your computer monitor is designed to display the full range of RGB color values (0-255). Television can only display a limited range of color values. There's a good chance you may be using colors in your Flash movie that fall outside the television value range, resulting in very noticeable color bleeding.

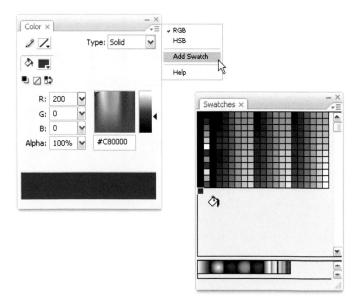

3 To add your new color as a swatch, use the drop-down menu in the upper right corner of the Color Mixer panel. An alternative method for adding colors to your Swatch panel is to hover over the empty area below the existing swatches. Your cursor will automatically become a paint bucket and when you click anywhere in this area, the current color will be added.

HOT TIP

Remember, Flash is resolutionfree; as long as vou are working in the correct aspect ratio, you can always resize when exporting without a loss in quality. If you have imported bitmaps in your Flash movie, you will want to use a width and height that is 100% of your final output to avoid having them scaled in Flash.

2 You will need to limit this range to between 16 and 235. The RGB color value of the darkest color (black) is 0-0-0. For television this must be limited to 16-16-16. This should be your new black color for any project exported to video. The RGB value of the lightest color (white) is 255-255-255. This must be limited to 235-235-235 for export to

video format. Since this will be the brightest color in your palctte, it will appear to be stark white in comparison to all other colors. The color red has a tendency to bleed more than any other color so it may be a good idea to compensate more than you need to by lowering the value to around 200–0–0.

NTSC.clr

4 Sometimes the default color palette is not needed and simply gets in the way of your workflow. This is a good time to remove or replace the current swatches. You can start all over by mixing and adding new colors one at a time or by importing an existing color set, color table or even a

GIF file. From the drop-down menu choose Replace Colors and navigate to the *.clr, *.act or *.gif file containing the colors you want to use. Here I have imported an NTSC safety color palette provided by Warren Fuller (www.animonger. com). This palette is included on the source CD (NTSC.clr).

Flash to video

Keeping it all in sync

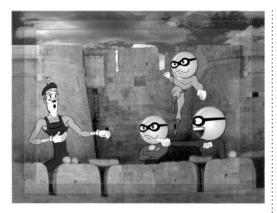

If your timeline contains Movie Clips, you must convert them to Graphic behavior. To convert a Movie Clip to a Graphic symbol, select the movie clip instance on the Stage and change its behavior from Movie Clip to Graphic using the Properties panel. Then change its property from Single Frame to Loop or Play Once depending on your needs.

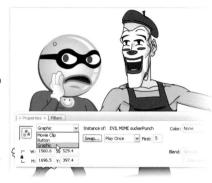

ITH THE RELEASE of Flash CS3, we now have two approaches to authoring Flash for video output. The old school method requires everything to be on the main timeline. Movie Clip symbols have to be avoided altogether since their timelines are independent of the main timeline and only render during runtime in the Flash Player.

Flash 8 introduced filters and the ability to add drop shadows, blurs and other cool effects to Movie Clip symbols. But due to the dynamic nature of Movie Clips, they had to be avoided as well. Flash CS3 has remedied this issue with its new Quicktime Exporter, which we'll take a look at later in this chapter.

For now, let's take a look at the old school method of creating Flash animation for export to video. This is analog Flash in its purest form, straight-ahead timeline animation, streaming sound and nested graphic symbols.

3 One of the disadvantages of using scenes is confusion during the editing process as it can be difficult to find assets within multiple scenes. Another disadvantage with multiple scenes is having more content in your FLA, which can result in a very large file size. This increases the chances of corruption and loss of work. It's usually better to work with several smaller files, then edit the individual exported video files together in your video editor.

Layer folders are a great way to organize your timeline, especially if your animation involves a great number of layers, which is often the case with animation. Layer folders combined with nesting animations can go a long way in making efficient timelines. You can place all your character animations inside a Graphic symbol. This makes it much easier to edit and control your entire scene from the main timeline if you need to position, scale, pan, zoom as if playing the role of a Director. Since the nested animations are inside Graphic symbols, you can still scrub the timeline with the playhead to see the animations play.

2 Scenes are a great way to manage long timelines. For example, you could have your title sequence in Scene 1, your story in Scene 2 and ending credits in Scene 3. Using scenes is similar to multiple files chained together since each scene has its own timeline. The timeline of each scene combines into a single timeline in the exported file. The advantage here is having the entire project in one FLA.

HOT TIP

To keep the file size of your FLA(s) as small as possible, it is sometimes good practice to avoid inporting high quality steren sound files. If you are planning on editing several exported video files together in your video editing program, then import a compressed MP3 audio file into Flash to use as a "scratch track". Place the sound file(s) on its own layer so that it can be easily deleted before export. In Flash CS3, you can simply turn off the visibilty of this laver to exclude it from export. Use the high quality stereo sound file in your video editing program instead.

The Flash timeline has its own limitations. 16,000 is the number that represents the maximum amount of layers in a single Flash movie as well as the maximum amount of symbol instances and number of frames. It is rare to see this number reached in any situation, but it is good to understand the limitations in order to avoid them. A Flash document that is 16,000 frames long at 30 fps is nearly nine minutes long. A file that large will cause problems even in the best situations. The file will take longer to open as well as to save. It will exhaust

your system's resources and make it harder to work with multiple Flash documents open at the same time. It will also take a very long time to export to video and will create an enormous file. If you export to AVI, you will very likely exceed the 2 GB limit that is placed on AVI files on most operating systems. Best practice is to break up your project into several smaller FLA files, typically between 30 and 60 seconds each. I often work with FLA files less than 20 seconds in length. It makes the entire process more manageable when animating, exporting and editing.

6 You can quickly expand all layer folders by right-clicking over any one of your folders and selecting "Expand All Folders" from the context menu. Collapsing all folders is done the same way.

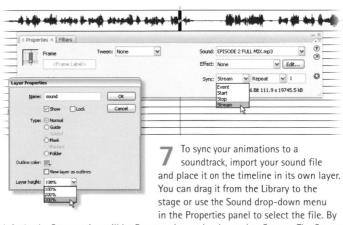

default, the Sync setting will be Event and must be changed to Stream. The Stream behavior embeds the sound into the timeline and will be in sync with any timeline animation. You can adjust the height of a layer by right-clicking over the layer name and selecting Properties. In the layer Properties panel you can set the layer height to as much as 300%. This can be useful if you want to see the waveform in as much detail as possible.

Flash to video

QuickTime Exporter

XPORTING FLASH MOVIES to video format used to require that all animation be on the main timeline. Dynamic content such as ActionScript, button symbols and movie clips could not be exported to a fixed-frame video format. This included movie clip animations, filters, ActionScript and just about anything dynamically loaded into your SWF file.

Welcome the new Flash CS3 QuickTime Exporter. You now have the ability to export dynamically created Flash content including effects generated with ActionScript as well as effects created with movie clips and filters.

Proceed with caution when using the new Flash CS3 QuickTime exporter. If the dimensions

of your document are particularly large (for example, 720 x 540 pixels), it may be necessary to change the frame rate of the Flash movie to avoid dropping frames during the export process. Why does this happen? The QuickTime Exporter, during the export process, is actually capturing the playback of your movie as an SWF movie in the background. Various aspects of your animation can cause frames to be dropped and the exported QuickTime file to not be frame-specific as intended in the Flash timeline. A large stage size, a high frame rate, multiple filters and animated effects can all contribute to frames being dropped during the export process.

You have more than one option when you export your video, and there are slight differences depending on whether you are authoring in Mac OS or Windows, Basically it comes down to three different options: AVI (Audio Video Interleave), Apple QuickTime, or an image sequence. Formerly your choice of platform dictated your format. Macintosh users exported to QuickTime and Windows users exported to AVI. Now both formats are compatible across platforms.

When you export from Flash to QuickTime, you will have several options to choose from. Typically it is good practice to keep your movie as uncompressed as possible and at the highest color bit available. You can change the width and height of your movie based on a maintained aspect ratio, or you can choose to change the aspect ratio by deselecting this option. Select "Ignore stage color" to add a transparent alpha track to your video. You must select a video Compression Type that supports 32-bit encoding with an alpha channel such as Animation, PNG, Planar RGB, JPEG 2000, TIFF, or TGA. You must also select Millions of Color+ from the Compressor/Depth setting.

The Movie Settings panel allows you to adjust the video and sound settings. If you are exporting sound, you can set the amount of compression, sample rate, sample size and number of channels.

You can also prepare your movie for the internet if it is intended for online viewing. Select "Fast Start" to allow the movie to start playing from a web server before the movie has completely downloaded.

If you plan on importing your Flash animation to After Effects or Premiere, export as a PNG sequence. After Effects CS3 also supports SWF format as well. So you can simply publish your Flash movie to SWF and import that into After Effects.

4 If you choose to click "Settings", the Standard Video Compression Settings will open, allowing you to refine how your movie will be exported. This is where you can select the compression type, frame rate, click the QuickTime Settings button to select the type of compression desired. Typically no compression is best but I have had great results using the Animation codec. In this panel you can also adjust the color depth, change the frame rate (useful if your Flash movie isn't using a standard frame rate for video), as well as set the amount of keyframing and, once again, the size.

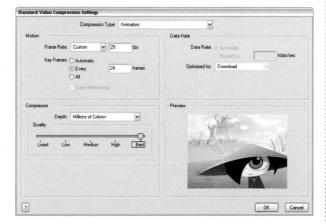

HOT TIP

When you export from Flash to AVI or QuickTime, you will have a few options from which to choose. Typically it is good practice to keep your movie as uncompressed as possible and at the highest color bit available. Best practice has always been to export your Flash movie as a PNG image sequence. This maintains control of each frame when editing in Premeire or After Effects. With the new After Effects CS3, you can now import SWFs as well.

6 Flash to video SWF2Video

HE FLASH QUICKTIME EXPORTER allows you to export dynamic content to the QuickTime video format. But dynamic content that pushes the limits of the Flash player may have undiserable results upon export. The process of the QuickTime Exporter is to capture each frame of your movie as it plays in the Flash player. This all happens behind the scenes during the export process. If the frame rate is relatively high and your movie contains animated movie clips with filters applied to them, the results may be dropped frames or a slow frame rate after exporting. The width and height of your movie may be a factor in how well the exporter performs. A larger stage translates to more data that has to be captured on the fly, with results dependent on the amount of RAM and your processor speed. A large stage, high frame rate, long timeline and multiple animations with some filter effects will most likely choke the Flash

QuickTime Exporter.

You do have an alternative solution, however. Welcome SWF2Video, a powerful utility that uniquely supports the conversion

of Flash SWF format to AVI. This conversion supports movie clips, ActionScript, user interactions and audio. SWF2Video can output an alpha channel to be used for compositing effects in video post-production. There is also an SWF2Video Plug-in for Adobe Premiere Pro to enable the import of SWF files directly into Premiere projects for editing.

SWF2Video can be found at www.flashants. com and is a valuable tool to have if your project contains dynamic content and requires output to video.

The SWF2Video IDE is amazingly simple. Upon launch there's little more than a window with the familiar File, Control, Options and Help menus. Select File > Open and navigate to your SWF. Open the File menu again and select Create AVI or Create Image Sequence. SWF2Video even supports batch processing of files. Using SWF2Video is super simple. Go to File > Open and locate the published SWF file on your hard drive. The first frame of your SWF movie will be displayed in the SWF2Video interface.

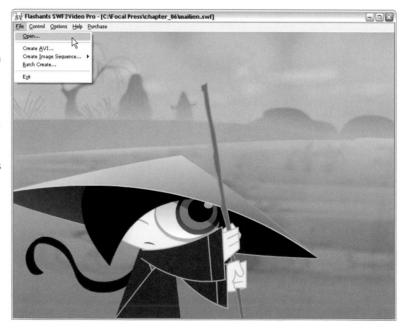

2 When you select Create AVI, the AVI Export Setting dialog box opens, allowing you to refine your movie considerably further.

The Sequence settings are as follows:

Skip "goto backward frame" in main timeline: If the Flash movie contains a loop in the main timeline by using the gotoAndPlay(0); command, select this option to break the loop by ignoring the ActionScript code.

Frame by frame in main timeline: Convert the main timeline animation into a keyframe sequence.

Normal: Convert with the movie's normal playback sequence, including movie clips and ActionScript events. For the Duration setting, specify the start and end points during export by entering the exact frame numbers.

Color depth: Select 24 bits RGB or 32 bits RGB with Alpha format. The 24-bit color setting represents eight bits for every RGB color value. The 32-bit color setting is the same as 24 bits with the addition of eight more bits representing the transparency of the color value.

Record from current SWF file: Record audio from the current SWF file and then merge it with the video.

Recording volume: Adjust the volume level of the waveform recording device.

From WAVE file: Use an external WAVE file to create your audio by clicking Browse to choose the WAVE file. The audio data of this WAVE file is merged with the video data; the audio in the original SWF file is ignored.

Clicking Select in the Video section opens the Video Compression dialog box. Here you can choose the appropriate compressor to apply to your video. Leave this set to Full Frames (Uncompressed) because this is always best when working with high-quality video.

4 The Seek Controller helps to browse into Flash movie's frames easily by dragging the slider bar or entering the frame number in the Current Frame field. It is a very handy tool to help you quickly and easily locate the frame number range in the Flash movie to convert.

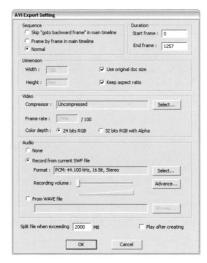

HOT TIP

Once you export your Flash project to your preferred video format, you can import it into a video editing program such as Premiere or Final Cut Pro, or a compositing and motion graphics program like Adobe After Effects, for further editing, special effects, and color correction.

Graphics tablets

THERE ARE SOME THINGS I JUST CAN'T WORK WITHOUT, and one of them is my Wacom tablets. They are indespensible when it comes to my workflow and actually save valuable production time on a daily basis.

My first experience with a graphics tablet of any kind was during my employment at a small production company creating animated television shows. Early on we had very small budgets and therefore relatively cheap equipment to work with. We used Summasketch graphics tablets (Summagraphics) and even though they got the job done, they were pretty clumsy to work with. The main reason was the lack of wireless technology - the stylus was not cordless. It constantly got in the way of my arm as I moved across the tablet's surface and would get pretty twisted and tangled. If you weren't careful you could easily get the cord on the wrong side of a full cup of coffee and with one artistic stroke of the stylus, end up with a huge mess. The learning curve was not so bad, however. It took me about three full

The learning curve was not so bad, days to get used to not looking a slightly uncomfortable surface where your

where I was actually drawing. There's feeling of not looking at the actual pen meets the paper. Once I got used to looking at the computer display and not my own drawing hand, the next learning hurdle was the relationship of the tablet angle and the display angle. If my tablet was rotated as little as an inch or less, any vertical or horizontal lines became exponentially difficult to draw. Alignment between the

tablet and monitor became important and soon I had a specific setup that worked for me, which

was having the tablet to the right side of the computer and at a slight angle towards me. Some of the other animators had their tablet directly in front of them, center to their body. Of course left-handed people had their tablets to the left of the computer or centered. There was one particular illustrator who, being

left-handed, used his tablet with his left hand and trained his right hand to use the mouse. Truly an ambidextrous advantage.

Eventually, as the company became more successful, the budgets grew. Better equipment was being purchased and soon we graduated to Wacom tablets. My appreciation for the quality of Wacom tablets is directly related to having used tablets of lesser quality. The look and feel of the Wacom tablet was truly awesome. Not only is the stylus cordless, it requires no battery either. The tablet surface is super smooth and a joy to work on. Some people find it to be too smooth and one nice trick is to tape a regular piece of copy paper to the tablet. The stylus will work fine and the extra friction lends to a more realistic drawing feel.

I have used tablets in various sizes: 4x6, 6x8, 9x12 and 12x12. My personal preference is the 6x8 and the 9x12 sizes. As Goldilocks found out while visiting the home of the three bears, these sizes are "just right". I don't have to physically move my hand and arm as much as I do with the 12x12 version and the 4x6 is simply too small for any serious graphics work. My 17" laptop display is in perfect harmony with the 6x8" tablet and they both fit perfectly in my laptop bag.

Then there's the ultimate in graphics tablet technology and what I consider the best piece of hardware around, the Wacom Cintiq. I do not own one (yet) but have used one briefly. I can honestly say I fell in love with it within the

first 5 seconds. With the Cintiq you work directly on the screen.

This allows you to take advantage of your natural hand-eye coordination since you are actually looking where you are working. There is little or no learning curve because of this natural "pen-on-paper" work approach. The Cintiq works with any Graphics application and is especially useful with Flash. It feels as close to natural as any paperless production process could.

■ Surprisingly, the most impressive of Flash effects are often the simplest to create. The above characters are animated running in place as a looped sequence. It looks cool as it is but if you copy and paste an instance of it, flip it vertically and lower its opacity, you can achieve the sense that the surface they are running on is reflective and maybe even a bit slippery.

I HAVE SPENT MY FAIR SHARE of time on various Flash online forums, reading, learning and providing my own perspective when needed. As a result, I have seen what animation techniques and examples Flash users are always requesting. I will often create a sample FLA and make it avalible for everyone to download and dissect for themselves. It's very difficult to teach design and animation in text format and, often, a simple FLA can make all the difference.

This chapter contains some of the most popular "How do I..." animation requests from Flash users as far back as Flash version 4. If this chapter teaches you one thing, I hope that it teaches you how to think differently about how you approach Flash as a tool.

Super text effect

O OFTEN THE SIMPLEST OF ANIMATION TECHNIQUES is the most effective visually. Take this simple website introduction for Superbusy Records as an example of simplicity at its finest and how to get the most bang for your buck with the basics of Flash animation. The text animation is comprised of basic motion tweens and scaling, and the bee animation takes advantage of some old school blurring with a linear gradient. Timing is everything and the fast-paced editing of this animation makes it look more complicated than it truly is.

Start off with a text field set to Static and type in your text. Nothing fancy here, just some basic text to get you started.

4 Select all layers on a frame somewhere down the timeline (frame 30 will do) and insert a keyframe for every layer by hitting the F6 key. Go back to frame 1 and select your first letter. Use the Scale and Rotate (Ctrl + Alt + S) to scale it to 400% or greater.

The bee graphic is introduced using a simple linear gradient first, then the bee "pops" into position. This technique is identical to the "Flying text" topic in Chapter 4.

2 Break apart the text field once using *B *B * ettl* B * and each letter will be broken apart but still editable. Break apart twice to convert your text to raw vector shapes. Your text will no longer be editable once broken down this far. You can choose to break aprt only once if you think you might want to edit the text at a later time.

3 Select each letter individually and convert each to a Graphic symbol. Once all letters are converted, select them all, right-click over them and select Distribute to Layers from the context menu.

HOT TIP

You may want to break apart vour text into raw vector shapes if you plan on shoring this FLA with someone else on a different computer. If the font you use is not installed on the other machine, then Flash will substitute that font for the default font or a font of your choice. If this project is for a client and they request the FLA, you should make sure they have the same font you are using or break apart the text into shapes.

5 Apply a motion tween to animate this letter scale from 400% to 100%. Select the keyframe in frame 30 and move it to around frame 5. Play back to test the speed based on your frame rate. Adjust the tempo as necessary by adding or removing frames in the motion tween.

The bee is a Movie Clip containing a very simple, twoframed animation of the wings. The original wing is replaced with a radial to provide the illusion that it is blurred because it is moving faster than our eye can see.

6 Repeat this procedure for each letter. Then stagger each letter's animation by sliding the motion tween down the timeline so each letter animates into place one after the other. Your timeline tweens should resemble a staircase.

9 The blur animation is comprised of only two frames with the radial gradient slightly rotated between them. The looping of these two frames at 30 frames per second is enough to convince us that they are oscillating at a very high speed. Adding the appropriate sound effect makes it even more convincing.

Page turn

AGES THAT CURL up and away to reveal more pages are always an appealing effect for introducing content on your website or as buttons to other web pages. There are variations created entirely with ActionScript, but my AS skills are not anywhere near the level required to generate this effect dynamically. But that doesn't mean you can't add some interactivity by placing this animation in a movie clip and controlling its playback when the mouse rolls over it. I leave that part up to you (see Chapter 10 for a detailed explanation about adding interactivity to your Flash project).

Start with a simple rectangle with a linear gradient fill or your own color fill preference. Convert it to a Movie Clip symbol and apply a drop shadow filter to add a little depth.

2 Duplicate the cover symbol, and place it on a new layer above the original. Edit the graphic inside by filling it with a different color. Add some text or an image of your choice.

6 Insert a new layer and create a triangular shape that resembles a page curl similar to the example above. The easiest way to make this shape is to start with a rectangle. Turn on the Snap tool and drag one corner until it snaps to another corner. Now that you made a triangle, move the remaining three corners into the positions as seen

in the above example.

Mix a linear gradient using three colors. The first and last color swatches should be the brightest and similar in value. The middle swatch should be the same color but darker in value. Fill the curl shape and use the Gradient Transform tool to rotate and position the gradient so its bottom edge shows a slight amount of the lightest value.

Insert a new layer again above your existing layers. Convert it to a mask layer and draw a shape that spans the lower right corner. Insert a keyframe in frame 30 so that a duplicate of this shape is created.

4 Select the shape in frame 1.
With the Free Transform tool ②.
position the center point at the bottom corner. Hold down all and scale the shape until it is very small.

5 Holding down will will constrain the shape based on its center point. Apply a shape tween so the shape grows from small to large. This animation will reveal the content page.

1 1 24.0 fps 0.0s €

Convert the shape from step 7 to a Graphic symbol and double-click it and add a new layer inside this new symbol. Create another shape in this new layer using the rectangle tool for the shadow created by the page curl. This shadow will be cast onto the page below, so draw the shape to span only the area necessary inside the content

page.

9 Fill this shape with a linear gradient consisting of two colors. Mix about 50% alpha into the first color and 0% alpha into the second color. Use the Gradient Transform tool to rotate the shadow so that it fades away from the curl. Convert both shapes to a Graphic symbol.

Animate the curl just as you animated the mask in steps 4 and 5. Insert a second keyframe in frame thirty and select the curl graphic in frame 1. With the Free Transform tool, move the center point to the lower corner, hold down and scale it until it is the same size as the mask shape in this frame. Apply a motion tween.

Smoke with gradients

HERE ARE SEVERAL WAYS TO ANIMATE SMOKE and each technique is based on the style of the smoke itself. Do you need your smoke to be a cartoon style smoke cloud? Maybe you want a more realistic billowing of soft puffy clouds? How about a very stylized smoke effect with curling hard-edged shapes simulating the basic movement of smoke? There are many different ways to achieve the same results in Flash - whether it's with ActionScript or animation. Flash has always been a blank canvas for us to express ourselves. Let's take a look at a few ways to approach the dynamics of the elusive smoke cloud.

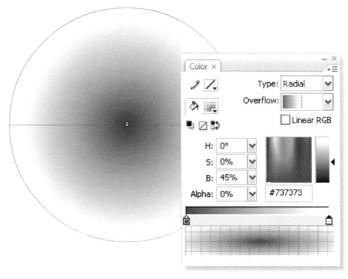

Create a radial gradient with a dark gray center and the outer color mixed with 0% alpha. Create a circle with the Oval tool with this gradient as your fill color (no stroke). Convert this shape to a Graphic symbol.

4 Select the entire motion tween, copy all frames and keyframes, insert a new layer and paste all frames into it. Select the graphic in the first frame and move it a few pixels in any direction. Do the same for the Graphic symbol in the last keyframe. Select the entire motion tween and drag it down the timeline a few frames. Repeat this procedure until you have several layers of slightly different animations of your gradient starting small and rising while fading out completely.

2 Select the Graphic symbol and convert it to a Movie Clip symbol. Double-click this Movie Clip to enter edit mode. This is where the animation will take place.

3 Insert a second keyframe several frames down the timeline. Scale the Graphic symbol to about 200% and move it up about 75 pixels. Apply a motion tween.

5 On the main timeline, copy and paste the Movie Clip containing your "smoke" animations to a new layer. Drag the keyframe to a frame later in the timeline; frame 25 will work fine. Select the instance and flip it horizontally to help change its apearance from the original.

6 Since the animation is inside a Movie Clip, it is best to stop the timeline once the second instance is introduced on the timeline by adding a stop action. The Movie Clip instances will continue to play and loop. Since they start on different frames, they will overlap to produce a constant flow of smoke.

HOT TIP

The Blur filter, when used excessively, can cause potential performance issues during playback. Test your animation frequently to avoid causing a processor intensive animation. Remember, the Flash player is not like prerendered video format. Flash renders on the fly in the Flash player, so too high a frame rate combined with complex animations can demand too much from the player. Optimize your shapes whenever possible and use a realistic frame rate.

Animation examples Smoke stylized

TYLE WILL ALMOST ALWAYS DICTATE the animation technique. Often the client will request a specific artistic style based on a pre-existing logo or company identity. The challenge here is to be consistent, not only with the artwork but also with the animation style as well. A realistic smoke animation would look nice but not match the client's style preference. It's time to be inventive and to create a smoke animation that is stylized, yet simple and effective. Oh, and the client needs it yesterday.

The easiest way to start is with the final shape you will want as your stylized smoke shape. This shape can be drawn with any of Flash's drawing tools. I recommend no outlines stroke.

2 Insert a keyframe (F6) in frame 2 and, with the Lasso tool, select a small section at the top end of the smoke shape and delete it.

6 Copy and paste all frames into a Graphic symbol so it can be reused later. Create a second keyframe down the timeline and, with the Free Transform tool, skew it and move it up about 30 pixels.

7 Create a third keyframe further down the timeline and adjust the alpha to 0% so it fades out. Apply another motion tween and maybe a little more skewing.

Repeat the process of inserting a keyframe and selecting a small section of your shape and deleting it. Use your keyboard shortcuts to make this task faster and easier.

4 Toggle between F6 and the Delete key while selecting sections of your shape until it has been completely removed from your stage.

5 Select the entire range of keyframes and then right-click over them to bring up the context menu. Select Reverse Frames. This will reveal your shape when you play back your animation.

HOT TIP

As you work through this example, you may realize at some point that you are creating a pretty sophisticated frame-by-frame animation sequence that looks like it was made by the nad of a very experienced animator. That's our little secret. You may choose to use the Eraser tool instead of the Lasso tool and avoid having to use the Delete key entirely. If you have a pressuresensitive tablet and a stylus with an eraser on one end. you may have the fastest way to pull off this technique.

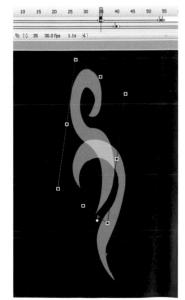

Add another layer and drag an instance of the same symbol (containing your animated shape) to the stage. Flip it horizontally and repeat steps 6 and 7.

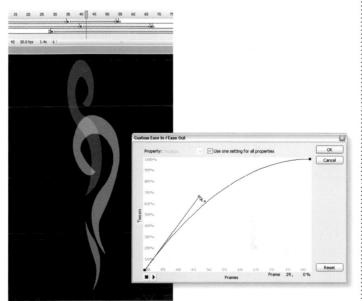

9 Add a third layer and repeat steps 6 and 7 again. Play back your animation frequently and adjust the amount of skewing, tweening and the overall timing as necessary.

10 You may want to apply a bit of easing out to the symbols as they fade away. Although it may not be necessary, it might just add that final touch to your overall effect.

Full steam ahead

to create realistic smoke or, in this example, steam. Since the image we are working with is an actual photograph, the animation needs to be just as convincing. Without the presence of steam, this cup of tea looks cold and somewhat unappealing. Not only can you use filters to blur objects in Flash, you can also animate these filters.

1 Start off by drawing some simple shapes with the Brush tool. They should be random and abstract.

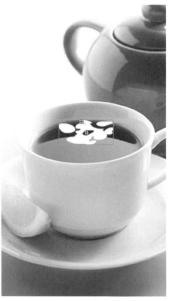

2 Select this shape (or shapes) and convert it to a Movie Clip symbol. With this symbol still selected, convert it to a Movie Clip once again so you end up with two Movie Clips, one nested inside the other.

6 Select the Movie Clip instance in the second keyframe and apply another Blur filter. Increase the amount of blurring so it is slightly more than the blurring in the first keyframe.

Select the Movie Clip instance in the third keyframe and apply another Blur filter. Increase the amount of blurring even more than you applied in the second keyframe.

3 Double-click the Movie Clip symbol on the main timeline to edit it. Insert a second keyframe a few frames down the timeline and scale the original Movie Clip symbol as shown above.

4 Insert a third keyframc down the timeline and scale the Movie Clip even wider and position it a little higher.

5 Go back to the first keyframe and apply a Blur filter using the Filters panel (Window > Properties > Filters).

HOT TIP

Filters can only be applied to Movie Clip symbols and you must publish Flash Player version 8 or 9. Animated effects involving filters can be very processor intensive. Use them sparingly and test often to make sure playback performance remains acceptable.

Apply motion tweens to all keyframes. Play back your animation and make adjustments as necessary. You may want to adjust the amount of blurring, alpha or transforming to your animation. You can also create a second steam animation by creating a new layer and drawing more shapes,

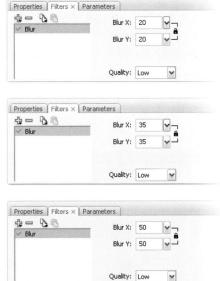

convert them to a Movie Clip symbol and repeat steps 1-7. Then select and drag the entire range of keyframes and frames down the timeline so they start after the original animation. This will help eliminate the repitition of one single looping steam effect.

Fireworks

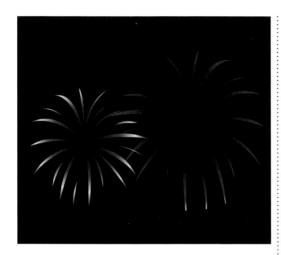

VERYBODY LOVES FIREWORKS. There's nothing like a warm summer night under the stars watching the skies light up with the brilliance of pyrotechnics. You can make every day the fourth of July by animating your own fireworks display, and there's no danger of getting hurt either. With some simple gradients, a little masking and some tweens, you'll be hearing "Oohs!" and "Ahhhs!" in no time.

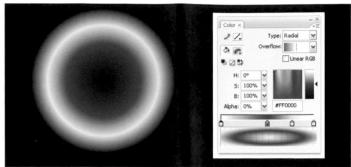

Start with a radial gradient with at least four colors. The middle and outer colors should be mixed with 0% alpha. The second and third colors are based on your own fireworks color scheme. Convert the gradient to a Graphic symbol.

Insert keyframes for both layers somewhere down your timeline and scale them both up about 300%. The gradient should be at least as big as the mask.

6 Insert two more keyframes much farther down the timeline and scale both the mask and gradient about 125% more. Fade out the gradient to 0% alpha.

 $10\,$ Since this stroke and its shape tweened animation simulate the ascending explosive, you will need to slide the actual fireworks animation down the timeline to make room for it.

You need to create a mask that resembles the shape of exploding fireworks such as in this example. Convert it to a Graphic symbol.

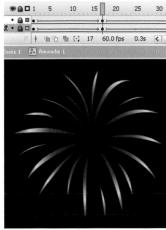

Lock both layers and play back or test your movie. You should have a pretty convincing fireworks explosion.

If you nest this animation

duplicate to create additional fireworks

with different colors.

into a symbol, you can easily

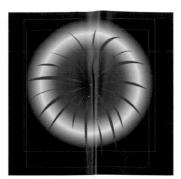

Place the radial gradient in the masked layer so when the layers are locked, the gradient shows through the mask only.

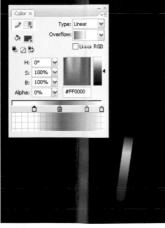

B Draw a stroke and mine. Since Innear gradient that contains two Draw a stroke and fill it with a

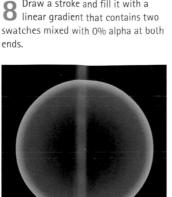

2 Edit the auphrease symbol. Edit the duplicate symbol with The darker the background the more vivid the fireworks will be.

Scale both the mask and gradient in frame 1 so they are very small. Scale the gradient even smaller than the mask.

Shape tween the gradient so it starts at the bottom of the stroke and ascends until it reaches the top and beyond so it disappears.

HOT TIP

If you have a solid color background such as black, it is best to avoid motion tweens with alpha because they can be very processor intensive - especially if multiple animations are overlapping. Instead of alpha, tint to the same background color instead. Tint is much more processor friendly and playback will always be better as a result.

Drag multiple instances of your fireworks to the stage and start them on different frames to control their timing.

Soft reveal

LASH LACKS THE ABILITY to create masks with soft edges. When you use masks in Flash, you are limited to a hard edge, even if the mask contains a gradient with one color mixed with 0% alpha. Perhaps someday a future version of Flash will support masks with feathered edges. Until then, we need a work-around. So far the only solution I have been able to come up with is not even a mask at all. It's a simple gradient with at least one color mixed with 0% alpha. In the end, the effect is successful because it is what the viewer doesn't see that convinces them visually.

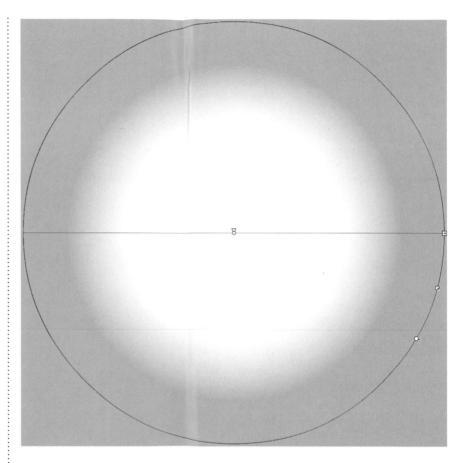

1 Start with a radial gradient (shown here with orange for clarity) with two colors. The outer color should match the solid color background which you will need for this effect to work. The middle color should be mixed with 0% alpha to make it completely transparent.

Use the Rectangle tool **(A)** to make a very large shape with this radial gradient as your fill color.

2 Convert this rectangle to a symbol and place it on a layer above the image you want to reveal. Scale the rectangle large enough so you can see the entire image through the middle color that you made transparent.

In frame 1, position the rectangle so that the image below it is completely obscurred from view. This is if you want to start your animation by revealing the image over time.

HOT TIP

This effect can be achieved not only with a radial gradient, but also a linear gradient. It depends on your needs of course, but a feathered edge can always be achieved if your animation contains a solid color background.

Create a second keyframe somewhere down the timeline and position the gradient so that the image below it is clearly seen through its transparent center. Apply a motion tween and play back your animation.

Star Wars text

EXT EFFECTS ARE ALWAYS a popular request among Flash users – specifically the "Star Wars" effect made famous during the opening scene in the original 1977 film. The effect is relatively simple to create but comes with a price: playback performance can suffer. Proceed with caution and test your animation often to make sure playback doesn't suffer. Remember, the text must be legible without giving the reader a headache.

This is how to make a "Star Wars" style opening text effect. It ain't too hard once you know how. This is how to make a "Star Wars" style opening text effect. It ain't too hard once you know how. This is how to make a "Star Wars" style opening text effect. It ain't too hard once you know how. This is how to make a "Star Wars" style opening text effect. It ain't too hard once you know how. This is how to make a "Star Wars" style opening text effect. It ain't too hard once you know how. This is how to make a "Star Wars" style opening text effect. It ain't too hard once you know how. This is how to make a "Star Wars" style opening text effect. It ain't too hard once you know how. This is how to make a "Star Wars" style opening text effect. It ain't too hard once you know how. This is how to make a "Star Wars" style opening text effect. It ain't too hard once you know how. This is how to make a "Star Wars" style opening text effect. It ain't too hard once you know how. This is how to make a "Star Wars" style opening text effect. It ain't too hard once you know how. This is how to make a "Star Wars" style opening text effect. It ain't too hard once you know how. This is how to make a "Star Wars" style opening text effect. It ain't too hard once you know how.

Start by typing your block of text. Try to use a simple and bold font that is easy to read. You will be transforming this text and animating it. Since it will be constantly moving, priority should be making sure it is legible and easy to read for the viwer. Select your text field and break it apart

until the text becomes raw vector shapes. The amount of vector information will be substantial and will most likely cause some performance issues during playback. This is another reason to choose a font that is as simple and clean as possible as it will produce fewer vector points.

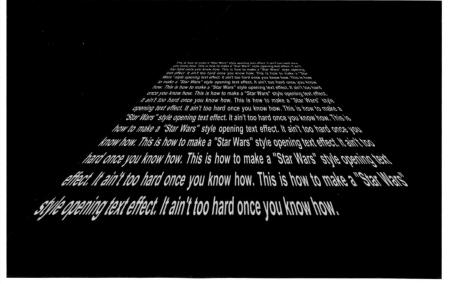

Insert a new layer and convert it to a guide layer. Make sure the layer containing your text is not "guided" or linked to it. You can drag the guide layer below your text layer to prevent them from being linked together. Anything on a guide layer will not be included in the exported SWF. Flash CS3 offers a nice new feature that

provides the option to export or not export hidden layers. This option is accessible by going to File > Publish Settings > Flash tab. On this layer use the line tool to draw a stroke at the same angle as your text field. Copy and paste it in place, flip it horizontally and position it on the opposite side of your block of text.

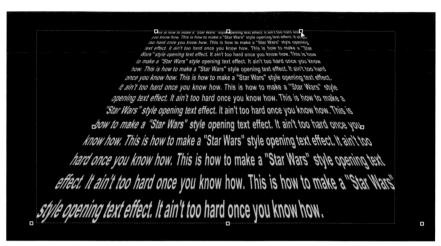

The next step is to simulate the perspective needed to provide the illusion that the text is receding. Select the Free Transform tool and then the Distort (subselection) tool. While holding down the holding down the similar key, drag one of the upper corners horizontally towards the middle of the

text. Holding down the **Shift** key constrains the proportions of the transformation by distorting the adjacent corner in the opposite direction. Convert this block of text to a Graphic symbol. If you have several blocks of text, it might be best to keep them as smaller individual symbols.

4 Add a second keyframe and scale your text until it fits inside your guides at their smallest point. You will need to insert several frames between these two keyframes and apply a motion tween. For smooth playback, you will need a combination of hundreds of frames and a high frame rate. The exact amount depends on

the amount of text, the font style and how large (width and height) your movie is. The larger the movie, the more processor intensive it will be. Any animated effect that uses a combination of these factors can cause poor playback performance. Test often and know your target audience.

HOT TIP

You could try this effect with a block of text made in Photoshop that is distorted in the same perspective. Import the text as a bitmap with the same solid color background as your Flash movie. It may result in a more processorfriendly animation sequence but will suffer from loss of quality when scaled. Flash doesn't scale imported bitmaps very well and the results may not be visually appealing. The trade-off is using crisp vector text with some possible performance issues during playback. Test often is your best defense.

Color adjustments

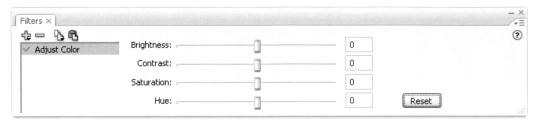

BEFORE FLASH 8 introduced filter effects, advanced bitmap effects meant having to spend time outside of Flash editing several duplicates of the original image. Depending on the desired effect(s), several different versions of the same image would have to be created and imported into Flash. With Flash 8 and now

CS3, this process became much easier. Using only one single bitmap image and the Adjust Color filter, you can create some striking color effects with minimal time and effort. The advantages of using this filter technique include smaller file sizes and faster results that can be mixed with any of the other filters.

To convert a full color image to gray scale, slide the Saturation slider all the way to the left.

2 Click the Reset button in the Filters panel to return each color setting to "0".

To adjust the overall color hue of your image, use the Hue slider. Here the Contrast and Saturation have been slightly adjusted as well.

	-
Brightness:	 _
Contrast:	
Saturation:	
Jacul acion.	

Brightness:	——————————————————————————————————————
Contrast:	
Saturation:	1
Hue:	

Brightness:	
Contrast:	
	U U
Saturation:	<u> </u>
Hue:	

The imported image here has been blurred and adjusted using the Blur and Adjust Color filters.

Here the Saturation and Hue have been increased as well as the Contrast.

3 Here's the original image without any filtered effects.

HOT TIP

You can copy a filter effect by clicking on the "Copy Filter" button in the Filter panel. Then you can paste it to another Movie Clip instance elsewhere in your Flash document.

4 Each of these color adjustments can be keyframed and motion tweened to create smooth color transitions.

5 Any of these color effects can be visually effective when introducing images for a variety of uses.

6 You can also add some basic ActionScript to control color changes when the user rolls over various menu buttons.

Brightness:			
Contrast:			
Saturation:			0
Hue:		<u> </u>	

Brightness:	
Contrast:	
	J (
Saturation:	J
Hue:	

	-	
Brightness:		
Contrast:		
Saturation:		
Hue:		

Vertigo

AUTION: THIS
EFFECT MAY CAUSE
temporary headaches
and possibly some minor
nausea if stared at too
long.

Well, perhaps it won't cause sickness but it is a great effect for representing vertigo: a balance disorder that causes a spinning sensation. If you are familiar with Alfred Hitchcock's film "Vertigo", you will already be familiar with how this visual effect can be used to induce the image of something or someone spinning out of control. With animation, it can also represent time travel or a worm hole or even the beginning of a dream sequence or hallucination.

The success of this effect is in the one single graphic: the spiral. It was created in Adobe Illustrator using, you guessed it, the Spiral tool. Flash does not have a tool like this so Illustrator proved to be a huge time saver. Of course you can always draw this spiral graphic by hand using the support of a pressure-sensitive stylus, but that would certainly require a very skilled hand.

This is a great effect to place a character or an object on top of. Place the object in a Movie Clip symbol and rotate it in the opposite direction as your swirl. This will enhance the effect by providing the illusion of the object traveling through time or space and may even induce some minor headaches and nausea.

Convert your spiral graphic to a symbol. Insert a second keyframe about 100 frames from the first keyframe. Apply a motion tween. Of course nothing will happen on playback because no change has been made to either instance of the sprial. Select a frame anywhere along the motion tween and in the Rotate drop-down menu, select CW (clockwise) or CCW (counterclockwise). Type in the number of rotations desired.

HOT TIP

You can get a lot of mileage from this spiral effect by adding objects that do more than just spin in the center of the spiral. You could add a rocket that is motion tweened from outside the stage into the center of the spiral, You'd want to scale it very small as it reaches the center point of spiral.

It's time to 4 have some fun! Change the colors of your spiral and then select the character or object (make sure it is in a Movie Clip) and experiment with some of the Blend Modes available from the Properties panel. There are some interesting effects to play around with here that may provide some cool results.

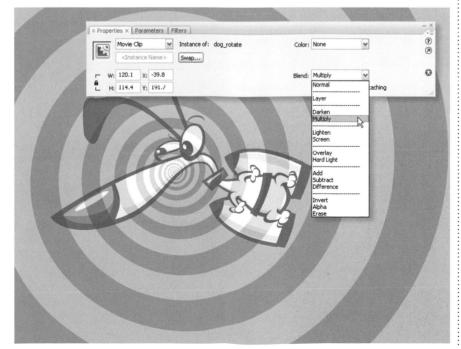

Let it rain

1 Use the Brush tool to draw your rain drop. Gravity suggests that the shape of the drop is thicker and rounder at its bottom. Fill your raindrop with a solid color or a radial gradient for some extra realism. This is a style choice for you to decide.

2 Convert your drop to a Graphic symbol and rotate it slightly. The amount of rotation is up to you based on how strong a rain storm you want to have. The more angle your rain has, the more wind is suggested.

Rain, to our advantage as animators, is repetitive. Reusing assets is one of the strengths of Flash. You only need to animate one raindrop and then populate your scene with multiple instances of it. You can then control how your rain acts by adjusting the angle at which it falls, its speed and how many instances of it appear at any given time.

6 Copy all frames of your circle animation. Insert a new layer and paste the frames into it. Select all the frames in this new layer and drag them about five frames further down the timeline.

Navigate back to the main timeline and transform your water drop symbol (containing its animation) by dragging the middle handle along the top or bottom edge (Free Transform tool).

Insert a keyframe further down the timeline. In frame 1, position the drop outside of the stage. In your second keyframe, position it near the bottom of your stage area. Apply a motion tween.

Place the symbol containing your ripple animation in a blank keyframe (F7) in the frame after your rain-drop animation. Position the ripple just below the rain-drop in its last frame. Copy all frames in this layer.

Let's create a ripple effect for the rain-drop after it reaches its destination. Using the Oval tool , draw a circle with a stroke color only. Hold down to constrain its proportions. Convert it to a Graphic symbol.

9 Paste these frames into a new symbol. Add several layers and continue to paste your animation into each one. Select and drag each layer's animation so that they start each on their own unique frame number.

5 Convert it to a Graphic symbol again and double-click it to edit it. Insert a second keyframe and motion tween it from small to large over approximately ten frames. Select the instance in the last frame and apply 0% alpha so it fades out completely.

10 Now that you have a rain sequence nested in a symbol, drag as many instances of this symbol as you need to the stage. Scale them and even tint some darker to suggest more depth to your scene.

HOT TIP

Nature isn't perfect. You simply can't find lines in nature that are exactly horizontal or vertical. Rain is the same way in the sense that it rarely falls perfectly straight down. Even a slight breeze will cause raindrops to fall at an angle. You can suggest stronger wind conditions by increasing the angle and speed of your rain drops. Decreasing the angle and speed of your rain animation will suggest a light shower.

Animation examples

Playing with fire

O FLASH ANIMATION BOOK is complete without a topic involving fire. How many times have you ever wanted to animate fire and had no idea how to even approach it? The first technique that comes to mind for animating flames is shape tweening. It just seems like the appropriate choice because of the nature of fire and how they dance and flicker. But in my experience, shape tweening doesn't seem to ever produce realistic results. Often, the shapes "implode" or simply morph in all the wrong ways. The effect of fire is simply not achievable using tweens.

Motion tweens are not an option for the obvious reason that they can only be applied to instances of symbols.

ActionScript might be a solution, but if you are like me, your scripting skills are not up to the challenge of producing fire from within the Actions panel.

Don't be frightened by what I am about to say, but frame by frame is the best option for animating fire. Don't be fooled, it's not that hard or time-consuming.

Start by making several overlapping rectangles (with no stroke outline). Don't concern yourself with color at this stage of the process, any color will do.

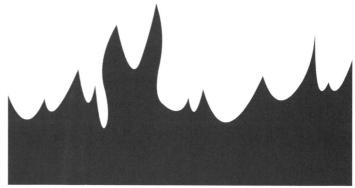

5 Ultimately your flames in frame 1 should look something like this. Try to alternate the direction of each flame. Fire is random and travels in unpredictable ways.

9 Create a Linear gradient using bright red and bright yellow as the two colors.

10 In each keyframe, select all and drag the Bucket tool vertically inside your flames to fill them. The gradient will follow the direction you drag in.

Use the Selection tool **V** to pull edges to create peaks.

Fire is naturally unpredictable. Avoid repetition with your shapes.

Try to incorporate some shapes

8 Continue to create ne, ... edit the shape of your flames in Continue to create keyframes and each one by pulling and pushing with the Selection tool.

6 Insert a keyframe (F6) on frame 2, turn on Onionskin and begin editing the next frame by pulling each point higher and lower.

"Punch" holes in the flames by drawing different colored shapes and deleting them. Fire is not solid, it will break up as it rises into the air.

Copy all frames of your animation and paste them 1 Copy all frames or your anniholous. ______ into a new Graphic symbol. Add three new layers to the main timeline and drag instances of this symbol to each of them. Delete your original layer. Select one of the instances and flip it horizontally. Scale two of the instances

so they are much wider than the stage. Position them offcenter from the stage while leaving one of the instances at its original size and position. Create a background shape with the same linear gradient to make it look like the entire scene is ablaze.

HOT TIP

Art imitates life, and there's no substitute for studying the flames of a real fire. Just as Disney's animators went to Africa to study real animals in preparation for production of The Lion King, you should also study from life as much as possible. Although your budget may not allow for world travel, something like fire is a bit more accessible to find.

Winter wonderland

ET IT SNOW, LET IT SNOW, LET IT SNOW.

Creating constantly falling snow is fun.

Like the rain example, snow can be animated several different ways. The easiest way is to motion tween a snowflake symbol along a Motion Guide path. Other methods include using ActionScript-generated snow but don't ask me to show how that is done because I admittedly do not know how to write scripts on that level. Let's stick with my "analog" method of animating in Flash shall we?

The more snow you create, the more processor intensive your animation becomes. Proceed with caution and test your animation frequently to make sure the constant looping snowfall doesn't cause unexpected playback issues. There's nothing worse than creating a cool animation only to find it skips and chugs during playback.

1 Start with a snowflake design using the Line tool. It's hard to make a mistake here since there's no real way to create an incorrect snowflake pattern. Make one "arm" of the snowflake, convert it to a symbol or as an Object Drawing. Copy it using **Cotto of and paste it in place using **Shift of atto Shift of the snowflake, convert it to a symbol or as an Object Drawing. Copy it using **Shift of atto Shift of the snowflake pasted of the snowflake pasted enough to complete the pattern.

Here's what your Movie Clip's timeline should look like (give or take some frames or layers). Notice the stop(); action in the last frame of the top layer. This prevents this Movie Clip from looping. Since all instances of the snowflake Movie Clip are present, they will loop by default.

2 Convert your snowflake to a Graphic symbol and then convert the Graphic symbol to a Movie Clip symbol. Double-click the Movie Clip and edit it by inserting a Motion Guide layer. Draw a curvy stroke for the guide and motion tween your snowflake along the path (traveling downwards of course).

3 You now have a Movie Clip containing an animation of a snowflake tweened along a motion guide. Next, in your Library panel, create a new Movie Clip and insert several new layers. Drag an instance of your snowflake Movie Clip into each layer. Position each snowflake Movie Clip randomly throughout your scene. For each layer, select and drag the keyframe in frame 1 to a different frame number so they each start playing at different times. Make sure each snowflake animation begins outside of the viewable area of the stage.

5 On the main timeline, place an instance of your Movie Clip containing your snowflake Movie Clips onto the stage in its own layer. You can place multiple instances of this Movie Clip around your stage as many times as you like. But be aware that the more instances of the snowflake

animations you have present on the stage, the more processor intensive your movie will be. If maintaining a high frame rate is your priority, you may want to experiment by using a simple oval shape for your snowflake graphic. Remember, fewer vector points means better playback.

HOT TIP

The length of the motion tween in your quided snowflake can help make the difference between a soft snowfall or a blizzard. **Experiment** with the number of frames in your tween to get the best results for your particular animation. To animate a blizzard you would need to shorten the length of the motion tween and populate the scene with an abundance of snowflake instances. You could even try making the **Motion Guide** path one big "S" turn to suggest a strong wind that is changing direction.

N. T. E. R. J. D. E.

From the inside out

I AM A DIGITAL ANIMATOR. A "digimator" if you will. I learned how to animate on a computer, which is inherently different than the traditional animation process. Sure, it shares some similarities when it comes to animation techniques, but ultimately any animation program can have a mechanical feel to it since we work by selecting options from menus much of the time. The trick I have learned is how to make a software program like Flash feel more organic, as if it were a ball of clay, starting with a basic shape and pushing and pulling it into something unique. If this book teaches anything, I hope it teaches you to think differently as to how you approach Flash. Just because the help docs, online resources or even other books tell you how something can or should be done, don't take that as carved

in stone. Take it as carved in clay, meaning you can continue to expand upon the ways the tools are used, even beyond what you may have read elsewhere. If 100 people were given their own ball of clay, they would all create something unique. No two clay creations would be the same because of the organic nature of the medium. Clay can be pushed and pulled in any direction, and this is how I will teach you to approach Flash.

Many years before Flash even existed, I studied everything from art history to sculpture, color theory to lithography and, above all, how to draw. This combination made the progression to the world of computer graphics and animation tremendously helpful. I feel just as comfortable with a mouse or stylus in my hand as I do with pencil, paintbrush, airbrush or printing press. They are all just tools, nothing more. Each tool is just as powerful as the other. A quick and loosely sketched pencil drawing can have just as much impact visually as a full-blown animated action sequence that took three months to complete. It's the subject matter that counts and this applies to Flash as well. Several people have asked me why I am so forthcoming with my home-grown

tips and techniques and why I'm not afraid that many will use them to emulate my own personal style. As with the ball of clay metaphor, everyone is different, therefore everyone will express themselves in a unique fashion whether it's through a ball of clay or an animation program like Flash. These are just tools, and in different hands come unique results. I'm here to show you how I use these tools for my own self-expression. Your own results may, and probably will, vary.

I have spent several years adopting and inventing Flash drawing and animation techniques. This book will show you different ways of approaching Flash and how to make it work for you. Whenever possible, I will try and avoid explaining what is readily available in the help docs and the multitude of online resources. You bought this book for a reason, to learn what isn't found anywhere else. You will get a first-hand look at how I create characters and motion graphics from scratch, and learn how Flash,

as a tool,

can be pushed and pulled, limited only by imagination.

My philosophy, with tools like Flash, is to learn as much as I can, then go back to the first 10% of what I learned, and take a left turn.

your

How to Cheat in

■ Having the ability to record your own high quality sound effects, vocals and musical soundtracks opens up a world of artistic possibilities. Many of my daughter's candid recording sessions have inspired several popular original animations, one of which was chosen as a Flash Forward Film Festival finalist.

Working with sound

FOR ME, ANIMATION IS about timing and rhythm. I've always been visually sensitive to the moving image and as a drummer for three decades, my senses are also very fixed on musical patterns. The combination of animation and the right soundtrack can be a wonderful experience for both senses. When the right sound complements the perfect animation, it can produce a most memorable experience for the viewer.

In this chapter we'll look at how you can incorporate sounds into your animations, where to find them, how to record, edit and load them dynamically.

Working with sound

Recording sounds

OUNDS CAN ENHANCE your animation in wonderful ways. Recording and designing sounds is an art form all its own and a job typically left to dedicated sound editors who have an innate ability to edit, mix and craft sounds into works of audible art. But chances are you don't have a dedicated sound designer at your disposal 24 hours a day. Since Flash does not record or create sound files, you need to find or record your own and import them into Flash. So what is the best way to

find, edit and incorporate sounds into your Flash projects? The easiest way is to purchase sound effects from your local music store or online. A quick search on Amazon.com for "sound effects" will return a few dozen audio CDs available for purchase. These are handy to have around, but may include some legal restrictions as to how you can use the sounds. Some publishers may retain the royalty rights to the contents of CDs, limiting you to noncommercial usage. This may pose some legal

Get yourself a good microphone. I'll be honest, you will get what you pay for when it comes to the quality of recording. There are several different microphones designed to record

> sounds for almost every situation you can think of. The cheapest solution would be a USB

> > microphone that can be found at your local computer supply store for around \$20 US. A microphone like that is great for transferring your voice during an

quality recordings.

On the other hand, you don't need to spend your next five paychecks on the most professional studio microphone either. The microphone pictured is an AKG Perception 400 and retails for around \$300 US. It produces great sound whether you are recording voice, sound effects or musical instruments. It is a condenser microphone, which tends to be more sensitive and responsive, making them wellsuited to capturing subtle nuances in sounds. The best feature of all is the three different recording settings you can switch between depending on the recording situation. You can set it to record only what is directly in front of the microphone, which is great for voice, sound effects and intruments. If you have two voices or instruments next to each other, there's a setting to record bidirectionally. The third is an omnidirectional setting that will record sounds in a 360 degree pattern around the mic. This is great for picking up general room or ambient sounds.

issues for you and most importantly your client, who would rather avoid paying legal fees for a few *thumps*, *swooshes* and *pop* sound effects in the project you delivered to them six months prior. Another potential issue with published sound effects CDs is their sound quality. Depending on the equipment used to record and edit the sounds, there is no guarantee they are of high enough quality to justify using them. It's always a good idea to try and find out the technical information regarding the actual

sound files before you purchase the CD. You will want sounds that are high quality, usually 44 kHz, 16-bit stereo. You may also want to edit your sounds by applying effects, editing loops or even compose original soundtracks. For this you'll need to choose a decent audio editing program. Some of you may already be using an audio editing application, but for those of you that are unfamiliar in the area, we'll take a look at what's available a bit later in this chapter.

Next, you need a way to get your shiny new microphone to connect with your computer. Once again you have a variety to choose from. Assuming you don't need every bell and whistle available, a good choice is something like M-Audio's FireWire Solo mobile audio interface. It has a standard XLR microphone input and a 1/2" guitar input, allowing you to record guitar and vocals simultaneously. There are also dual line inputs for effects, drum machines and other outboard gear. The biggest decision to make when purchasing an interface like this is whether you want to use USB or FireWire connectivity. FireWire may provide faster data transfer over USB, but double check that your computer's hardware supports FireWire. If not, you can purchase a FireWire card separately.

So now how much can you expect to spend? An audio interface is between \$200 and \$400 US depending on how many features it offers. The M-Audio FireWire Solo mentioned here will

back about \$250, US

but I found one on sale for \$200 at my local music vendor. Throw in a microphone stand and cable and you could be looking at spending around \$600. Yeah, I know what some of you are thinking: "I just spent that much to get Flash! Are you kidding me?" I can understand this being an expensive decision but I'm providing information based on equipment I feel provides the best bang for your buck. There are many less expensive microphones to choose from, some with USB connectivity that avoid the need to purchase a FireWire interface. It's a balance between the level of quality you prefer and the size of your budget.

Adobe® Soundbooth®

Sb

C OUNDBOOTH IS A BRAND NEW audio editing program from Adobe that is designed for the casual Flash user and video editor while offering professional-level features. Soundbooth is streamlined in a way that doesn't require you to be an audio expert. You will not be overwhelmed with a plethora of knobs, buttons and sliders, or effects that require hours of reading through pages of help docs, but don't underestimate its capabilities either. From realtime effects processing to composing your own custom music bed, Soundbooth is the perfect complement to Flash. You can even add Markers to your audio wave form in Soundbooth, export them as XML data that can then be used with a Flash FLV component and ActionScript. Soundbooth fills a much needed niche for the casual audio editor who doesn't mind getting professional results.

Not unlike Adobe Audition and Premiere, you can scale and drag panels to new locations and in configurations that suit your working needs. As you rearrange panels, other panels will resize themselves automatically to fit the workspace.

The Tools panel
offers Time
Selection, Frequency
Selection, Rectangle
Marquee, Lasso,
Hand and Zoom
tools.

The scrollable
Files panel lists all
currently opened
audio and video files.

Soundbooth offers several real-time effects such as . Channel Volume. Invert, Parametric EQ, Swap Channels, Phaser, Vocal Enhancement and more. Effects are applied in real-time and therefore are non-destructive to the original source file. You always have the option to turn on or off selected effects until you wish to apply them permanently.

The Video panel — plays back video files for referencing while editing an audio waveform.

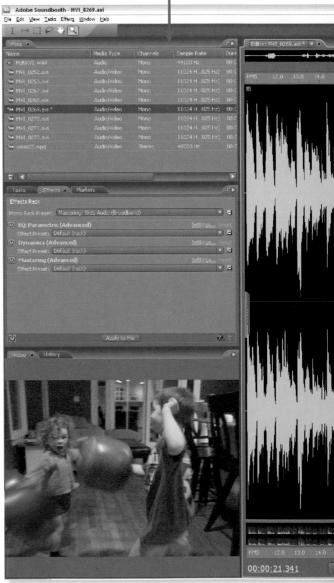

The workspace in Soundbooth is completely customizable.

PRODUCT SCREEN SHOT(S) REPRINTED WITH PERMISSION FROM ADOBE SYSTEMS INCORPORATED

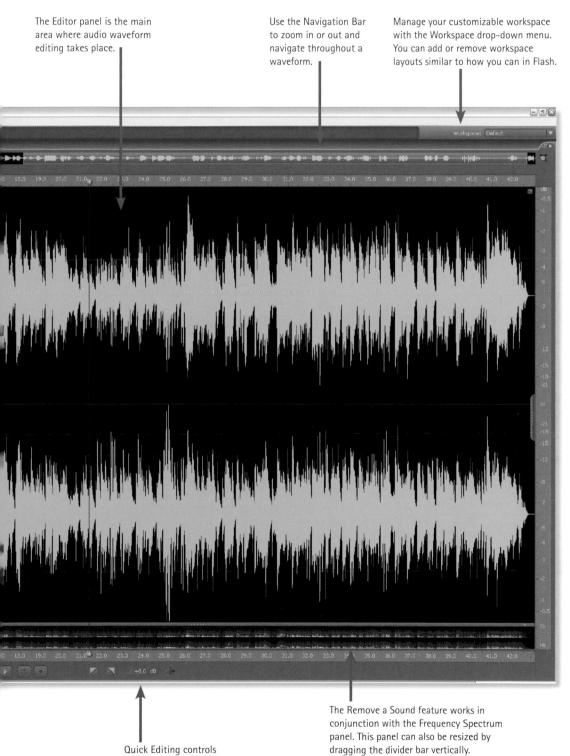

HOT TIP

If you require more advanced audio editing features, you might consider Adobe Audition, a more advanced, full featured audio editing program for those who need just about every bell and whistle available to them.

R Working with sound

Sound in Flash

HE EDIT ENVELOPE WINDOW offers some limited sound editing features without having to leave the Flash environment. There's enough features here to control the starting and ending points of your sound file, as well as some basic fading effects. But don't expect much more beyond that.

As much as Flash could use a few more bells and whistles in this area, it was never meant to be a sound editing program in the first place. Let's leave that for the dedicated sound editing applications and use Flash for what it is. We can't expect Flash to do everything can we?

Select frame 1 in your Flash document and then go to File > Import > Import to Stage and select your WAV or AIF file. Your sound will be in frame 1 but you will need to insert enough frames to accommodate its length. By default, the sound will be set to Event. Use the drop-down to change the sound's behavior.

Event: This is used to play a sound at a particular point in time, but independently of other sounds. An Event sound will play in its entirety even if the movie stops. An Event sound must be fully downloaded before it will play.

Start: The same as Event, except that if the sound is already playing, no new instance of the sound plays.

Stop: This stops the selected sound.

Stream: This is used to synchronize a sound with the timeline and, subsequently, the animation. Streaming sounds will start and stop with the playhead.

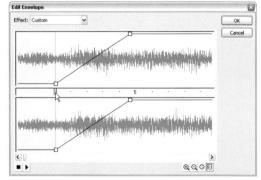

4 You can add up to eight envelope handles by clicking anywhere within the sound window. Each handle can be dragged around to control the volume of the sound at that point in the sound file. The higher the handle is positioned, the louder the sound. To remove a handle, drag it out of the window. To change the sound envelope, drag the envelope handles to change levels at different points in the sound. Envelope lines show the volume of the sound as it plays. To create additional envelope handles (up to eight in total), click the envelope lines. To remove an envelope handle, drag it out of the window.

5 To change the start and end points of a sound, drag the Time In and Time Out controls in the Edit Envelope. The tricky thing about this is, without the ability to scrub the waveform in the envelope window, it's a game of hit or miss (mostly miss).

If you need to continue a long sound file across multiple Scenes, you will have to add a new instance of the sound to each scene. Next, determine where the sound ended in the previous Scene and manually adjust the Time In controller for the current Scene so that the sound starts where the previous Scene ended. It's not an exact science and not an ideal solution if your audio file is one continuous sound (such as a musical score).

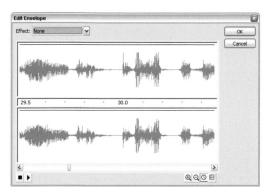

2 Click the Edit button in the Properties panel to open the Edit Envelope window. Here you will see the waveform of your sound file and a few basic control features. Along the bottom you will find stop and play button3, magnification tools, and the option to switch between time units of seconds and frames.

locate the Layer Height drop-down menu and select 300% to

increase the height of the layer to its maximum.

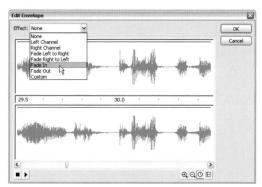

3 The Effect drop-down menu offers some convenient effects to add to your sound.

Left Channel/Right Channel: Plays sound in the left or right channel only.

Fade Left to Right/Fade Right to Left: Shifts the sound from one channel to the other.

Fade In/Fade Out: Gradually increases/decreases the volume of a sound over its duration.

Custom: Lets you create custom in and out points of sound using the Edit Envelope.

HOT TIP

Once the sound has been set to Stream behavior. you can then drag the playhead across the timeline to hear your soundtrack. The default Event setting sends the sound to your system's sound card and forgets about it. It is no longer part of the timeline and will not maintain sync with any animation. The only way to stop an Event sound from playing while in the Flash authoring environment is to hit the Esc key. Event sounds are typically used with shorter sounds and attached to buttons.

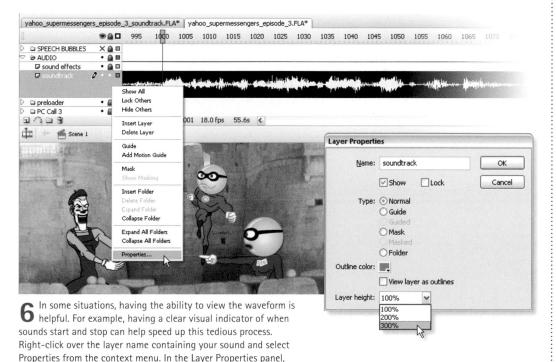

Working with sound

Dynamic sounds (AS3)

T'S ALWAYS FUN when sound and graphics come together to create an engaging and dynamic experience. This example uses ActionScript 3.0 to assign sounds to invisible buttons. The sounds are triggered when you roll over individual drums and cymbals. Each sound file in the Library is exported for ActionScript, allowing you to assign each sound to a different keyboard command as well. As a result, the Flash movie converts your keyboard to a musical instrument. This is just one of an infinite

number of ways sound and ActionScript can be combined to create a fun, interactive experience.

The first step is to create an invisible button for the area you want to assign a mouse command to. On a new layer above your image, draw a solid color in the same shape as your image. Convert the shape to a Button symbol and then double-click it to enter Edit Mode. Drag the Up keyframe to the Hit frame. The Hit state dictates the active area of the Button and will not be visible in the compiled movie. Back on the main timeline the button is semi-transparent for editing purposes. With the instance of the Button selected, type in a descriptive instance name in the Properties panel so you can assign some commands to it.

The first line creates a suitably named variable and sets it to an instance of Tom 1. You'll do this for each sound clip class, which preps each sound for play. The other lines here show how to trigger the sound with a keystroke. Set the focus to the stage, then add a "key down" event that checks for the event's charCode. In case it's 68 or 100. play the sndTom1 sound. What are 68 and 100? These happen to be ASCII codes for the letter D. See asciitable.com for a chart (you'll want the Dec column).

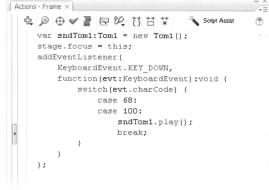

6 Now that you have created a hit area and assigned a mouse and key command to trigger a sound dynamically, repeat steps 1-5 for each additional sound you want to add to your project. In the dynamic_sounds_AS3.fla provided on the source CD, I have created an additional 12 invisible buttons "mapped" to specific areas of the image of the drum set. Each Button was given a unique instance name.

Import your sound file into your Flash document. In the Library panel, right-click over the sound and select Linkage from the context menu.

Open the library and you'll

exported to ActionScript and given

Actions panel and you'll see all the ActionScript has been provided as

This example was written by David

written a version in AS2 which has

also been provided on the source

CD. We hope that these samples

will provide a springboard for your

own dynamic sound projects and

experiments. Have fun!

a unique Class name. Open the

well.

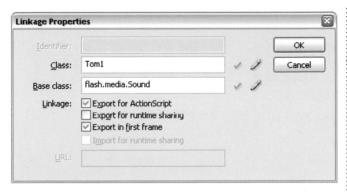

3 In the Linkage Properties panel, click the Export for ActionScript checkbox. That will automatically check the Export in the first frame for you. If you're using AS3, provide a unique Class name (AS2 uses Identifier instead). Here, I've named it "Tom1". The Base class must be "flash.media. Sound" but Flash is smart enough to fill that in for you. When you click OK, Flash may give you a warning about a missing class in the classpath. That's the Tom1 class you just named, so let Flash generate its automatic fix. If you like, check "Don't warn me again" to avoid a repeat wearning. Click OK.

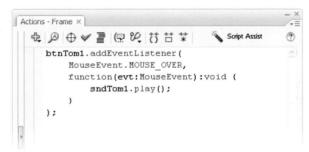

If you want to trigger the sound with a mouse movement, add the desired mouse event handler to your btnTom1 button and have the function play the corresponding Sound instance. Check out the sample file to see how easy it is to repeat this small block of code as often as necessary.

tom3.wav

tom4.wan

200 3K

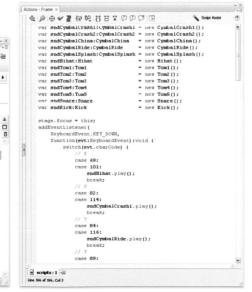

HOT TIP

Choose instance names carefully to help "sort" things in your code. At a glance, it's easy to see that the Tom1 class relates to the sndTom1 instance, which is a sound, and to the btnTom1 instance, which is a button.

SHORTCUTS

MAC WIN BOTH

189

Flash isn't perfect

SINCE YOU PURCHASED THIS BOOK, IT IS SAFE TO SAY you probably already have a passion for the Flash platform. It may even be accurate to say you actually *love* Flash. The actual level of adoration in this case seems a bit obscure. Of course the definition of *love* may not be the same level of passion you would typically express towards a spouse, parent or child. The *love* anyone could have for a software program could only be emotionally superficial in nature, not unlike the love you would have for your first car or the last book you just read. Yet how many times have we said to someone: "I LOVE Flash!" But we don't truly mean what we say, yet it's the first emotion that we use to describe our feelings for this program. Isn't all this *love* a bit unnerving if not emotionally unhealthy in an overly biased kind of way? Is it too much of a good thing? Is Flash really so perfect and wonderful to use that it invokes the feeling of true *love* from us? Well, I am not about to attempt the definition of true *love*, but let's at least look at just how perfect Flash is by examining its imperfections.

I have been on several of the Flash beta teams and it's always an honor to be invited to test and provide critical feedback on the toolset I rely on every day. Therefore I spend a lot of time putting the software through its paces in as many real world situations as possible. Being granted a direct line of communication to the Flash team is a privilege and the experience has provided me with the opportunity to make Flash better with each new version. I have seen how the beta process works externally as well as internally, and while Flash offers an amazing arsenal of tools, it's still not perfect. We all have our own personal wish-list for features or enhancements – heck, maybe some of you have true anger towards certain features (or lack thereof). Maybe this is evidence of a true love/hate relationship you might have with Flash. However you relate to Flash, let's take a *loving* look at some of my own pet peeves with the hope that our relationship with Flash will grow even stronger once everything is out on the table.

The frame number indicator in the Properties panel is wide enough to display a limit of two digits. This is frustrating when a Graphic symbol containing more than 99 frames is selected. Let's say the nested animation is 1000 frames long, in the Properties panel it looks like there are only "10" frames.

The Blur filter is restricted to horzontal and vertical directions only.

Flash has no native Inverse Kinematics (IK). There's no camera or three-dimensional stage to set up scenes and animate the camera within. There's no option to place the Grid on top of our content and we can't add custom eases to shape tweens like we can to motion tweens. Flash doesn't offer artistic brush styles like Illustrator and, so far, no option to bend gradients. When copying symbols from one Library to another, it would be nice if any offending symbol names provided more options than what currently exists (like the ability to itemize the conflicting symbols and rename them). There are no keyboard shortcuts for resizing the Brush tool like we can in Photoshop.

Ahhh...it's nice to get that out in the open. You may have your own wish-list for Flash and, the cool thing is, Adobe will listen. Go to Adobe's website (adobe. com) and search for "feature request" - you will find a feature submission form. To be fair, Flash CS3 not only improves upon some existing features, it also adds a few new ones. Integration between Photoshop and Illustrator is a huge workflow enhancement for most of us. Having the ability to export dynamic content to QuickTime Video is now possible. For designers, a much improved Pen tool and the introduction of Shape Primitives are great to have. We can, for the first time in the history of Flash, draw inside a horizontally flipped symbol instance. The option to copy and paste the motion of an object is a welcome addition, as is the ability to copy animations to ActionScript 3.0. I must also mention the overall interface is, in my opinion, the most streamlined workspace Flash has ever seen.

My love for Flash grows as each new version is embraced with new and improved features. Flash is, in a way, only human. If on occasion, it forgets to put the toilet seat down, I don't let it bother me.

■The above image shows a video sequence composited with Flash animation for a popular children's television program. The bottom image shows an animation in the FLV fomat, seamlessly integrated into a website.

Working with video

FLASH VIDEO HAS REVOLUTIONIZED online video. Since its inception, the FLV format has grown exponentially as the favored medium for delivering video content. Google Video, You Tube, AOL, Yahoo! Video and MySpace are just some of the websites that have adopted Flash as their method of video deployment. Not to say other media players such as QuickTime, Windows Media and Real Player are "dead" by any means. But in comparison, it's as if they stood silently by as Flash boarded the internet video bus and drove away.

This chapter features two separate client projects that show how video was used with Flash in different ways to achieve two very different goals.

Working with video

Importing video

BETWEEN THE LIONS is a popular children's education television series designed to foster the literacy skills of its viewers, while playfully demonstrating the joys of reading. Teaching is done through the use of catchy songs and often animated shorts. This particular segment combines both live action puppet characters, music and animation.

The main characters were videotaped against a blue screen. The idea is to replace the blue screen with animation. It was our job to create the animated sequences while maintaining sync with the provided video and ultimately deliver the final product suitable for high quality broadcast television. Between the Lions is produced by WGBH Boston, Sirius Thinking, Ltd. and Mississippi Public Broadcasting, BTL®, TM and characters WGBH Educational Foundation. © 2007 WGBH & Sirius Thinking. Animation production by Pileated Pictures.

The purpose of the blue screen is to provide an evenly lit, monochromatic field of color that can be easily keyed out using a video editor and replaced with a different image or video. Open the

3 Once the wizard has finished importing the video, insert enough frames on the main timeline to accommodate its length.

The script called for the live action puppet to react to an animated character falling from the sky. Having the video in a Graphic symbol embedded into the main timeline made it easy to sync the animation with the puppet's reaction.

video in QuickTime and go to Window > Show Movie Properties and extract the audio track as a WAV file. Import this into Flash on its own layer and set it to Stream to sync with the animation.

4 Import the audio track you extracted in QuickTime earlier and place it on its own layer. Set its behavior to Stream.

Once the animation is complete it's time to export it to video format. But you don't want the embedded video to be included. Convert this layer to a guide layer so it will not be included in the exported file. You could also delete this layer.

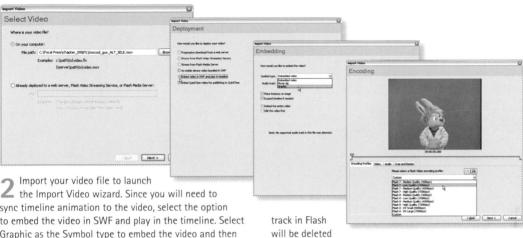

sync timeline animation to the video, select the option to embed the video in SWF and play in the timeline. Select Graphic as the Symbol type to embed the video and then finally choose an encoding profile. Since this video track is for reference only, select a low quality profile. The video

Since the video was converted to a Graphic symbol during the import process, you can transform it over

before exporting the animation and added later in After

The video is motion tweened smaller to make room for the animation sequences. Don't worry about how the

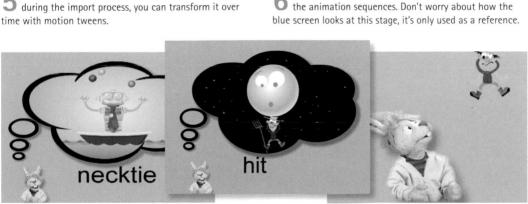

The exported animation from Flash is composited with the high quality video of the live action puppet in Adobe After Effects. The blue screen is replaced with an alpha channel so the animation can be seen through it. Syncing both the video and animation sequences back together is

easy since they both share the same frame rate (29.97fps) and start on frame 1. As video files, all you need to do is place them both on the After Effects timeline on the same starting frame. A drop shadow was applied to the live action puppet as a final touch.

HOT TIP

To help keep your Flash file size as small as possible, reduce the width and height of the video before importing it. For this project the video was only used in Flash as a timing reference and its quality was not a priority. When selecting an encoding setting, a lower quality will be less processor intensive during playback in the Flash authoring environment. This will make it easier for you to get a sense of timing without having to export to video format every time you want to check your work.

Working with video

Flash Video (FLV)

to add video into your project. The best part is that video can be treated like an object in Flash, allowing you to layer it, add ActionScript and even animate it. Depending on your project needs, video can be imported into the Flash timeline or kept external of the SWF and progressively downloaded.

Due to the ubiquity of the Flash Player, the client was confident integrating Flash video into their website while providing their audience with an engaging online experience.

Let me explain why Flash video was used for this project in the first place. The client's logo incorporates a photograph of a rubber band. The concept is to animate the rubber band flipping and catching the "Cone" logo in a rubber band-like way. It is rare that I ever need to leave the Flash toolset, but in this situation, Hash simply doesn't offer the essential tools to manipulate

4 Click on the Video tab and select either On2 VP6 or Sorenson Spark. If your video includes an alpha channel that you want included in the FLV, you must encode with the On2 VP6 codec.

a photograph in such a way. I turned to Anime Studio Pro (e-frontier.com) because of it's *Bones* and *Image Warp* features – perfect for this style of animation. I was able to manipulate the rubber band image over time by assigning an IK (Inverse Kinematics) chain to it. Anime Studio also supports native motion blur effects as seen above. The animation was then exported to QuickTime.

5 The Video Encoder allows you to adjust Audio (if any), add Cue Points and Crop and Resize the video before exporting. Try cropping the video as much as possible to keep the file size down.

With the FLV Component on the stage, you can position it based on any other design elements you wish to include. Here a simple graphic was added on a layer above to hide the top edge of the FLV. Content was also added with simple text fields. When compiled, the FLVPlayback component will load and play the external FLV during runtime in the Flash Player. You can control when the FLV starts by moving the component to a later or earlier frame in the timeline.

The FLV progressively downloads which simulates streaming. Depending on its size, playback starts within seconds of loading.

2 File size is always a concern when dealing with video files. Since this is only a site introduction, loading the animation quickly is priority. The QuickTime file is over six megabytes, an unacceptable size given it's only seven seconds long. Launch the Flash Video Encoder and add your video file. Then click on Settings to launch the Flash Video Encoding Settings window.

Open Flash and go to Window > Components to open the Components panel and drag the FLVPlayback component to the stage. In the Component Inspector you can specify the path to your FLV file.

Once your Flash document is published to the web, visitors to the website are introduced with a Flash Video animation that they, without any inside information, assume is an animation made entirely with Flash. There is no indication that an FLV is being progressively downloaded, especially when combined with actual vector graphics. The resulting file size of the FLV is under 200k, very acceptable for web animation.

Taking advantage of the FLV fomat can be very useful if you have very long animations that are very processor intensive as when played back in the Flash Player. Export your movie to the FLV format and progressively download it instead.

In the Encoding Profiles tab, select an encoding profile that best suits your image quality, file size requirements and Flash Player version.

HOT TIP

Experiment by exporting several various encoding settings to achieve the best ratio between file size and video quality based on your target audience.

The intro animation is designed to fit in seamlessly with the rest of the page. Therefore the controller skin is removed completely using the Component Inspector.

FLV tools and articles

THE UBIQUITY OF THE FLASH PLAYER is the reason why most of the web surfing public can view Flash video without downloading additional plug-ins. This is the main reason why Flash video has grown so rapidly in recent years; the player had already penetrated the market as the most downloaded plug-in

in the history of the internet. Now that the FLV format has reached overwhelming popularity, various tools have sprouted that cater to this platform.

Wimpy is a free FLV player available from wimpyplayer.com. It is cross platform (Mac and PC) compatible, allowing you to watch your FLV and SWF

files on your local drive.

An alternative free FLV player is available from Martijn de Visser and can be

downloaded from his wesbite martijndevisser.com. Keep in mind, Martijn's player is still in beta and he admits it may have some rough edges. Martijn offers the source files if you have an inkling to improve FLV Player 1.3.3

file: 'mcguirk.ft' @ 100%
video: 400 kb/s. - audio: 96 kb/s. - stre: 360x243 (360x243)

upon what he has already started.

The Flash Video

Encoder lets you encode video files in either the On2 VP6 or Sorenson Spark video codecs. The Flash Video Encoder is a stand-alone product that comes with Flash CS3. You can install it separately from Flash or other Adobe Creative Suite programs. The most useful feature is the ability to batch-process multiple video clips.

You may find that Adobe Bridge fulfills your needs when it comes to previewing and managing your FLV files. With Bridge, you can easily organize FLV files and folders, preview their contents and display their metadata.

There's more to the FLV format than what this chapter offers. I recommend visiting Adobe's Flash Developer Center, where you'll find a number of indepth articles, tutorials and example files that will broaden your own Flash video horizons.

Flash Developer Center

http://www.adobe.com/devnet/flash/video.html

Encoding Flash Video

http://www.adobe.com/designcenter/dialogbox/encode_video.html

Selecting a Flash 8 video encoder

http://www.adobe.com/devnet/flash/articles/selecting_video_encoder.html

Handling cue points for audio files in ActionScript 2.0 and ActionScript 3.0

http://www.adobe.com/devnet/actionscript/articles/cue_points_audio.html

Controlling Flash video with FLVPlayback programming

http://www.adobe.com/devnet/flash/articles/flvplayback_programming.html

Examining the ActionScript 3.0 Flash video gallery source files

http://www.adobe.com/devnct/flash/articles/video_gallery.html

Using the Adobe Flash CS3 Video Encoder

http://www.adobe.com/devnet/flash/quickstart/video_encoder/

Wimpy FLV Player (free)

http://www.wimpyplayer.com/products/wimpy_standalone_flv_player.html

Martjin de Visser FLV Player (free)

http://www.martijndevisser.com/blog/article/flv-player-updated

■ Flash really comes to life when animation is combined with ActionScript for a truly interactive experience. The possibilities are endless when it comes to what can be achieved when design, animation and code overlap.

Interactivity

ACTIONSCRIPT KEEPS GETTING more powerful with each new release, but don't be afraid to experiment with older versions of the language. In some cases, you may need to! For example, many ad agencies still require that SWFs be published for Flash Player 6. In a situation like that, ActionScript 3.0 is out of the question. If you're a die-hard fan of on() and onClipEvent(), you'll find you can't use those any more in AS3, so even if you publish for Flash Player 9, you'd have to bump back the version of ActionScript in your publish settings.

The choices are yours, and Flash now offers more choices than ever. Although ActionScript 2.0 was introduced in Flash MX 2004 (Flash Player 7), it is supported by Flash Player 6, so for the purposes of the following pages, AS2 refers to Flash Player 6 through 8 and AS3 to Flash Player 9. That said, you'll find tutorials on the web for ActionScript 1.0 and even earlier, before the language had numbered versions. Flash Player 9 supports all of them but only one at a time, based on publish settings.

Event handling

Contributed by David Stiller (www.quip.net)

HEN SOMETHING OCCURS in a Flash movie, the occurrence is called an event. Events can be triggered by something in the Flash Player itself (system events) or by interaction from the person enjoying your content (user events). System events include, for example, the completion of an audio file or the incidence of a timeline frame. Let's explore that second one for a moment. Think of the playhead in terms of a car. When the playhead moves along the timeline, like a car driving along the street, it dispatches an "enter frame" event at a rate comparable to the movie's frame rate (by default, 12 frames per second). The event is simply a behind-the-scenes message that states, "Hey, I just entered a frame!" This happens, by the way, even if a stop() action tells the timeline to halt.

If a car arrives at a duck crossing and hits the brakes, its engine continues to idle, after all. At any time, you can program other objects to react to this event. We'll build up to this ourselves in just a bit. First, let's respond to some user events.

When a user clicks one of your buttons, a number of mouse-related events is dispatched in much the same way as above. One event happens when the mouse is pressed, another when the mouse is released and, depending on the version of ActionScript you're using, yet another when the mouse is pressed inside a button symbol but released outside of it. In all of these cases, the event happens whether you respond to it or not. If you do respond — this is called event handling — you need to write a function for it.

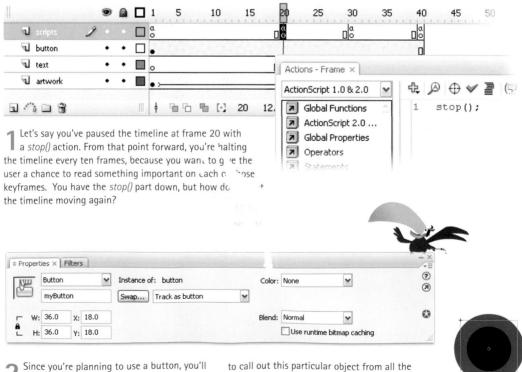

2 Since you're planning to use a button, you'll need to put a button symbol on the Stage. Use the Property inspector to give your button an instance name — that's what allows ActionScript

to call out this particular object from all the others and, use that instance name to tell the button what to do. In this example the instance name is *myButton*.

myButton.addEventListener(event, function);

ActionScript 3.0

In ActionScript 3.0, the main way to associate an event handler function with an event is the addEventListener() method. In this case, we're "wiring up" the myButton instance by way of two parameters. The first parameter specifies what event to listen for and the second defines the function to perform.

These parameters can be simple, such as the event part MouseEvent. MOUSE_UP or fairly complex, such as the complete definition of a function, which might otherwise stand on its own.

5 Putting the pieces into place, these parameters would fit as shown. Use the Actions panel to type the following code into a keyframe at frame 1.

You could optionally use a named function, like this. See the difference? In this second approach, you're defining the function as an entity of its own, a custom function arbitrarily named startTimeline(), then using that function's name as the second parameter. Notice that it doesn't matter how many lines it takes to code up the addEventListener() method. As long as you provide the two parameters it's looking for, you're good.

```
Actions - Frame ×

Actions - Frame ×

Decomposition (evt: MouseEvent): void (
2 play();
3 )
4
```

HOT TIP

The version of ActionScript you're using determines how this function is associated with the event at hand. Every object has its own selection of events, and these are listed in the relevant ActionScript Language Reference entry for the object in question.

Continued...

Event handling (cont.)

This ActionScript appears in frame 1 in a layer named "scripts," while the myButton symbol appears in its own layer, but also in frame 1. That's the important part, that they line up vertically; that is, they both appear in frame 1, so that they can "see" each other, otherwise the code and the button can't be associated. They might both appear in frame 2 or frame 10, it doesn't matter — as long as they line up.

ActionScript 2.0

ActionScript 2.0 handles things a bit differently. If you're publishing for Flash Player 8 or earlier, you can't use ActionScript 3.0 (only Flash Player 9 contains AVM2, the virtual machine that understands AS3). If your project specs require Flash Player 8 or back to Flash Player 6, here's a more "old-fashioned" approach to the previous scenario.

This time, the pattern is *myButton*. onRelease = function; and here, too, the function can be dictated right in the event handler or defined elsewhere as a named function.

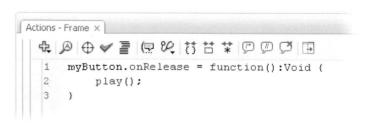

```
Actions - Frame ×

| Image: Action of the content o
```

Let's make sure we're caught up on the nitty-gritty details. In the AS3 version, the event handler function receives a parameter that the AS2 version's function does not, captured here under the arbitrary name evt.

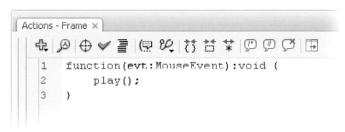

What's going on here? In this version of the language, every event carries with it an event object. In this sample, that incoming object isn't actually being used - we're just having the function execute a native p(ay()) action — but AS3 is pretty strict, so the function needs to at least let that object "in the door" even if it just sits there. The type of object matters, and this is a MouseEvent, so that explains the :MouseEvent suffix after evt. Finally, there's that : void business at the end. In AS3, type matters not only for in-coming objects, but also for outgoing objects. This is a

Actions - Frame X

Actions - Frame X

Learning ActionScript 2.0 in Adobe Flash

E Using on and onClipEvent with even Specifying events for on or onClipEv

E Attaching or assigning multiple hand

E Handling Events Using button and movie clip event h

E Event handler scope

onClipEvent handle

function, and functions either return a value or they don't. This function does not — it just performs an action, then guits - so the :void suffix lets AS3 know not to look for a return value. In the AS2 version, you'll notice the .void suffix starts with an upper case letter. It's just one of those things. In AS2, all datatype suffixes start that way. In AS3, most do, but a handful don't, and those are all lower case. Yes, it's like learning state capitals back in grade school, but there are only three all-lower case examples: int (integers), uint (unsigned integers) and void.

myButton.addEventListener(MouseEvent.MOUSE UP, startTimeline);

ing ActionScript 2.0 in Adobe Flash

Search Clear

000

Program 3.0

In both AS3 and AS2, neither of these named function approaches (above) uses parentheses after the startTimeline() function. What gives? The reason for this omission is that the parentheses actually carry out whatever the function does. By leaving them off in these lines, you're telling ActionScript to carry them out when the event occurs, rather than when the playhead encounters them.

In the Help panel, filter the books for ActionScript 2.0, which covers both AS1 and AS2, to look up "on handler" and "onClipEvent handler" for AS1 coding. To look up the AS2 events for buttons, search "Button class"; for movie clips, search "MovieClip class". You'll find even more events to pick from! For ActionScript 3.0, filter the Help books appropriately and look up button events under "SimpleButton" and movie clip events under "MovieClip". Buttons in AS3, believe it or not, support 27 events, so each new version of the language gives you greater control. In addition, the AS2 and

AS3 approaches allow you to reassign and even cancel event handlers after the movie is compiled. The full list for each of these can be found in the built-in documentation and in the live docs:

Programming ActionScript 3.0 El Handling movie clip events Basic event handling Examining the event-handling p Event-handling examples Strategies for designing a class About events and interaction Playing and stopping movie clips E Capturing keypresses E Lising the LoadVars class Attaching code to objects E How ActionScript 3.0 event handling dif E Defining event handler methods in A The event flow ActionScript 2.0 Language Reference Setting Stage pro Setting Stage properties
Changing position
Panning and scrolling display of
Setting color values with code
Example: SpriteArranger F fscommand function E onClipEvent handle I updateAfterEvent function tial issues for working with filters this property Loading external sound files E loadMovie (MovieClip.loadMovie met Controlling sound volume and pannin onData (MovieClip.onData handler)
 onLoad (MovieClip.onLoad handler) Simplifying sound loading and playback Smelliving sound loading and playback using.
 Bests of user imput.
 Capturing mouse input.
 Capturing mouse input.
 Capturing mouse input.
 Cameeting to other Hash Flayer instances
 Working with file upload and download
 Example: Using other instances
 Cameeting with in action in a comparing the standard in the standard ActionScript 3.0 Language and Cor E UIComponent.hide IE DataGridEvent class

Search Clear 🗘 🗘 🖟

button events

ActionScript 3.0

myButton.onRelease = startTimeline;

dling Events

HOT TIP

The Flash 5era on() and onClipEvent() functions are not supported by ActionScript 3.0, so if you see those in sample code online, be prepared to upgrade the general principles to the format shown here.

Scrip

Script A

he startDrag() method accepts a number of optional parameters that allow you to constrain the drag, that is to box it in to specified dimensions and it's really easy to do.

ActionScript 3.0

```
Actions - Frame X
   中 Ø → ▼ I P Ø 片 甘 菜 Ø Ø Ø F Script Assist
         smilevFace.buttonMode = true;
         smileyFace.addEventListener(
     2
     3
             MouseEvent.MOUSE DOWN,
     4
             function(evt:MouseEvent):void {
     5
                 smileyFace.startDrag();
     6
     7
         1:
     8
         smileyFace.addEventListener (
     9
             MouseEvent.MOUSE UP,
    10
             function(evt:MouseEvent):void {
                 smileyFace.stopDrag();
    11
    12
    13
         );
```

In this example, we're using a Movie Clip symbol, because the MovieClip class supports startDrag() and stopDrag() methods. The movie clip has the instance name smileyFace. This code goes in a keyframe where that movie clip starts. Two event handlers, this time. The MouseEvent. MOUSE_DOWN event occurs when the user clicks the mouse over the movie clip and triggers a function that initiates the startDrag() method. The MouseEvent.MOUSE_UP event occurs when the

user lets go of the mouse over the movie clip. It triggers a function that initiates <code>stopDrag()</code>. The very first line makes the finger cursor show when the mouse moves over the movie clip. Unlike buttons, movie clips in AS3 don't show the finger cursor by default, even if you're handling mouse-related events. Note that the functions mention the <code>smileyFace</code> instance by name. This is a difference from how things worked in AS2.

ActionScript 2.0

```
Actions - Frame ×

Script Assist

Actio
```

Here's the AS2 version. This code goes in a keyframe where the movie clip starts. Note the absence of any sort of *buttonMode* reference. In AS2, buttons and movie clips alike display the finger cursor when mouse-related events are being handled. If you want to turn the finger cursor off, precede the code below with a single line:

smileyFace.useHandCursor = false;.

Even more important is the presence of the global *this* property. In AS2, the lines of code inside the function actually see that function as their "point of view". Because the function is associated with the *smileyFace* instance, the term *this* ultimately refers to *smileyFace* in this context.

Constrained drag and drop

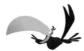

ActionScript 3.0

Because AS3 has no "release outside" event, you can use a "mouse up" event for the Stage itself. If the movie itself is listening for the mouse to lift, it doesn't matter where the event occurs, even if the mouse lifts outside the button or movie clip it started in. The trick is to only handle this event when you need it. You might, after all, want to listen for stage-wide "mouse up" events for other reasons, so we'll only commandeer this event while the mouse is pressed for the drag. We'll give the event back after the release. To do this, use the named function approach.

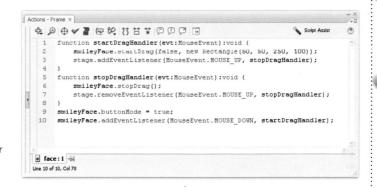

ActionScript 2.0

2 Thanks to the onReleaseOutside event, things are much easier in AS2. Notice that AS2's version of the startDrag() method accepts five parameters instead of two. The last four correspond more or less to the Rectangle object in AS3's version, except these are actual coordinates rather than a starting point plus a width and height.

In the last line, the onReleaseOutside event is set to the same thing as the onRelease event, so the mouse will stop dragging whether or not it's inside the movie clip when the user lets go.

```
Actions - Frame ×

| Actions - Frame ×
| Script Assist | Scrip
```

// ActionScript 1.0 and 2.0 someMovieClipInstance.startDrag (lockCenter, left, top, right, bottom); // ActionScript 3.0 someMovieClipInstance.startDrag (lockCenter, {x, y, width, height});

The first parameter isn't so much about constraint as it is where the mouse stays during the drag. By default, the lockCenter parameter is false, which means dragging occurs from wherever the mouse first clicked the movie clip. If you set this parameter to true, dragging occurs from the movie clip's registration point.

The rest of the parameters are numbers, based on the parent timeline of the movie clip. The way these numbers are provided depends on the version of ActionScript. An interesting thing happens with constrained dragging: if the mouse goes outside the bounds of the constraint, it might actually end up outside the movie clip when the user lets go. When that happens, the "release" event doesn't apply, because a bona fide release hasn't occurred. Instead, a "release outside" has. In AS1 and AS2, there is an event tailor made for this circumstance. In AS3, it takes a bit more effort.

HOT TIP

In AS3, drag methods originate with the Sprite class, and movie clips inherit some of their functionality from Sprite. Buttons do not inherit from Sprite, which means they don't have access to these drag-related methods. That explains why we're using a movie clip in this example.

Pausing the timeline

OONER OR LATER you're going to want to pause the timeline for a few seconds or even a few minutes, then resume the action after the viewer has had the chance to read something important or cast a lengthy gaze at your artwork. Flash banner advertisements are commonplace throughout the web and the ability to pause the playhead to help emphasize a specific advertisement message can be critical to the success of the ad itself.

The obvious way to handle this is to add extra frames where you want the pausing to occur. Depending on the length of the pause, though, that can make for an unwieldy timeline, especially if you have a high frame rate (five seconds at 30 fps is a 150 frames of "dead space"). What if you could pull that off with a single frame?

ActionScript 3.0

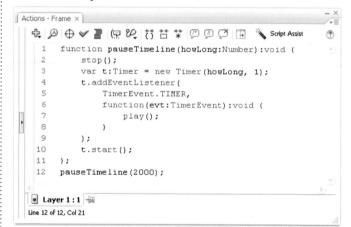

This pause mechanism comes in two parts. If you only need to pause once, put both parts in the same frame; otherwise, put the function in frame 1, then call that function in later frames as needed. This is like an "everything" burrito. Everything you need is stuffed into this custom function. The first thing it does is stop the timeline. Next, it declares a variable, t, and sets it to an instance of the *Timer* class. The two parameters, howLong and 1, tell Flash how long to wait before the timer

completes and how often to run the timer, respectively. Once the Timer variable is in place, things start looking familiar again: a *TimerEvent.TIMER* event is added to the *t* instance and told to perform a function that causes the timeline to play again. Finally, the timer is started.

Once the function is in place, call it by name from the same frame or any subsequent frame. The value 2000 refers to 2000 milliseconds (that is, two seconds).

ActionScript 2.0

```
Actions - Frame X
   亞 Ø ● ♥ 臺 (県 80 付 替 禁 (型 型 Ø ) 匝 N Script Assist
                                                              3
         function pauseTimeline(howLong:Number):Void {
     2
             stop();
             var id:Number = setInterval(
     3
                 function(): Void {
     4
     5
                     play();
     6
                     clear Interval (id);
     7
                 },
     8
                 howLong
     9
             );
    10
       };
```

The AS2 version relies on the *setInterval()* function, which repeatedly triggers whatever other function you tell it to, as provided in its first parameter. The second parameter here, *howLong* defines when the triggering should occur, in milliseconds. A companion function, *clearInterval()*, stops the repeated triggering after a single run. How? Earlier, *setInterval()* returns a Number value that gets stored in the id variable, then *clearInterval()* references that number by way of id as its own parameter.

Here, again, you've got two parts. Put the first in frame 1. Then call it in that same frame or any later frame(s). Calling the function is the same as the AS3 version.

HOT TIP

Timers are useful for all sorts of purposes, and you may not always want your timer to stop. In AS3, specify 0 as the second parameter in new Timer() to loop forever. In AS2, don't call clearInterval().

SHORTCUTS
MAC WIN BOTH

Interactivity

Loading images (AS3)

LASH IS CAPABLE OF loading quite a few file formats at runtime, including audio (MP3), motion graphics (FLV and SWF), and images (JPG, GIF and PNG). When you load such files with ActionScript, you're doing your visitors a favor: not only does this practice reduce the file size of the main SWF, it also gives users the chance to decide which files they want to see. Why make them download it if they're not interested, right? With dynamic loading, everyone wins. Let's look at a JPG example using ActionScript 3.0.

The simplest way to load an image is to use the Loader class. Three short lines will do it. The variable photo is set to an instance of Loader. The Loader.load() method is invoked on the photo instance, with a URLRequest

instance provided as the parameter. If you wanted to, you could certainly create a separate variable just for the *URLRequest* instance and pass in that instead, but it's shorter to drop the new *URLRequest()* expression inside the parentheses of the *load()* method. The quoted string is the

name (and path, if needed) of a JPG file. Finally, invoke the *addChild()* method and pass it the photo instance in order to actually display the loaded image. Without that third line, the image will load, but you'd never see it.

If you want to change the scale of the imported image, or manipulate it in any other way, you'll have to wait until its fully loaded before you do. An event handler makes this easy.

Handling Loader class event handlers is a bit different from previous examples in this chapter. Instead of applying addEventListener() directly to the Loader instance, you have to apply it, instead, to the contentLoaderInfo property of that instance. After that.

it's business as usual. Here we're listening for an *Event.COMPLETE* event and adjusting the scaleX and scaleY properties of the holder movie

clip to 45%. Again, this only works because the adjustment occurs after the image has loaded.

5 Create a third layer, name it scripts, and type the following ActionScript (top, right). Pretty familiar, huh? This line is identical to the corresponding line from the Loader example. The UILoader Component makes things a bit easier for you in that it turns the earlier three lines into one line of code.

At this point, you're set, but you'll probably want the progress bar to disappear after its work is done. You can take care of this with an event handler (bottom, right).

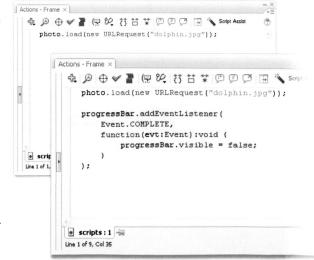

The addChild() line happens to give you some leeway. For example, create an empty movie clip and drag an instance of it to the Stage. Position it at 50 pixels in and 50 pixels down from the upper-left corner of the movie. Give this movie clip the instance name holder, and change that last line to holder.addChild(photo). This time, the image loads into the empty movie clip, which means you can easily position it where you like.

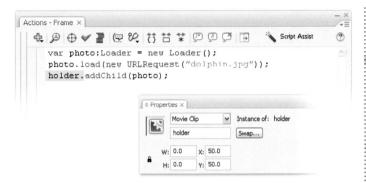

If you want to display load progress while an image loads, it's easy to do with the ProgressBar Component. Instead of the Loader class, we'll let the UILoader Component take over loading duties, which means you can also drop the holder movie clip. Starting with a new document, drag an instance of the UILoader Component to the Stage and give it the instance name photo. Create a new layer and drag an instance of the ProgressBar Component to the new layer. Give it the instance name progressBar. Select the progressBar instance and flip to the Parameters tab of the Property Inspector. Set the source parameter to photo. This associates the loading mechanism of the UILoader Component instance, photo, with the visual display of the progress bar.

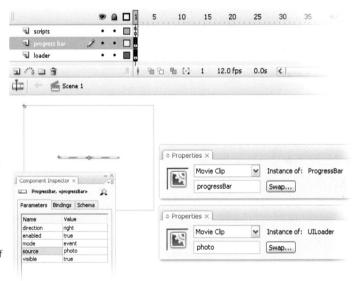

HOT TIP

The Parameters tab makes it easy to configure Components without having to use ActionScript. but if you prefer to code, you can program parameters by referencing the Component's instance name, then a dot, then the parameter in question. For example, step 4 would look like this: progressBar. source = photo.

You can test and simulate your movie by going to Control > Test Movie or using Ctrl + Enter on your keyboard. A new window containing your compiled SWF will open. Go to View > Bandwith Profiler to show a graph of the downloading performance. Go to View > Download Settings to select the bandwidth profile you wish to test with. Once you've made your selection, go to View > Simulate Download to emulate how fast your image will most likely load under these conditions. Keep in mind Flash can only estimate typical Internet performance and not exact modem speeds.

SHORTCUTS

MAC WIN BOTH

Loading images (AS2)

AS2 differs significantly in how it loads images. In fact, there's more than one way to do it. The approach that comes closest to the ease of AS3 involves the MovieClipLoader class. In this case, you'll want an empty movie clip. Again we'll call it holder, as before, to act as the container for your image which lets you position the JPG as desired. Loading the image isn't especially complicated, but responding when the load is complete ... that's a little more convoluted. Here's the easy part, first.

To recognize when the image has loaded, wc'll need to program an event listener using an instance of the Object class. This generic object will act as a liaison between the MovieClipLoader instance and its event handler function. In this case, the association is not as direct as it is in the AS3 examples. The name of the listener variable isn't important, but it's listening for events, so "listener" makes sense enough. This variable points

to an object, and the object is given an onLoadInit property, which is set to a function (the event handler). Why onLoadInit? The MovieClipLoader class provides quite a few events, listed in the ActionScript 2.0 Language Reference, and this is the one that not only states when content is loaded, but allows access to the properties and

```
Actions - Frame x

Actions - Frame x

The property of the prop
```

methods of the loaded content. The function references the holder movie clip and sets its _xscale and _yscale properties to 45%. Finally, the MovieClipLoader instance, photo, is associated with the listener object. Note, in AS2, under these circumstances, that method is addListener(), not addEventListener().

In this case, photo is an instance of the MovieClipLoader class. The name is a bit misleading, because this class also loads JPGs, GIFs and PNGs, depending on what version of the Flash Player you publish to (see the Help docs for specifics). The MovieClipLoader.loadClip() method is invoked on the photo instance, specifying the file to load and the movie clip to load it into.

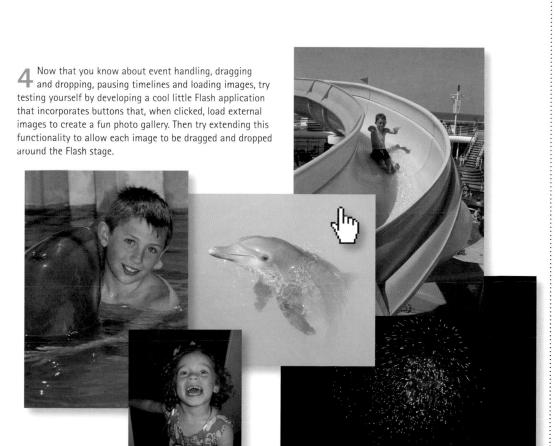

HOT TIP

Properties like alpha and scale belong to different camps, between AS3 and AS2. In ActionScript 3.0, these sorts of properties generally range between 0 and 1, which makes 22% look like 0.22. In ActionScript 2.0, these usually range between 0 and 100.

Objects, objects everywhere

WHEN PROGRAMMING IN FLASH, it's helpful to think in terms of something called objects. In the real world, an object is generally defined as a material thing, something you can hold in your hands, observe and possibly manipulate, like a Rubik's cube. As often as not, you'll find that multiple copies of a particular object can exist at the same time. For example, you might belong to a Rubik's fan club, where each member brings a cube to weekly meetings in order to see who can solve the puzzle the fastest. On one level, everyone's cube is the same; and yet, everyone's cube is also unique. Each cube can be

jumbled into millions of configurations, even though all are made in the same way from the same parts. Mr Rubik presumably has a blueprint for those parts in a filing cabinet somewhere.

Before we get too far afield, how does this analogy relate to objects in ActionScript? Let's look at the parallels. Just about everything in ActionScript can be

described as an object. This includes such "material things" as movie clips, buttons and text fields, as well as intangibles like dates, arrays (lists of things) and sounds. Each type of object has its own set of characteristics, comprised of distinguishing attributes, things it can do, or things it can react to. It is the particular combination of these characteristics that defines an object's datatype, the thing that makes an object the type it is. In order to create an object, its "blueprint" must be consulted. In ActionScript, this is outlined by something called a class.

Classes determine objects

Classes define an object's properties, methods and events. Properties are the attributes an object has, such as a movie clip's width and height. Methods are things an object can do, such as loading an external JPG or jumping to a certain frame label. Events are things an object can react to, such as a mouse click or the occurrence of a timeline frame. Conveniently, Flash's

the

documentation features two ActionScript Language References (2.0 and 3.0) that are closely structured around these classes. If you're dealing with a movie clip in ActionScript 2.0, search the phrase "MovieClip class" and you'll quickly dial in to a handy movie clip Owner's Manual. In ActionScript 3.0, just search "MovieClip". It's odd, but the documentation search is different between the two. As a general rule of thumb, omit word "class" when you're searching for classes in AS3. Many classes build off of each other, so don't forget to click any hyperlinks in the documentation that say "Show Inherited Public Properties", "Show Inherited Public Methods" and the like. Doing so

will give you the full picture of an object's capabilities.

If you're dealing with a text field, search "TextField class" (or "TextField"); if you're dealing with a sound, search "Sound class", and so on. By convention, class names are capitalized, and multiple words are combined into a single term. That makes it pretty easy to look things up. You just have to ask yourself two questions. First, "What object am I dealing with?" This will lead you to the necessary class entry. Then, "Am I trying to tell this object how to be, what to do, or how to react?" This will steer you toward the relevant property, method, or event summary. These tips should help you avoid a sense of "Where do I even begin?" when dealing with the built-in documentation.

Contributing author David Stiller is a career multimedia programmer/designer whose portfolio includes NASA, Adobe, and major US automotive and boat manufacturers. He likes anaglyph 3D photography, finely crafted wooden game boards, Library of Congress field recordings, and Turkish coffee. David is self-taught and gets a kick out of sharing "aha!" moments with others through consultation, mentoring and regular contributions to a variety of Flash forums. He lives in Virginia with his amazing wife, Dawn, and his beguiling daughter, Meridian. www.quip.net

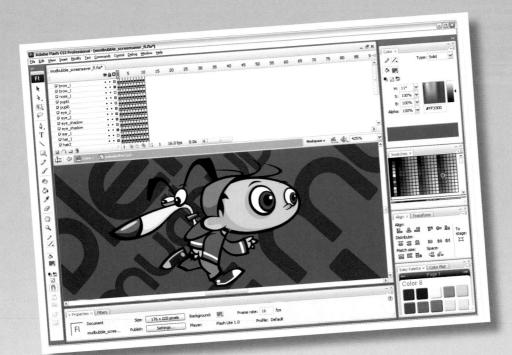

You may already have a hard drive full of Flash animations and applications that, with a little optimizing, could be repurposed for the mobile platform. From Flash to Adobe Device Central, you already have the necessary tools available for preparing your content for this exciting and fast growing platform.

Going mobile

THERE ARE CURRENTLY OVER TWO BILLION mobile device subscribers worldwide, surpassing the personal computer as the work and communication tool of choice. It is predicted by the year 2010 that the number of global mobile phone subscribers will increase to over 3 billion. If you are having difficulty deciding what platform to author content for, you may want to consider going mobile.

Mobile devices do have their limitations, however, processing power being the most significant, followed closely by lack of memory, small screen sizes and bandwith limitations as well. We'll look at how to create an animated screensaver for a mobile device and how to test its performance across all supported devices, even if you don't own one.

Going mobile

Creating a dynamic screensaver

Contributed by Vivek www.i2fly.com

LASH LITE ™ is the mobile version of Flash Player which is currently available in two versions: Flashlite 1.1 which is based on Flash 4 technology, Flash Lite ™ 2.0 which is based on Flash 7 technology and the upcoming Flash Lite ™ 3.0 which is expected to arrive in August 2007.

From interactive applications, games, browser, screensavers, wallpapers and more, Flash will continue to play a huge role in the mobile platform, providing creative opportunities to develop and design content for a variety of devices.

1 Create a new Flash document and click the Templates tab, then select Global Handsets. In the Templates column choose your appropriate device format. For this example we are creating a screensaver for the Nokia 40. Click OK.

2 You will notice your document has the appropriate stage size already set and there are two layers in the timeline. One layer contains ActionScript that you do not need for a screensaver. You can safely delete this layer.

Next create a new layer above the grass layer and drag the *heart* Movie Clip from the library to the stage. Double-click this symbol to see the animation already created. There's also a layer containing some ActionScript in frame 1

that randomizes the animation of this Movie Clip by varying its size and rotation. In the last frame there's some ActionScript that returns the heart symbol to the "0" position.

Occate the FPS-Meter extension from the source CD. Copy it to your hard drive and double-click it. The Adobe Extension Manager will launch automatically and prompt you to install the extension. Restart Flash (if necessary), and go to Window > Common Libraries > FPS-Meter Lite. FPS-Meter Lite is for flash lite 1.1 and FPS meter Lite2 is for Flash lite 2.x. Drag the FPS-Meter Movie Clip to a separate layer in your Flash Lite document and publish your movie. The FPS Meter provides accurate feedback when played inside the actual mobile device you are testing on. Based on your movie's performance, you may need to optimize your graphics, which is discussed in the next topic.

Next, create a background with the Rectangle tool (A) and a color fill. Make sure the shape extends just beyond the actual size of the stage.

4 Open *luv_i2fly.fla* from the source CD, and you will find a few movie clips and graphics in the Library for creating this screensaver.

dots

J bar

5 0 B

(中)

Actions - Frame X

ActionScript 1.0 & 2.0

Global Functions

ActionScript 2.0 Classes

Global Properties

5 Drag the *grass* movie clip to the stage and align it along the bottom edge, making sure it extends beyond the stage itself.

20

16.0 fps

Script Assist

= random(200);

3

HOT TIP

Do not leave unnecessary blank key frames or layers on your timeline. Empty frames and keyframes contain bytes, so it's always good to keep your timeline as clean as possible. While using vector graphics for mobile devices, it's always best to use the builtin optimization tool which you can find under Modify > Shapes > Optimize. Use the slider to adjust the amount of optimization based on your needs and the integrity of the shape(s).

Return to the stage and drag the bg_bar Movie Clip from the Library to the stage on a new layer. This Movie Clip contains some graphics to help add interest to our otherwise plain red background.

Double-click the *bg_bar* Movie Clip and you will find some frame actions that move the graphics randomly. Of course you also have the option to create timeline animations with keyframes. The result of using ActionScript to generate randomized motion is a smaller file size than if you created long timelines filled with keyframes and motion tweens.

99 9 []

•

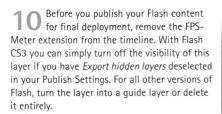

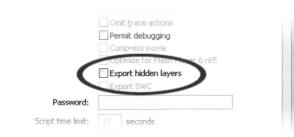

Going mobile

Optimization

Contributed by John Say (www.saydesign.com)

AME DESIGNERS who understand the limitations of the medium used to deploy the game, and especially those who have a programming background, are able to creatively solve performance issues at the highest level, that of the style and gameplay design. If you don't have the horsepower to make a compelling simulated 3D game, it is necessary to focus on a game design that perhaps can provide the same exciting gameplay that can still allow for a higher frame rate that delivers an exciting arcade experience.

limitations of the target platform are always a focus of the serious Flash game programmer. Because every game and every platform will be different, you can imagine how difficult it is to create some kind of formula or table that would make this an easier task. It is recommended to only go as high as you need for the particular game experience, and no higher. If the game plays well at 15 frames per second, then changing it to 30 frames per second is unnecessary and will most likely have adverse results. It is best to stick with the lower

The best way to become proficient at this is to build a wide range of games for a variety of platforms with varying system requirements. Flash Lite enabled devices, due to their limited processor speeds, require the game designer and programmer to think outside the box, or in this case the desktop PC. From a production standpoint it could save days, if not weeks, of code and graphical optimization if the developer simply focuses on a game mechanic and concept that is more "Flash Lite friendly".

value, especially when dealing with slower processors.

Frame rate

Bitmap graphics

Identifying optimal frame rates that map most effectively for both desired gameplay and

Unless your game really relies heavily on rotation and scaling, it is best to stick with bitmap graphics. Original art can be made with vectors, but then parsed into bitmaps in Photoshop. This allows you to keep the game running in low-quality mode and enjoy dramatic improvement in both the number of objects incorporated into the game as well as improved frame rate. You can increase the level of quality dynamically on game menus and screens that you wish to use vector art. When

the user enters the actual gameplay, force the quality back to low to optimize playback for both animation and ActionScript. As far as which graphic formats are optimal for bitmaps, there aren't any real hard-and-fast rules. Sometimes it is best to experiment with a few before you lock-down on any particular format. For critter crossing we stuck with 24-bit PNG format with 1-bit transparency to avoid making the processor have to deal with grayscale alphas. This we felt gave us a performance boost. But again, ultimately it is best to try a

few different approaches, test on the target device, and ultimately you will have the optimal strategy for your particular game.

Code optimization

There are so many great Flash game programming books out there that really go into detail of optimizing code. Flash Lite and the devices that employ it demand that one becomes adept at understanding what Code is friendly, and what work-arounds should be utilized in order to contribute to the desired end-result. The more you learn these "tricks of the trade", the more you can leverage multiple strategies to create outstanding results. Keep in

mind that just because the Flash Lite instruction set may give you a quick and easy way to create functionality for your game, you should still watch the frame rates achieved once deployed to the target platform. Benchmarking a few approaches to core functionalities is the best thing since you can find that perhaps one out performs the others by as much as 200%! There are some great resources on the net that contain various benchmarks for various programming functions in Flash. The main walk-away is that there are numerous ways

of accomplishing the same desired result or calculation in Flash. Nurture your optimization skills by building and benchmarking various techniques until you find the best solution, and can leverage those findings as you progress forward.

You will always have more compelling and engaging content than your competition because of your focus on creating more fluid and engaging experiences. This can only help push the proliferation of the technology into yet other devices and platforms, thus allowing a much larger audience to enjoy our content.

HOT TIP

The CPU can only do so much at any given time. If you learn to structure your calculations, sounds and especially animations in a way where things are happening in succession rather than simultaneously, you will avoid any choking points where things seem to come to a screeching halt.

Going mobile

'LL BE HONEST, the Flash Lite mobile platform was always an elusive technology for me. It may have been because I have never owned a Flash-enabled device, even as of this writing I still don't own anything that supports the Flash Lite™ player. Without a tangible mobile device, creating Flash Lite™ content has always been a disconnect for me. I'm the type of guy that needs to see the content perform with my own two eyes while holding it in my hands to be convinced and ultimately satisfied it really works - that is, until Adobe Device Central CS3 came along. The fog has finally been lifted from the mobile

device platform.

My Favorites Sample Device Set Flash Lite 1.1 16 176x208
Flash Lite 1.1 32 176x208
Flash Lite 2.0 16 240x320 Flash Lite Flash Lite 2.0 32 240x320 240 x 320 px Flash Lite 2 1 16 240 v 320 16 bit RGB 16 565 Generic 1.0 (1) Fujitsu 53 x 109 x 23 (ii) Kyocera LG Mitsubisi D NEC Nokia 3250 Nokia 5200 Nokia 5300 240 x 320 p: Nokia 5500 208 x 208 p □ Nokia 6085
□ Nokia 6125
② Nokia 6131 Nokia 6151 128 x 160 p Nokia 8800 208 x 208 ps

A wealth of information is available for each device just by clicking on the device profile folder. Detailed information about Flash Lite version, display size, operating sytem, networks and languages is just a sample of the information provided. There's even a handy search function available to help you quickly find the device you are looking for. Probably the biggest

Adobe Device Central CS3

File Edit Devices View Help

advantage of using Adobe Device Central is having the ability to preview and test mobile content for a wide range of mobile devices. You don't even need to own any of these devices to get a really good idea as to how your content will perform on them. Of course nothing is better than testing on the actual device(s), but that's not a realistic option for most of us.

When you test your Flash Lite ontent in Flash, Device Central will launch, allowing you to emulate your movie's performance in the included device skin. If your movie is designed to react to the device's hardware, you can test these features with your mouse by clicking the Emulator tab keypad directly or using the keyboard shortcuts that are specifically mapped to each button: The arrow keys on your keyboard map to the corresponding navigation keys, the Enter Return keys correspond to the Emulator tab select key, Page Up and Page Down keys correspond to the Emulator's left and right soft keys, and the number keys on your keyboard map to number keys on the Emulator keypad.

Your client has just asked you to help them develop mobile content over a variety of devices. Before Device Central, that may have been a difficult assignment from a technical standpoint. You can now organize your project by creating a custom device group in Device Central and drag the preferred devices to its folder. When you click on this folder, each device will be categorized by screen sizes. You can sort by player version, ActionScript version and content type from the drop-down menus. Click the Create button to launch Flash with a new document matching the profile for the device you had selected. Blissful integration.

4 In the Display category, adjust the level of backlight to simulate the characteristics of the device screen and how your content will be seen (or not seen). The Backlight slider lets you adjust the amount of backlight to simulate a device entering sleep mode. Some mobile device users lower their backlight brightness purposely to save battery power. When designing mobile content, check if the content is visible with low backlight. You can even simulate how the display might react to indoor, outdoor or sunshine lighting. Simulate Timeout, Contrast and Gamma features and even rotate the device if your content is designed for a landscape orientation.

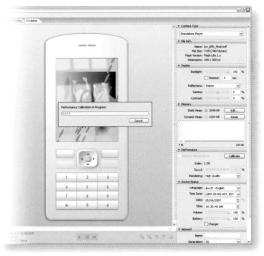

5 Simulate the performance of your content with the handy Calibrate feature. When you click Calibrate, the series of performance tests will begin measuring the performance of your content. There's no substitute for testing with the actual device itself, but that is usually not realistic when there's over 200 device profiles to choose from. Device Central is as close to real world testing as you can get without the device(s) itself.

HOT TIP

You can keep up to date with all mobile devices by selecting Devices > Check For Device Updates. Device updates are also available as part of the Adobe Update Manager process.

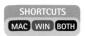

Cheap tricks

LAUNCHING FLASH FOR THE FIRST TIME can be an overwhelming experience. Between the multitude of panels and menus, knowing where to start can become frustrating almost instantaneously. My first experience with Flash was with version 3 many years ago when it was still in its infancy as a simple web animation program. I had the luxury of incrementally growing with each version of Flash through the years. With the latest CS3 toolset Flash has to offer, feeling a bit intimidated and not knowing where to start can be normal. At least now, with Flash CS3 and its integration into the entire suite of Adobe products, there's a better chance you might feel a little more at home with the general interface. Here are a few tips and tricks I have found useful in my daily workflow that aren't all documented in the Help files.

The new Edit Bar performs a variety of helpful tasks. Alternatively it can be removed completely by going to Window > Toolbars > Edit Bar.

As you might already know, double-clicking a symbol instance on the stage will bring you to Edit in Place mode. What you might not know is, to return to the stage just double-click anywhere outside of your artwork in the stage area to return to the parent timeline.

With an object on the stage selected, zooming in to the stage using the keyboard shortcuts Ctrl + = and Ctrl + - will always keep the selected object centered.

You can specify any directory for your published files by clicking on the folder icons to the right of the format file name fields. Go to File > Publish Settings and click on the Formats tab. When you click a folder icon, you will be prompted to locate the new folder on your local hard drive. You can even provide a new name for your published files as well. If you ever want to return to the default name and the default directory, click the Use Default Names button.

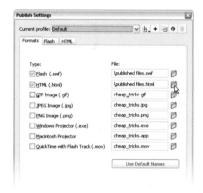

Toggle the Tools panel between the new CS3 single-column format and the older style two-column layout by clicking the arrows in the upper left corner.

You can change the default document properties every time you create a new Flash document by opening the Document Properties panel (Ctrl + J) and making your preferred changes. Before clicking OK, click the Make Default button to force your

Want a quick way to remove all the contents of the stage for the current frame? Double-click the Eraser icon in the Tools panel.

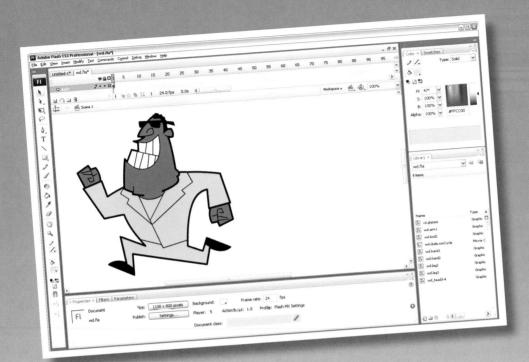

■ The default layout for Flash, above, is suitable for most users, but in time can become limiting. The addition of a few custom extensions and commands, right, can add a whole new toolset to Flash and an enhanced workflow.

Extending Flash

FLASH OFFERS A WIDE ARRAY of features for designing and animating. As great as it is, Flash can sometimes lack some of the functionality that you might benefit from. There always seems to be some drudgery that ought to be automated or some desperately needed tools that simply don't exist. Other than petition Adobe for these coveted new features, what's a poor "Flasher" to do? Thankfully, since Flash MX 2004, the curious and proactive Flash user has an alternative: Flash JavaScript, or JSFL for short. JSFL is a scripting language that interfaces directly with the Flash authoring environment. In a nutshell, it allows you to create your own Flash extensions.

Contributed by Dave Logan www.dave-logan.com

N EXTENSION is basically a plug-in, something

that is added to Flash and extends its functionality. JSFL only affects the Flash authoring environment (i.e. Flash CS3) and has no effect on published Flash Player files (i.e. .swf files).

The best part about JSFL is that anyone can use it to speed up and improve their workflow. JSFL is based on the ECMAScript standard, which means it's very similar to other languages based off the standard, such as JavaScript and ActionScript. If you don't know anything about programming, you're still in luck. You can create custom commands without touching a line of code. The best way to dive into JSFL is to play around with the History panel. To open the History panel, go to Window > Other Panels > History.

Select the Rectangle tool **(A)** and draw a rectangle. As you can see, the History panel behaves like it does in most Adobe programs, compiling a list of your actions.

5 Now go to the Commands menu, and lo and behold, there it is! Your very first Flash command. You can make all kinds of simple commands like this. If you find yourself doing some simple action over and over, create a command for it!

2 Select the Rectangle and delete it. You'll see each action added to the History panel.

3 Select the first event, Rectangle, which popped up when you drew the rectangle. Press the "Replay" button. Voila! The original rectangle reappears.

A Now let's make it into a command. Click the floppy disk icon in the lower right-hand side of the History panel to save this command. Name it something like "Create Rectangle".

6 Afterwards, you can access the command even more easily by assigning it a shortcut by going to Edit > Keyboard Shortcuts.

There is a catch, however. Use the Brush tool to draw something on the stage. Look in the History panel. Notice the little red X next to the Brush event? That means that you can't use it in a command. To put it simply, Flash treats some tools a little bit differently than others, and because of that you can't use them in your commands. The important thing to know is that the History panel can be used as the foundation of custom commands. This goes far beyond replicating rectangles.

HOT TIP

To add your own shortcuts, you have to create your own shortcut set. It's easy. In the Keyboard **Shortcuts** window, click the little **Duplicate Set** button with two pieces of paper and an arrow at the top right. Name your set (it doesn't matter what) and press OK. Now you can modify and add your own shortcuts.

2 Extending Flash

Trace Bitmap and JSFL

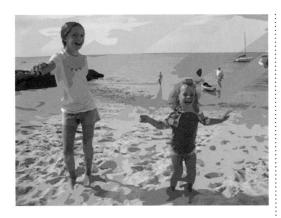

eT'S SAY YOU'RE WORKING on a project and decide to give some video an artsy rotoscoped effect. A great way to achieve this in Flash is with the Trace Bitmap command. Trace Bitmap converts bitmap images into vector graphics that can be edited using Flash's drawing tools. Using a video program such as After Effects or QuickTime, you can export the footage as a sequence of images and import them into Flash, ready to be traced.

But the Trace Bitmap command only works for one image at a time. That means to trace a series of images, you must tediously apply the effect to each and every image. Luckily, this is just the type of task JSFL excels at automating.

Tirst, you need to apply the Trace Bitmap effect to one image. Import the image sequence from the CD by selecting File > Import > Import to Stage and navigate to *image_sequence001.png*. Select image_sequence001.png and click Open. A menu will pop up asking if you want to import all of the images in the sequence. Click Yes.

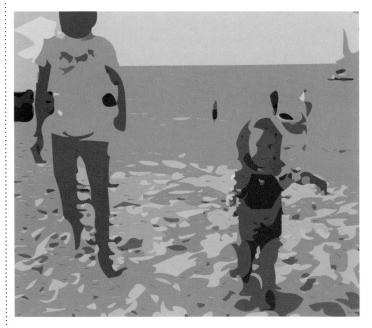

The Trace Bitmap panel also allows you to preview your current settings before committing to them. Change any of the setting values and click on "Preview" to see how they will affect your image. When you're happy with the results, click "OK". Depending on the complexity of the image, Flash will pause briefly while it converts the image into a series of vector shapes.

2 Each imported image will be placed in its own keyframe on the main timeline. You can play your movie to see the "video" play as a sequence of frames.

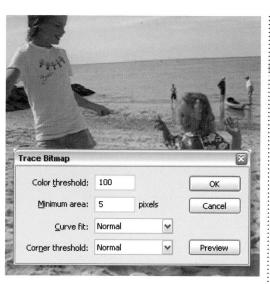

3 Select the image in frame 1. Go to Modify > Bitmap > Trace Bitmap. In the Minimum Area box, type "5". This makes Flash re-evaluate what color to use for every 5 pixels instead of every 8, which produces a more realistic looking trace. Don't click "OK" just yet.

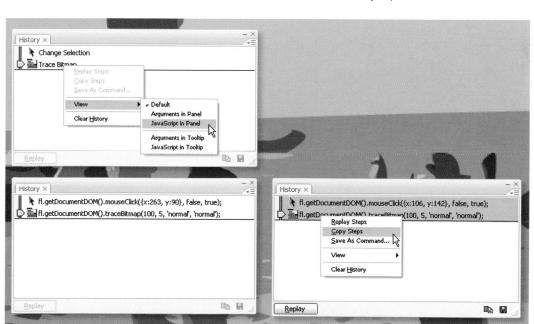

5 Next, right-click on the History panel and select View > JavaScript in Panel. The History panel will update itself, displaying the JavaScript for the commands you just executed.

6 Don't worry if the first set of numbers is a bit different than yours. They correspond to the exact coordinates on the screen that you clicked on to select the image. Copy these steps by selecting them, right-clicking and selecting Copy Steps.

(Continued...)

HOT TIP

Be careful about your Trace Bitmap settings. The more complex your images are, the more vector information may be generated during the trace function. This can quickly lcad to a very processorintensive Flash movie, especially if you plan to animate these images. It is also common for the resulting trace to create a larger file size than the imported bitmap alone would. Resize your images as small (width and height) as you can and your sequences as short as possible before importing into Flash.

Trace Bitmap and JSFL (cont.)

(Continued...)

OW DO I KNOW about all this JSFL stuff?

Maybe you are thinking I have all of the JSFL methods and arguments meticulously memorized? Not exactly (although that would be convenient and pretty impressive at the next Flash conference I attend).

The secret is, I clicked on the word *mouseClick* and the word *traceBitmap* and hit F1 (Flash help docs). Flash's Help panel popped up and instantly took me to the entries I selected for these methods. Whenever you get stuck or confused, your first stop should be the help docs.

7 Go to File > New and select Flash JavaScript File. If you are not running Flash CS3 Professional, you'll notice there is no option to create a new Flash JavaScript File. Don't worry, just open up a text editing program like Notepad and carry on. JSFL in the end is just a text file, so it doesn't matter how you create it. Paste the code that you copied from the History panel.

9 Let's shorten the code we have so far to something a bit more manageable. We'll do this by creating a variable. Add the code to the beginning of the existing code.

```
trace_bitmap.fla* | Script-1* |

the power of the process of the p
```

11 While we're at it, let's define a few more variables. The first new variable, tl, is another abbreviation. It refers to the document's timeline. The curLayer variable refers to the currently selected layer (which it gets from the currentLayer method), and the current frame we're on (which, again, it gets from the currentFrame method).

```
trace_bitmap.fla* | Script-1* |

var doc = fl.getDocumentDOM();

var t1 = doc.getTimeline();

var curLayer = tl.currentLayer;

var curFrame = tl.currentFrame;

doc.mouseClick((x:117, y:160), false, true);

doc.traceBitmap(100, 5, 'normal', 'normal');
```

B Let me explain a bit of the gibberish that you're looking at. The fl at the beginning of both lines refers to, you guessed it, Flash itself. The getDocumentDOM() method tells Flash that we wish to work with the currently active Flash document. Both mouseClick and traceBitmap are pretty self-explanatory; the former is the method that describes a single mouse click, and the latter is the method which actually turns the image into a bunch of vectors.

HOT TIP

Variables can

named whatever

generally be

you like, but there are a few rules: no spaces in the names, no punctuation except for _ or \$, and don't

start the name

with a number.

The stuff inside the parentheses is the arguments that are passed to these methods. So the first line tells Flash to execute a mouse click at x:117 and y:160 within the active document (the false and true after the coordinates have to do with whether the Shift key is down). The second line tells Flash to execute a bitmap trace with the parameters you set when you went to Modify > Bitmap > Trace Bitmap. The threshold, or number of colors in the tracing, is set to 200, the minimum area is set to 5, and the curve fit and the corner thresholds are both set to normal. The ; at the end of both lines tells Flash that the line of code is over. Think of it as a period in a sentence.

10 Now go down to the next two lines of code and replace each fl.getDocumentDOM(); with the more elegant doc. So now you should have something like this.

```
trace_bitmap.fla* | Script-1* |

the A | The Color | The Color | The Color |

var doc = fl.getDocumentDOM();

doc.mouseClick({x:117, y:160}, false, true);

doc.traceBitmap(100, 5, 'normal', 'normal');
```

You now have variables that know what frame the user is on. Now let's find out how many frames are in that layer. In line 5, the frames property at the very end of that line returns an array, which gets stored in the frameArray variable. An array is basically a list of items. In this case, it's a list of frame objects. Arrays have a length property that tells you how many items are in the array, that's what's getting stored in the *n* variable from the expression frameArray.length in line 6. (If an array represented a year, it would have a length of 12, for each month.)

```
trace_bitmap.fla* Script-1*

var doc = fl.getDocumentDOM();

var tl = doc.getTimeline();

var curLayer = tl.currentLayer;

var curFrame = tl.currentFrame;

var frameArray = tl.layers[curLayer].frames;

var n = frameArray.length;

doc.mouseClick((x:117, y:160), false, true);

doc.traceBitmap(100, 5, 'normal', 'normal');
```

(Continued...)

12

Extending Flash

Trace Bitmap and JSFL (cont.)

trace_bitmap.fla* | Script-1*

3

4

6

7

8

9

10

11

12

\$ B V = @ 0 t t t # D D D I ■ ▶

var doc = fl.getDocumentDOM();

var tl = doc.getTimeline();

(Continued...)

13 Now we have a variable that knows how many frames are in our selected layer. Why is this important? When you imported the image sequence, Flash put each one on its own frame. We want to use the Trace Bitmap command on each one, so the script has to know how many there are so it can tell how many times it should run the command.

15 All that's left is finding a way to make Flash run the *traceBitmap* method for every frame. Luckily, that's pretty easy to do with a *for loop*. A *for loop* is a type of control flow statement. A control flow statement is basically a way to change the normal flow of

A for loop is a type of control flow statement. A control flow statement is basically a way to change the normal flow of a program, one line after the other. For loops are ideal for going through lists of data, or an array of frames. The important parts of a for loop are within the parentheses. The first part, i = 0, declares that the variable i is initially set to 0. The second part, i < 10, is the condition.

part, i < 10, is the condition. This means that the code contained within the brackets will only be executed if this condition is met. In this case, the condition is that i is less than 10. The third part, i++, tells the script what to do after each iteration, or turn. Each time the condition is met, the contained code is executed, and afterwards this statement is executed. Each time the code is executed, the value of i will be increased by 1. As complex as it looks, it's pretty simple in function. So the loop starts out

at the currently selected frame, and as long as the current frame is less than n (that is, less than the length of the layer), the code within the brackets will be executed and the image will be traced. Finally, tl.currentFrame = i + 1; sets the current frame to the value of i (already the current frame) plus 1, which puts us on the next frame.

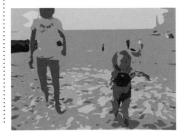

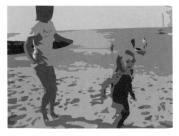

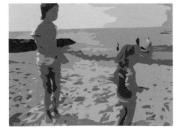

Next, add a command to lock every layer other than the one you're using. Why are you doing this? Because you need a better way of selecting the image we are going to trace. What if you have an image that doesn't end up in the area you clicked when you first ran the Trace Bitmap command? The script will fail. So instead of simulating a mouse click, you're going to lock all the other layers and then perform the selectAll method. The selectAll method does the same thing as using **A** **A** **A*** **A***

```
trace_bitmap.fla* | Script-1*
1
   var doc = fl.getDocumentDOM();
2
   var t1 = doc.getTimeline();
3
   var curLayer = tl.currentLayer;
4
   var curFrame = tl.currentFrame;
5
   var frameArray = tl.layers[curLayer].frames;
6
   var n = frameArray.length;
7
   tl.setLayerProperty('locked', true, 'others');
8
   doc.selectAll();
9
   doc.traceBitmap(100, 5, 'normal', 'normal');
```

HOT TIP

Programmers often start for loops with 0 rather than 1 because arrays happen to start counting at 0. By matching these starting numbers, the for loop easily keeps pace. Frames, however, start at 1, which explains the arithmetic in line 11.

16 You're done! All you have to do is save the command with a descriptive name, such as *Rotoscope.jsfl*, in the Commands folder on your local drive. See the Interlude at the end of this chapter for the folder paths for your operating system. Once you have the command saved, you can import an image sequence into a new document and go to Commands > Rotoscope. Now that all this legwork is done, whenever you want to get this hand-drawn effect, all you have to do is import the images and run the Rotoscope command. And it only took 12 lines of code!

This is just scratching the surface of what is possible with JSFL. As you can see in the following pages, some amazing additions to the program have been created by normal Flash users like yourself. If you're intrigued, I highly recommend the book *Extending Flash MX 2004* by Keith Peters and Todd Yard. While the book is a bit old, JSFL hasn't changed much in the last few incarnations of Flash, and the instruction is still very valid. And, of course, there's always the internet. Do a search for JSFL, hunker down in your computer chair, and make some kick butt extensions!

Easy Palette

Easy Palette is a color management system developed by Dave Logan that gives you a friendlier and more useful way to manage custom palettes. Easy Palette will allow you to name colors to speed identification (useful for groups that are working on the same project), save and load custom palettes (useful for easily applying color schemes across various documents, or to have specific palettes for each character in your animation), and quickly navigate through saved colors.

This extension is available on the source CD along with several more extensions provided by many kind and generous designers and developers around the world. Check out the Interlude at the end of this chapter for more information.

AnimSlider Pro

IMP MY PROPERTIES PANEL! Warren Fuller of animonger.com has developed one of the most popular Flash plug-ins for animators. It's called the AnimSlider and it is simply indespensable if you use Flash for animation. In a nutshell, this plug-in literally does everything the Properties panel does, but better and with many more features. Think of it as a one-stop panel for almost all your animation needs. AnimSlider is so useful that it is the first plug-in I install after installing or upgrading Flash. It will save you valuable production time and, as a result, will pay for itself many times over the more you use it. There's a trial version avialable on the CD in the back of this book. You can also download the trial or purchase the full version at animonger.com.

Swatches X

- X
- E
- I

Warren has developed an NTSC color safe palette that can be imported into the Swatches panel. This is a free *.clr file included on the CD with this book or from Warren's website. To use this palette, open the Swatches

panel and click on the upper right corner drop-down arrow. Select Add Colors or Replace Colors and navigate to the NTSC.clr file on the CD provided or if you downloaded it from Warren's website to your local hard drive. You can learn more about color safety and video in Chapter 6.

The AnimTools plug-in is a panel that includes the same editing

tools found in the AnimSlider panel but conveniently grouped together for your convenience. The AnimTools panel includes two additional features that the AnimSlider panel does not.

The New Folder Tree feature creates a folder hierarchy in the current document's Library

with one simple click. Type in a folder name in the pop-up dialog panel and click OK. Open the Library panel and notice your new folder tree created for you. This will greatly enhance the organization of your Flash file.

The Move to Existing Folder feature allows you to move Library items to existing folders. Select the objects in the Library you want to move, and click the Move to Existing Folder button. In the path dialog box, type in the case-sensitive name and path of your folder. For example, to move the selected items to a folder named "Arms" inside a folder named "Joe", type "Joe/Arms".

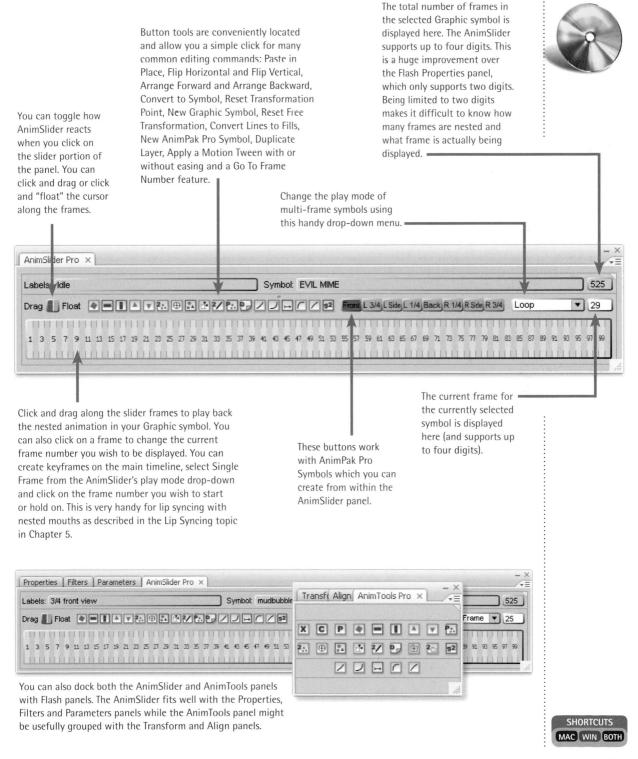

ik'motion

HE KNEE BONE'S CONNECTED TO THE...well you get the idea. Here's a super cool extension that provides a feature sorely lacking in Flash: Inverse Kinematics (IK). The iK'motion toolset utilizes Flash's powerful extensibility layer to deliver dynamic inverse kinematics animation capabilities directly to the designer! These tools and commands give you the ability to create parented IK chains, manipulate movements and automatically generate tweens on the timeline, all within the standard flash IDE.

This awesome extension can be found on www.flashextension.net, where you will find a cool collection of extensions, components, tools, vector artwork, sounds and other add-ons for the Flash authoring tool.

After installing the iK'motion plug-in, go to Window > Other Panels and click on "iK'motion" to launch the iK'motion panel. The interface is clean and easy to navigate.

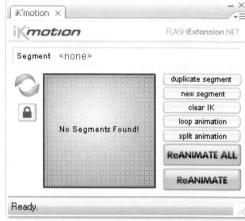

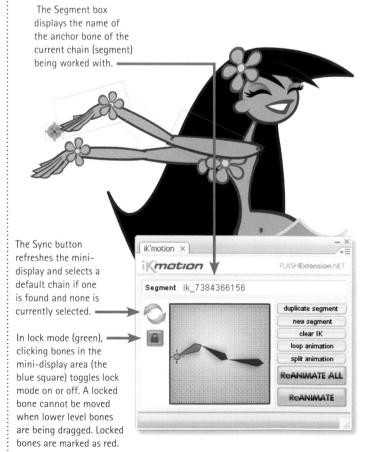

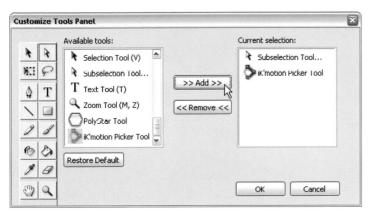

Go to Edit > Customize Tools Panel. Here you can add and remove various tools to and from your Tools panel. From the table of tool icons on the left side of the dialog, select the tool that you would like to have the iK'motion picker tool appear underneath. A good choice might be the white arrow (Subselection Tool). After clicking the icon, scroll to the bottom of Available Tools and select the "iK'motion Picker Tool". Click the ">> Add >>" button. You should now see the iK'motion Picker Tool in the list under "Current selection".

HOT TIP

In order to make a Flash symbol usable by iK'motion it must be a Movie Clip. Graphics, **Buttons**, Shapes and other symbol types cannot be used. If your instance is not set as a Movie Clip, you can change it by selecting the instance on the stage and then selecting "Movie Clip" in the type drop down box inside the Properties panel. This extension comes with its own online tutorial that goes beyond what you see here. So be sure to check out all the features that this must-have tool offers on flashextensions. net.

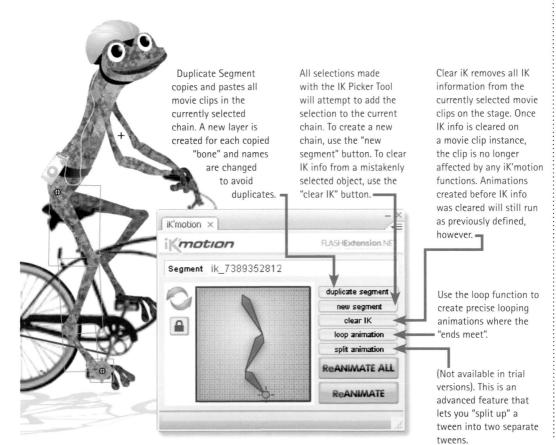

SHORTCUTS

MAC WIN BOTH

Extending Flash

Swift 3D Xpress

WIFT 3D XPRESS is a 3D extension for Adobe Flash that allows users to convert drawings and text on the Flash stage into 3D animations without having to leave the Flash interface. Swift 3D Xpress is a revolutionary 3D extension (plug-in) that allows users to quickly convert 2D text and artwork into 3D animations without leaving the Flash interface. Vector objects on the Flash stage can be brought into the Swift 3D Xpress interface and customized using pre-built animations, lighting schemes and materials. The 3D scenes are rendered and placed into a specialized movie clip in Flash's Library for further use or future editina.

Swift 3D Xpress is a very easy and intuitive tool to use. It provides instant results and real-time 3D feedback when applying materials and animations. It's great for making anything from animated logos to animated buttons and more.

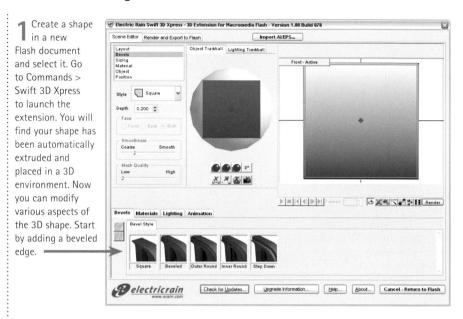

3 Click on the Lighting Trackball tab to edit the lighting of your 3D scene. How you adjust the lighting of your scene is directly related to how the materials of your object will look after being rendered. The placement of each light and the number of lights will affect the color contrast of the object. Experimentation here is key. There are several variations of animations that

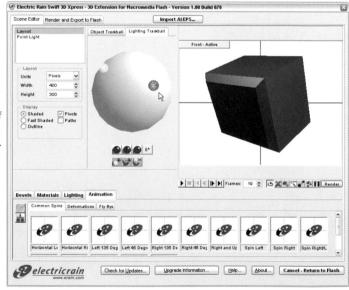

can be added to your object. Click on each thumbnail in the Animations panel to see a preview of the animation. Once you have decided which animation to use, drag and drop it to your 3D object in the Viewport.

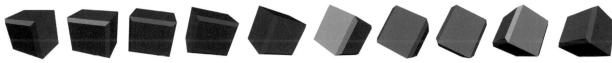

© Electric Rain Swift 3D Xpress - 3D Extension for Macromedia Flash - Version 1.00 Build 078 Click and drag the Object trackball to rotate the selected object. You Import Al-EPS... Object Trackball Lighting Track can also have the option to lock the Sizing Materia rotation based on its horizontal and/or vertical axis. Bevaled V Click on "Sizing" in the upper left menu 1.150 🗘 and adjust the amount of depth to O Front O Bade @ Both create a cube. You can apply different materials by To Kender clicking and dragging your preferred Bevels Materials Lighting Animati material from the Materials panel directly to the surface of your 3D object. = 99 electricrain Check for Updates... Upgrade Information... Help... About... Cancel - Return to Flash

Flectric Rain Swift 3D Xpress - 3D Extension for Macromedia Flash - Version 1.00 Ruild 87

4 When you are satisfied with your work, click on the "Render and Export to Flash" tab. You have two format options to export to: Vector and Raster. Each will generate an image sequence that can then be converted to a Movie Clip or an SWF file.

The Vector format provides several options such as various Fill and Outline styles. You can also render Specular Highlights, Reflections and Shadows.

The Raster format also provides some options such as Quality level, Color Depth as well as Antialias Quality.

Once you have chosen your desired settings, click on Render Frames. Swift 3D Xpress will render each frame of the animation that can also be played within this same panel using the playback controls.

If you choose Create Flash Movie Clip, a Movie Clip containing your animation will be added to your Flash Document's

Library. You can then drag it to the stage and incoporate it into your Flash project. If you choose Export to SWF File, Swift 3D Xpress will provide you with the option to name your SWF file and choose a location on your hard drive to save it to.

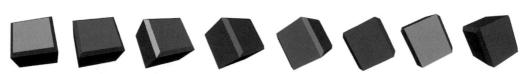

HOT TIP

You can apply various styles of beveled edges to your 3D object and control the depth of the bevel as well. Chose from Square (no bevel), Beveled, Outer Round, Inner Round and Step Down. You can even apply a material to the beveled edge that is different from a material chosen for the object's surface(s). You may also want to check out Swift 3D, the full standalone version from Erain (erain.com). It has all the same features of the Xpress version plus an advanced 3D modeling environment, **Animation Path** tools, Extrusion and lathe editing tools and more!

SHORTCUTS

MAC WIN BOTH

2 Extending Flash Flashjester

HE LIST OF FEATURES that Jugglor and Creator offer are so extensive, it is simply impossible to fit them all on just these two pages. As an animator, you'll be excited about Jugglor's Desktop Pet feature. Extend the interactive capabilities of your Flash animated character by dragging, dropping and bouncing your character around your desktop. This only scratches the surface of Jugglor's full range of features and to really gain an understanding as to how Jugglor can fully extend your Flash projector files, visit their website (www.flashjester.com) for a: comprehensive feature list.

Creator is a screensaver creation tool from Flashjester that provides everything you need for converting your Flash movies to screensavers.

1 Jugglor provides the option to specify detailed information about your movie such as a title, a new Juggled name, the path to where you want the Juggled file, the size of the compiled projector file and detailed information regarding the movie's player version, size, width, height, frame rate, etc.

Jugglor's ActiveX settings allow you to control how your desktop pet will be rendered, how it will play or loop, customize the right-click menu and much more. I have included on the source CD a file named mudbubbleDesktopPet. fla. Open it and locate the layer named "Rightclick menu". Select the Movie Clip instance in this layer and open the Actions panel to see the right-click menu code.

Jugglor's setup settings offer plenty of options for customizing the level of interactivity, right-click menu visibility, mouse and keyboard interaction, icon tray support and even Joystick support. You can also specify if and when you want your file to expire.

Creator

1 Creator shares a user interface very consistent with Jugglor. After launching Creator, start your screensaver project by populating the available fields in the General Settings section. This information will be available in the screensaver settings menu after it has been installed to the computer's operating system.

If your Flash file includes mouse events, or any type of interaction, Always have Interaction will allow interaction with the screen saver without closing it. You have the option of including or muting sounds or leaving it for the user to choose. Creator supports right-click menu options and multimonitor support. You can also set your expiration by run times (number of times it is executed), by a certain date, or after a certain by-day period (example, a 30day trial).

This screen is the illian accion in creating a screensaver. This screen is the final step It allows you to build your final project into an .scr screensaver file, and an .exe installer file. Additional files may be created, depending on which options you choose. Creator produces screensavers that are ready for distribution. Simply zip them or copy them to a storage medium, and you're ready to get your product out there. No plug-ins are required to run Creatorcompiled screensavers! Creator bundles all required plug-ins so your users don't have to worry about them.

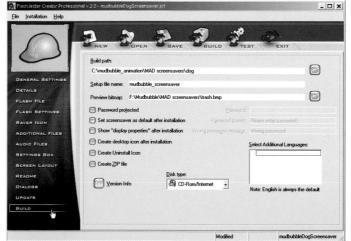

HOT TIP

Flashjester also makcs a great tool called JShapor that allows you to customize the shape of your projector files. Without JShapor, projector files published from Flash will always be square, specifically the width and height you specified in the document's properties. Using JShapor's transparency tool, it's easy to shape the projector however you want.

Pimp my Flash

GETTING THE BEST OUT OF FLASH can sometimes mean customizing it to suit your needs. Since Flash MX 2004 and the introduction to JSFL, many commands and extensions have been developed to enhance your Flash workflow. From custom JSFL commands to customizing the panel layout to customizing keyboard shortcuts, Flash can truly be molded into a tool that suits your personal design and animation preferences.

Many of the available extensions for Flash are installed via the Adobe Extension Manager. The AEM is installed along with Flash CS3 and will launch automatically when you double-click a file with the ".mxp" extension. Once installation is complete, Flash will need to be restarted before using the extension. Clicking once on the name of each extension will update the bottom panel with a description of what the extension is designed to do. These descriptions are written by the developers of the extensions and often include a URL that explains in more detail how the tools can be used in various workflow envirments. In some cases, the developer has links to video tutorials, extension

ile Help	,						
3	1	Flash CS3		- 1		②	
On/Off	Installed Extensions		Ver	ion	Туре	Author	
~	AnimSlider Pro		1.0.4 0.9.9		Flash Dynamic Panel	animonger	
~	Autocolor				Flash Dynamic Panel	Dave Logan	
~))	D Colot Plot		1.0.2		Flash Dynamic Panel	Michael Gioffredi
~	JA.	Create Masking Layer		1.0.2		Command	Dave Logan
~	Enter Graphic at Current Frame		1.0.3		Command	Dave Logan	
~	do	us iK'motion		1.0.0		Suite	flashextension.net
NNNNNNNNNNNNNNNNNNNNNNNNNNNNNNNNNNNNNN	2	Keyframe Jumper		1.0.0		Command	Dave Logan
~	P	Merg	e Layers	1.0.0)	Command	David Wolfe
~	2	Phireworx Stage Scaler for Flash 8		1.0.0		Command	Phireworx
~	N	Pixel	Tools	2.0.1)	Flash Tool	Patrick Mineault - Setdemi.com
~	63	Potag	penko.com flash extensions	1.0.3	2	Other	Eugene Potapenko
~	2	reani	mator Camera	1.0.1	1	Command	Sockpuppet pty ltd
~	7	Skip Around		1.0.1		Command	Dave Logan
~	de	Symb	polize Frames	1.0.3	2	Flash Component (FLA)	
~	62	Timin	ng Chart	1.2.	1	Other	David Wolfe
hecking	up y	our br	is: Next Keyframe and Previous K reakdowns. Assign to keyboard st a the Commands menu				

updates and contact information.

Here are some more custom commands and plug-ins included in the "Extensions" folder on the source CD - thanks to your friendly neighborhood Flash users and the community at large. It's all about sharing what we learn and the contributors to this book are testament to that. Warm fuzzy feelings all around.

Dave Logan	Dave Wolfe	David Stiller
(dave-logan.com)	(toonmonkey.com)	(quip.net)
AutoColor.mxp	drawGuide.mxp	Apply Motion Tween.jsfl
CreateMaskingLayer.mxp	frameEdit.mxp	Apply Shape Tween.jsfl
CustomZoom.mxp	frameExit.mxp	mudbubble_Pause.mxp
DefaultColorsMX2004.	layercolor.mxp	$mudbubble_FPSMeter.mxp$
mxp	libAppend.mxp	Urami
Easy Pallette.mxp	mergeLayers.mxp	(Urumqi Malaysia & NjQuality.
Enter Graph Cur Frame. mxp	MultiSwap.mxp	com)
FrameAllLayers.mxp	New Anim Clip. mxp	Bitmap Smoothing Multiple.js fl
KeyAllLayers.mxp	TimingChart.mxp	Bitmap Smoothing Selected. js fl
Label Jumper.mxp	toggleGuide.mxp	Filter Set Selection.jsfl
Rotoscope.jsfl	toggleOutline.mxp	Filter Set All.jsfl
SkipAround.mxp	trace Sequence. mxp	Jarred Hope
SquashAndStretch.mxp	tween2keys.mxp	Camera.mxp
SwapColorsMX2004.mxp		Miscellaneous
SymbolizeFrames.mxp		StageCrop.jsfl
ViewLayer.mxp		

Some of the JSFL commands on the source CD include a *readme* file to help explain what they do when you run the command. Remember, any command can have a custom keyboard shortcut assigned to it for quick access.

For scripts that will appear as items in the Commands menu, save the JSFL file in the Commands folder in the following location:

Windows 2000 or Windows XP:

 $boot\ drive\ Documents\ and\ Settings\ Local\ Settings\ Application\ Data\ Adobe\ Flash\ CS3\ language\ Configuration\ Commands$

Windows Vista:

 $boot\ drive \ Users \ Vara \ Local \ Adobe \ Flash CS3 \ Varage \ Configuration \ Commands$

Mac OS X:

Macintosh HD/Users/userName/Library/Application Support/Adobe/Flash CS3/language/Configuration/Commands

What's the difference between these two photographs? Answer: in the top one I am highly productive, talking to the client while simultaneously animating and listening to John Mayer's Try! album. In the bottom photo I've long since completed and delivered the project on time and am currently lining up a ten foot putt at the local golf course.

Time-saving tips

HAVE YOU EVER LEARNED the hard way, that the project you finally finished for your client took two to three times longer to complete than you originally estimated? There's no worse feeling than realizing you broke even or possibly lost money because you underestimated your own productivity. Are you really too slow? Was the project more difficult than you originally thought? It's important, as a successful designer and animator, to hit a grand slam home run with each and every project. Nothing makes a client happier when you meet and exceed their expectations to deliver on time. Think of it as job security. If you keep the client happy, they will always come back to you.

There are several ways to speed up your workflow. If you're desperate for some rock solid time-saving techiques, then this chapter is for you.

Time-saving tips

Keyboard shortcuts

eyboard Sho	rtcuts		
Current set:	Adobe Standard	▼ € Ø B	
Commands:	Drawing Menu Commands	₩ Duplicate Set	1
	File Edit Iview Insert Modify Text Commands Comtrol		100
Description:	⊕ Debug		*
Shortcuts:	+ -		•
Press key:		Change	
		OK Cancel	

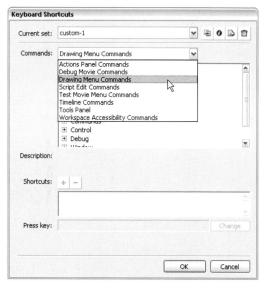

2 Commands are categorized and selected using the Commands drop-down menu. For now let's choose the Drawing Menu Commands category.

T MAY SEEM LIKE AN OBVIOUS TIME SAVER, but in my teaching experience, I have found that the majority of Flash users do not take advantage of creating their own set of custom keyboard commands. How often have you used the drop-down menus to apply a motion or shape tween, a transformation to an object or scrolled endlessly to get to the end of your timeline? All those mouse clicks add up to a substantial amount of time during the course of your production workflow.

Why not assign your own set of custom key commands for your most repetitive tasks? Just because Flash buries the Flip Horizontal under the Modify > Transform menus doesn't mean you have to drill down that far every time you need to flip something. If you are a designer or animator you know just how many times in a single work day you need to perform this task. Assigning key commands will save you valuable production time throughout the course of a day, a week, a month and beyond.

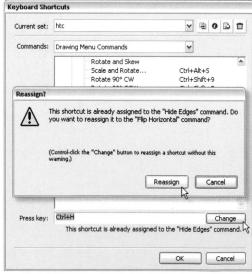

5 If you choose a shortcut key combination that is already assigned to a different command you will be prompted to reassign or cancel your choice. Since I rarely use the Hide Edges command, I reassigned (**) H to Flip Horizontal.

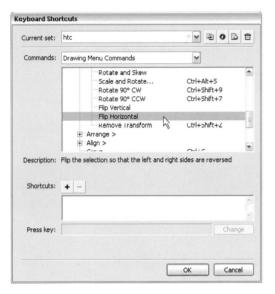

Click on the "+" symbols to drill down the menus to locate the command you wish to assign a shortcut to. You will notice the structure is exactly the same as the drop-down menus in the Flash IDE. Go to Modify > Transform > Flip Horizontal.

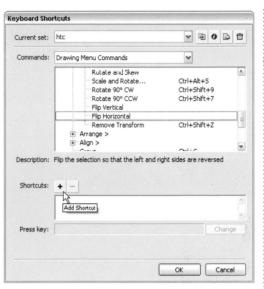

4 Click the "+" symbol next to Shortcuts to add a shortcut. The Press Key field will become active, allowing you to press the key combination you wish to assign to the chosen command.

HOT TIP

If you use a Wacom tablet, consider editing the exported HTML file by grouping and sizing your most common commands so they can be printed out and placed under your tablet's transparent overlay.

6 As you continue to assign shortcuts to various commands, you may realize committing them all to memory might be a challenge. Click the Export Set as HTML button in the upper right corner. You will be prompted to name and save an HTML file containing all of your new commands and shortcuts.

custom key commands

Debug Movie Commands

File	
New	Ctrl+N
Open	Ctrl+O
Browse	Ctrl+Alt+O
Open from Site	
Close	Ctrl+W
Close All	Ctrl+Alt+W
Edit Sites	
Exit	Ctrl+Q
Edit	
Сору	Ctrl+C
Select All	Ctrl+A
Find	Ctrl+F
Find Again	F3
Go to Line	Ctrl+G
Preferences	Ctrl+U
Keyboard Shortcuts	
View	
Hidden Characters	Ctrl+Shift+8

7 Open the HTML file to see your commands and their assigned keyboard shortcuts. You can now print this file and pin it to your forehead or make it your new desktop wallpaper. Whatever you do with it is up to you, just put it somewhere that is easy to access when needed.

Find and replace

HE CLIENT JUST CALLED with some last minute issues they have with a critical detail with the project. The character you have spent the last three weeks animating now has the wrong color shirt and shorts due to a change internally with their product line. Since this Flash animation is integrated into their new online marketing strategy for this new line of apparel, color accuracy is critical.

Now what? You already have a timeline consisting of more than 1000 frames, keyframes and tweens, and the colors that need to be changed exist throughout several different symbols.

The Find and Replace panel is easily the unsung hero of Flash. Surprisingly it is relatively unknown, perhaps because it is tucked away under the Edit menu as opposed to the more intuitive Windows menu. Regardless of its location, where we will launch this very handy tool as long as the Actions panel isn't focused. Both the shirt and shorts colors for the animated character must be changed. Mix the new colors and add them as swatches. Using the drop-down menus, select Current Document and then Color (default is Text). Click the 'Color' swatch and locate the replacement color.

2 Next, click the 'Replace with' color swatch and locate the new color already added to the Swatches palette.

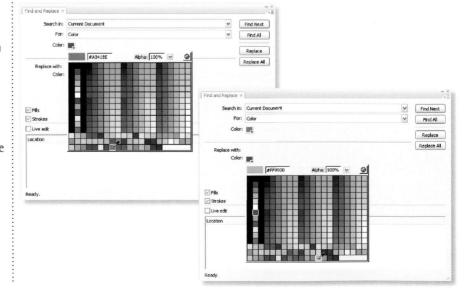

3 Click 'Replace All' and breathe a sigh of relief as Flash replaces the old color with your new color and updates the entire document. Repeat this procedure for each color needing to be changed.

4 Find and Replace also provides the option to limit the color change to strokes or fills or text or any combination of these three objects. This is useful if the same color is applied to more than one of these objects.

You can also find and replace text, fonts, symbols, sounds, video and bitmaps. In the time saved, you can relax, pour another cup of coffee and think about how happy the client will be when you deliver the revised project with no additional production time or cost added.

HOT TIP

The Live Edit option lets you edit the specified element directly on the Stage. If you use Live Edit when searching for a symbol, Flash opens the symbol in editin-place mode.

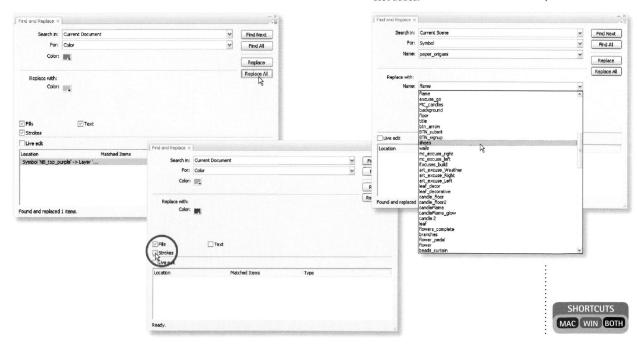

Time-saving tips

Common libraries

VER TIME YOU MAY FIND yourself accumulating a large number of assets from various projects.
Perhaps you are

involved with a project that contains a large

number of assets that are spread across

your hard drive like sprinkles on an ice cream sundae. What if you

could gain quick and easy access to any number of Libraries from the drop-down menus in the Flash IDE? It sure would be a lot faster than

searching the myriad folders on your hard drive for a set of eyes you designed six months ago or a certain sound effect on an external

drive from a project last year. The first step is to open

a new doc for every type of common asset you wish to access on a steady basis. If you want to have access to various character assets, then add them to the Library of a single Flash document and save it with a name that describes its contents. Repeat this procedure for every type of asset you wish to have at your fingertips in Flash.

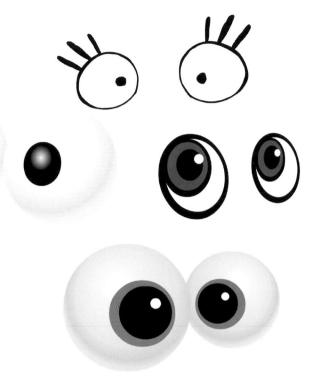

1 Place the Flash file in the user-level Libraries folder on your hard disk.

On Windows, the path is C:\Documents and Settings\ username\Local Settings\Application Data\Adobe\Flash CS3\ language\Configuration\Libraries\.

On Mac OS, the path is Hard Disk/Users/username/Library/ Application Support/Adobe/Flash CS3/language/Configuration/ Libraries/.

2 In Flash, go to Window > Common Libraries and select the desired Library from the list of Flash FLA files you copied to this folder on your local drive. This is why giving your documents short and descriptive names is important. You can continue to create new documents, populate each Library with common assets and save them to this folder. Each time you access these Libraries from within Flash, the list will automatically update to reflect any new FLA files located within the Libraries folder.

3 Once you select a Library, a new Library panel will open containing the assets you added to it earlier. The obvious gray tone in the Library window means these symbols cannot be edited. Click each one to preview the symbol and, when satisfied, drag and drop the symbol(s) to the stage or Library of your current document. Now you will have the freedom to edit the symbol any way you like without affecting the Common Library version.

This is a great way to set up and maintain an organized workflow with projects of any size. It's also a great way to access all of your favorite sound files. Create a new FLA for all your commonly used button sounds and cartoon effects.

Library - Eyes.fla ×

17 items

HOT TIP

Make a shortcut to the Libraries folder on your local drive and place it in a convenient location, By doing so you are always one click away from accessing this folder in the event you want to update any of vour common libraries with additional or newly created assets.

Creating templates

HE DEFAULT TEMPLATES
INSTALLED with Flash are
wonderful time savers. From
banner advertisements to
mobile content, templates for
a variety of applications are
already at your fingertips.
But what if your client asks
you to create a large number
of Flash movies with similar
document properties and media
assets?

Creating your own custom templates will prevent you from having to reinvent the wheel each time you start a new Flash document.

By default, Flash has a limited number of template categories. You can create your own categories by adding new folders to the Templates folder on your local drive: boot drive\user name\Local Settings\Application Data\ Adobc\Flash CS3\cn\Configuration\Templates. Add as many new folders as you need for as many categories as you want.

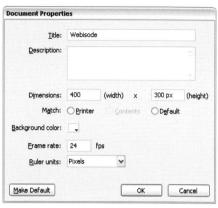

2 In Flash, create a new document and edit its properties using ***** J** on! J****. Here I have set up a document for a web-based animation series. I have set the width and height to a 4:3 aspect ratio in case I need to scale it later for export to video (always think ahead) and a frame rate of 24 fps.

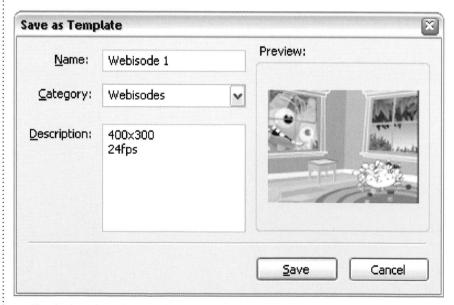

5 You also have the option of adding a description of your template file. This is where I like to add the properties information of my document as a reminder for me when I select it in the future. Add the width and height of your document, frame rate and any other information about the project you consider important to remember. Perhaps it's the client's contact information or the starting and ending dates for the project.

3 To make this document a template, go to File > Save as Template...

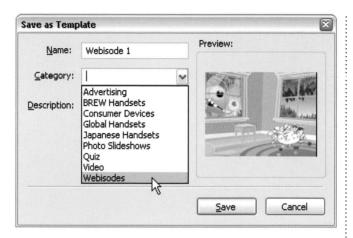

The Save as Template window will open, allowing you to name your template and select a category from the-drop down menu. You will see your own custom folders listed as well. Select the appropriate folder.

6 To open your template(s), go to File > New and click on the Templates tab in the New Document window. You will be able to select a category from the Category window on the far left side and then the actual template document from the updated Templates window. Click once

on the Template to view a preview image of the contents contained on its first frame. There's also a handy Description preview in the lower right corner as well. The more reusable templates you add to this category, the more productive you will be.

HOT TIP

Add a shortcut to the Templates folder on your local drive for quick and easy access any time you want to add new categories or remove old document templates.

Time-saving tips

Save workspace

F YOU ARE LIKE ME, you divide your time between designing, animating and maybe even throwing down some ActionScript on occasion. With the number of panels, tools and optionally installed extensions, wading through all those panels and menus can be a constant chore.

Don't work around Flash, make Flash work for you. Take advantage of the option to save various workspace layouts. Group any of the panels together and dock or undock them in a configuration that suits a specific area of Flash. For example, I have three different workspace layouts. The first layout is for design only, containing only panels and tools used for drawing. The second layout is comprised of panels and extensions I use only when animating. The third layout is basically just the Actions panel for those times I actually write my own ActionScript.

Here's an ideal animation workspace. It's comprised mostly of extensions developed by various animators and developers in the Flash community. To learn more about Extending Flash, check out Chapter 12.

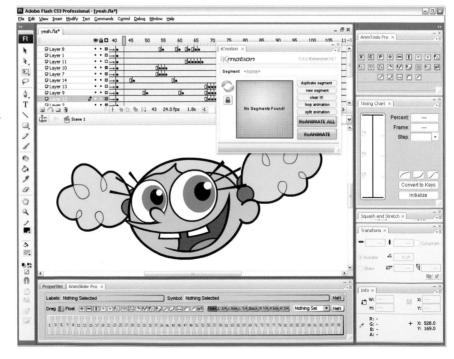

This is my design workspace layout. Only the tools and panels necessary are available for drawing, mixing colors, transforming and aligning objects.

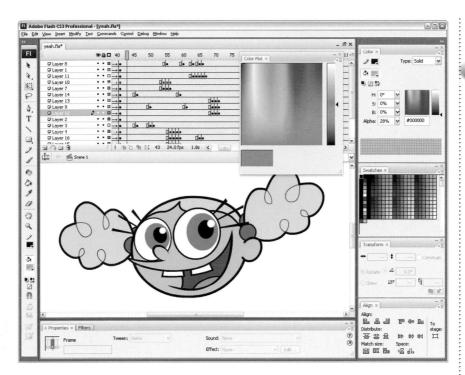

When the rare occasion of having to spend time in the Actions panel presents itself, I am ready. This workspace layout is as simple as it gets. It's basically just the Actions panel and it utilizes most of the screen real estate.

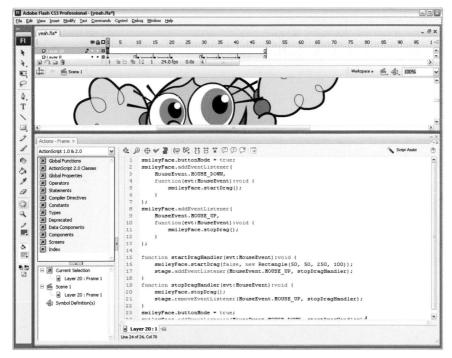

HOT TIP

The coolest tip of all is that you can assign keyboard shortcuts for your workspace layouts! Go to Edit > Keyboard **Shortcuts** and select Drawing Menu Commands from the Commands drop-down menu. Then drill down to Window > Workspace and select the name of your saved workspace layout and assign a keyboard shortcut. Repeat for each workspace you have saved.

Take me to the Bridge

NTEGRATION BETWEEN ADOBE PRODUCTS has never been better or faster than with Adobe Bridge CS3. If you don't know what Bridge is, think of it as a visual asset management application that bridges all Adobe CS3 applications together, making for a tightly integreted workflow between various file types and mediums. Adobe Bridge lets you easily organize, browse, locate and view creative assets. Bridge provides centralized access to project files, applications and settings, as well as XMP metadata tagging and searching capabilities. Bridge is also very useful for fast file searching and thumbnail viewing and also allows you a rating system for your images. Bridge is the hub of your Adobe applications and projects.

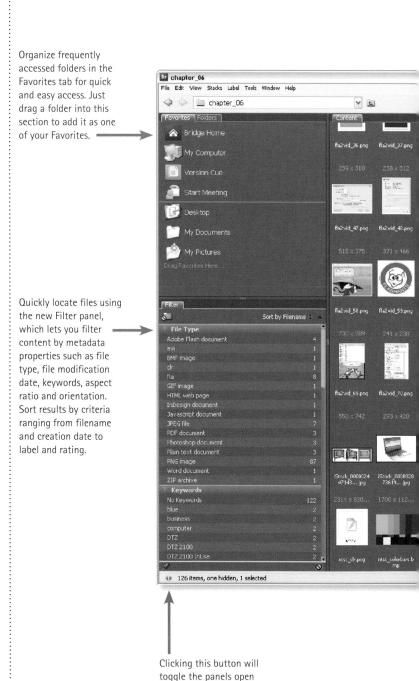

or closed to free up more space for viewing

thumbnails.

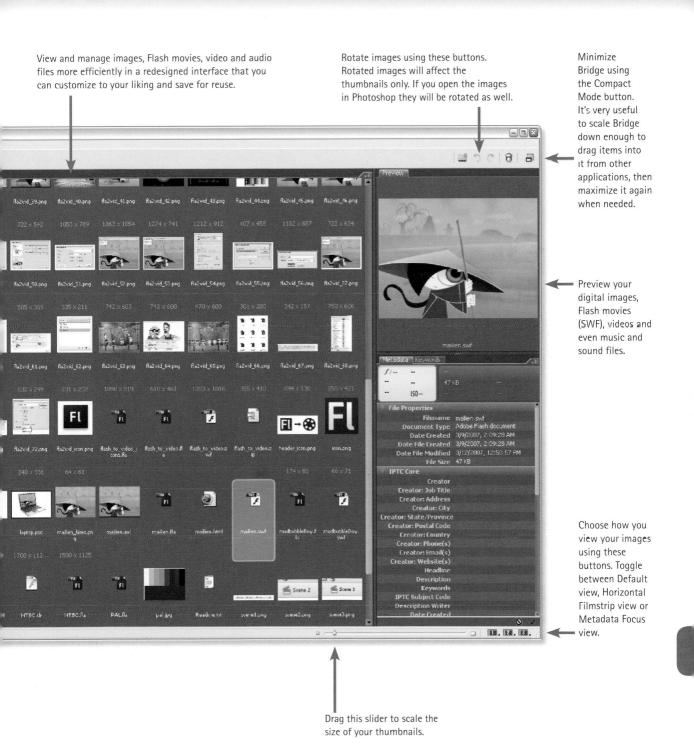

Don't go it alone

FLASH IS A DEEP PROGRAM and praised for its versatility as the tool of choice for what seems like an endless array of interactive and entertainment mediums. From engaging online content to rich internet applications to animation for broadcast television, Flash is the Swiss Army knife of software programs. I know hundreds of artists who use Flash all day, every day, as a design and animation tool, without ever touching the Actions panel. I also know hundreds of developers who use Flash with as much frequency who can't draw a straight line (even with the line tool) and have no need for the timeline (hard to imagine isn't it?). Then there are the elusive few who use Flash to design, animate and write code in virtually every language, especially ActionScript, and do it brilliantly.

For those of you still puzzled or intimidated by ActionScript, the Behaviors

panel offers some quick and easy point and shoot options. Adding some interactivity via the Behaviors panel is easy and very straighforward. Click on the "+" symbol and choose an Event from the drop-down menu. You can use Behaviors to control movie clips, load external graphics (*.jpg) instances as well as to load or unload, play, stop, duplicate, or drag a movie clip, or to link to a URL. Behaviors are not available for ActionScript 3.0.

Any Behavior you use will add the actual ActionScript to the Actions panel. The scripts will include comments to help you understand what the code means and does.

The Actions panel offers Script Assist, another great feature that literally assists you through the code-building process. If you are new to ActionScript and want to add some basic interactivity to your document, you can use Script Assist to help you add ActionScript to your FLA files. Script Assist helps you avoid syntax errors but still requires that you become at least familiar with

ActionScript methods, functions and variables. To learn about ActionScript, see Learning ActionScript 2.0 or Programming ActionScript 3.0 in the Flash help docs.

Did you know the Actions panel has its own set of Esc shortcut keys? Hold down the Esc key and type the first couple of letters of the action and Flash will automatically complete it for you. For example, Esc + S + T will automatically

complete the stop(); command. You can view the Esc shortcuts by selecting "Esc Shortcuts Keys" via the Actions panel's upper right drop-down menu. Once activated, any actions that have an Esc shortcut associated with it will display the shortcut for you. There are quite a few Esc shortcuts as you will find, so I have included a PDF file listing all of known Esc shortcuts for

you on the source CD. Keep in mind that not all shortcuts are compatible across both ActionScript 2.0 and 3.0.

As a full-time designer and animator using Flash, I have managed to pick up enough ActionScript to script a reasonable amount of interactivity. Whether it's controlling Movic Clips or loading external content, what little I do know can be put to use in many basic situations. I've even picked up a fair amount of HTML, JavaScript and PHP. I regard my style of programming as "blue collar coding", not very pretty but it gets the job done. I'll never regard myself as a true programmer because I know my strengths are drawing and making things move. Between the Behaviors panel, Script Assist and the ActionScript reference docs, you do not have to go it alone, but it does help to have good friends who are brilliant programmers also. Get involved with the Flash community, whether it's your local user group or public forums. Chances are you have something to offer in return as well.

2.5D animation, 90-5, 125 After Effects, 9, 145, 147, 195 Bezier handles, 16-17 AKG Perception 400 microphone, Biography, 130-3 182 ActionScript, 260-1 Animation examples, 150–77 digital animation, 178-9 color adjustments, 168-9 moment of truth, 64-5 Action-safe zone: video, 138-9 edges of masks, 164-5 simplifying style, 86-7 Actions panel, 63, 260-1 fire, 162-3, 174-5 subtlety, 48-9 ActionScript 2.0 (AS2), 201 fireworks, 162-3 Wacom tablets, 148-9 drag methods, 206-7 page turning, 154-5 Bitmaps: event handling, 204-5 rain, 172-3 distortion, 36-7 loading images, 212-13 smoke, 156-9 games, 220-1 objects, 215 snow, 176-7 JibJab Media, 108-9 timeline pausing, 209 spiral effect, 170-1 texture, 12-15 ActionScript 3.0 (AS3), 201 Star Wars text, 166-7 Trace Bitmap, 18-19, 230-5 drag methods, 206-7 steam, 160-1 Blank keyframes, 77, 219 event handling, 203, 205 text effects, 152-3, 166-7 Blend Modes, 171 loading images, 210-13 vertigo, 170-1 Blizzards: snow, 177 objects, 215 see also Character animation Blur filter, 74-5, 80-1 sound, 188-9 The Animator's Survival Kit realism, 31 timeline pausing, 208 (Williams), 118 smoke, 157 ActionScript, 200-13, 260-1 Anime Studio Pro, 196 steam, 160-1 color adjustments, 169 AnimSlider Pro, 101, 236-7 Blurring, 63, 74-7, 80-5 drag methods, 206-7 AnimTools, 236-7 background, 84-5 event handling, 202-13 Anticipation, 82, 120-1 flying text, 76-7 fire, 174 AS2 see ActionScript 2.0 selective blurring, 82-3 loading images, 210-13 AS3 see ActionScript 3.0 text effects, 152-3 page turning, 154-5 ASE see Adobe Swatch Exchange see also Blur filter screensavers, 218-19 files Body parts, 94-5, 104-5 timeline pausing, 208-9 Aspect ratios, 137, 141 Bouncing ball, 44-5 versions 2.0/3.0, 188-9, 201, Audio, 144-7, 183 Breeze presentations, 132 203-13 see also Sound Bridge: Adobe, 199, 258-9 ActiveX setting: Jugglor, 242 Audio Video Interleave (AVI), Brush tool, 6-7 Adjust Color filter, 168-9 144 - 7blurring, 82-3, 85 Adobe After Effects, 9, 145, 147, 195 Audition: Adobe, 184-5 commands, 229 Adobe Audition, 184-5 AVI (Audio Video Interleave). Paint Selection, 24-5 Adobe Bridge, 199, 258-9 144 - 7rain, 172 Adobe Certified Experts, 132 steam, 160 Adobe Device Central CS3, 222-3 texture, 13-14 Adobe Extension Manager, 218, 244 Bucket tool, 12, 21 Adobe Illustrator, 170, 191 Bush, George, 108-13 Adobe Photoshop see Photoshop Background blurring, 84-5 Butterflies, 46-7 Adobe Premiere, 9, 145 Banner advertisements, 208 Buttons, 188, 202-5, 237 Adobe Soundbooth, 184-5 Between the Lions television series, Adobe Swatch Exchange (ASE) files, 194-5

Beveled edges, 240-1

23

C

Caplin, Steve, 109 "Caps", 106-7 Card flip, 42-3 CDs, 182-3 see also Source CD Cell shading, 20-7 Certified Experts: Adobe, 132 Character animation, 88-129 anticipation, 120-1 bitmaps, 108-9 character drawing itself, 122 - 3gaps in design, 106-7 hinging body parts, 104-5 JibJab Media, 108-13 looping backgrounds, 124-5 motion guides, 102, 112-13 PSD importer, 110-11 syncing, 96-103 tradigital, 126-9 2.5D, 90-5 walk cycles, 114-19 Character Embedding panel, 59 Clarity: moment of, 64-5 Class names, 189 see also Instance names Classes: objects, 214-15 Code optimization: games, 221 Color adjustments, 168-9 Color filling, 128 Color mixing, 8-9 masking, 55 shading, 20-1 texture, 13 Trace Bitmap, 19 video, 140 Color safe palette, 141, 236 Color wheel button, 20 Commands: JSFL, 228-9, 234-5 Common libraries, 252-3 Compact Mode button: Bridge, 259

Components, 210-11 Compression: video, 145, 147 Constrained drag and drop, 207 Continents: globes, 52-3 Contrast, 71 Control flow statements, 234 Copy Filter, 169 Create AVI, 146-7 Creator, 242-3 Cropping images, 36-7 Current frame, 75 Customization: Custom Ease panel, 93 Customize Tools panel, 239 extensions, 244-5 key commands, 248-9 setups, 33 templates, 254-5

"Cutting in" technique, 5

D

De Visser, Martijn, 198 Design styles, 2-31 basic shapes, 4-5 Brush tool, 6-7, 13-14, 24-5 gradients, 10-11, 14-16, 28-31 mixing colors, 8-9, 13, 19-21 Pen tool, 16-17 shading, 20-7 texture, 12-15 Trace Bitmap, 18-19 Digital animators, 178-9 Digital cameras, 12 Distort tool, 38-9, 42, 46, 167 see also Transformation and distortion Distribute to Layers, 78, 153 Docking panels, 32 Document setup: video, 136-7 "Dot-com" boom, 131 Dragging: ActionScript, 206-7

distortion, 37, 39
realism, 29
shadows, 68
Drawing with basic shapes, 4–5
Drawing Object, 36
Drop shadow filter, 31, 70–2, 154
Dynamic sound, 188–9
Dynamic text, 58–9

F

Easing, 93, 121, 158 Easy Palette, 235 Edges of masks, 164 5 Edit Bar, 224 Edit Envelope window, 186-7 Edit Multiple Frames, 117, 119, 127 - 8Editing audio, 183 Editing video, 9, 147 Effects: text fields, 58 Encoding: video, 195-8 Envelope tool, 37-41, 99 Erain.com, 241 Eraser tool, 123, 159 ESC shortcut keys, 261 Event handling, 202-13 Event sounds, 186-7 Evil Mime character, 40-1, 106-7 Export Hidden Layers, 139 Extending Flash MX 2004 (Peters Yard), 235 Extension Manager: Adobe, 218, 244 Extensions, 226-45 AnimSlider Pro, 236-7 customizations, 244-5 Flash JavaScript, 227-35 Flashjester, 242-3 IK, 238-9 Swift 3D Xpress, 240-1 Eye dropper tool, 8, 13-14

shadows, 68-9 191, 238-9 Star Wars text, 167 Iris transition, 56-7 stylized smoke, 158 syncing, 101, 103 Fernandez, Ibis, 126 texture, 13 Fill Transform tool, 14-15, 28-9 2.5D animation, 91, 93, 95 Filter panel: Bridge, 258 JibJab Media, 108-13 walk cycles, 115 Filters, 70-5 JSFL see Flash JavaScript Fuller, Warren, 101, 141, 236 Adjust Color filter, 168-9 JShapor, 243 Drop shadow filter, 31, 70-3, Jugglor, 242 154 see also Blur filter K Final Cut Pro. 147 Game design, 220-1 Find and Replace panel, 250-1 Gaps in design, 106-7 Fire, 162-3, 174-5 Keyboard shortcuts, 248-9, 257 Gaussian blur, 63 Fireworks, 162-3 Kuler tool, 23 GIF file format, 18-19 FLA files, 45, 143 Gradient Transform tool, 11, 53, see also Source CD 74, 84 Flag waving, 54-5 page turning, 154-5 Flash: PSD importer, 111 improvements, 168, 190-1 Lasso tool, 122-3, 158-9 Gradients, 10-11 new interface, 32-3 Layer Folders, 142-3 see also Linear...; Radial... useful tricks, 224-5 Layer Properties panel, 187 Gray scale, 19, 168 Flash JavaScript (JSFL), 227-35, Libraries, 97, 252-3 244-5 Lighting, 21, 25, 240 Flash Lite, 218, 220-2 Line tool, 20, 85, 176 Flash Player, 201, 204 Line trick: shading, 20-1 Flash Video Encoder, 198 Handwriting, 58-9 Linear gradients, 10-11 Flash video (FLV), 196-9 edges of masks, 165 Help panel, 232 Flashjester, 242-3 fire, 163, 174-5 Hide object, 71, 73 Flowers, 28-31 fireworks, 163 Hinging body parts, 104-5 FLV (Flash video), 196-9 flying text, 76-7 History Panel, 228-9, 231 Flying text, 76-7 Pen tool, 16 How to Cheat in Photoshop CS3 Font, 153, 166-7 text effects, 152 (Caplin), 109 For loops, 234 texture, 14-15 HSB sliders, 8-9 Frame rates: games, 220 Linkage Properties panel, 189 HTML files, 249 Frame View menu, 100-1 Lip syncing, 96-9 Hue, 168-9 Free Transform tool, 34-47 Live Edit, 251 anticipation, 121 Loading images, 210-13 "caps", 107 Logan, Dave, 228, 235, 245 distortion, 34-47 Looping animations, 55, 85 hinging body parts, 104 IK see Inverse Kinematics Looping backgrounds, 124-5 motion guides, 113 Illustrator: Adobe, 170, 191 page turning, 155 Ink Bottle tool, 5, 17, 26

Instance names, 189, 202-7

Inverse Kinematics (IK), 104, 107,

PSD importer, 111

realism, 29

M-Audio FireWire Solo interface,	masking, 55	NTSC (National Television
183	motion guides, 112	Standards Commission), 136–7,
Magnification, 7, 11, 19	rain, 173	141, 236
Masking, 50-63	smoke, 156-7	
character drawing itself, 123	snow, 176-7	
edges, 164–5	steam, 161	O
fireworks, 162-3	syncing, 100-3	
flag waving, 54-5	text effects, 152-3	Object Drawing, 7, 126–7, 176
focus, 62-3	2.5D animation, 90-1, 95	Objects: ActionScript, 214–15
hand writing, 58-9	MouseEvent, 203, 205-6	Onion Skin tool:
iris transition, 56-7	Mouth shapes, 96-9	basic shapes, 4
rotating globes, 52-3	Move to Existing Folder feature,	blurring, 82
soft reveal, 164–5	236	card flip, 43
spotlights, 60–1	Movie Clips, 30-1	flying text, 76–7
walk cycles, 118	character drawing itself, 122	Pen tool, 16
Materials panel: Swift 3D Xpress,	filters, 70-2, 74-5, 80	squash and stretch, 45
241	IK, 239	syncing, 98
Merge Layers extension, 126–7,	masking, 53, 55, 62-3	walk cycles, 115, 118-19
129	screensavers, 219	Online forums/resources, 131-2
Microphones, 182–3	smoke, 157	Optimize, 19
Mixer Panel, 4, 21	snow, 176-7	Outlines, 26-7, 28
Mixing colors see Color mixing	spiral effect, 170-1	Oval tool:
Mobile devices, 216–23	steam, 160–1	basic shapes, 4–5
Adobe Device Central CS3,	text effects, 153	masking, 53, 56, 60
222–3	video, 142	Pen tool, 17
game design, 220–1	Movie Settings panel, 145	rain, 173
screensavers, 218–19	MovieClipLoader class, 212–13	smoke, 156
Moment of clarity, 64–5	Multiple animations, 163, 172–3	
Monkey animation, 94–5	Multiple object selection, 104–5	P
Motion guides:		1
Bush animation, 112-13	TN I	
butterfly, 47	IN	Page turning, 154–5
snow, 176–7		Paint Bucket tool, 19
Sync feature, 102–3	National Television Standards	Paint Selection tool, 24-5
Motion tips, 66–85	Commission (NTSC), 136-7,	PAL (Phase Alternating Line),
blurring, 74–7, 80–5	141, 236	136–7
combining effects, 78–9	Nesting:	Palczynski, Ben, 118
flying text, 76–7	blurring, 74–5, 85	Palette: color safe, 236
shadows, 68–73	lip syncing, 98–9	Parameters tab: Property Inspector,
Motion tweens:	rain, 173	211
anticipation, 121	shadows, 68	Pausing timelines, 208–9
blurring, 74–5, 81, 85	Sync feature, 100–1	Pen tool, 16-17, 28-9
combining effects, 78–9	walk cycles, 118-19	Perspective shadows, 72–3
distortion, 44–5, 47	New Folder Tree feature, 236	Peters, Keith, 235
flying text, 77	Nokia 40, 218-19	Phase Alternating Line (PAL),

136–7	Realism, 28–31	shading, 21–3, 25, 27
Photographs, 109, 160-1	Recoil of gun, 83	tradigital animation, 127, 129
Photoshop:	Recording sound, 182–3	Selective blurring, 82–3
character animation, 108–10,	Rectangle tool:	Shading, 20–7
122	basic shapes, 4–5	cell shading, 20–7
design styles, 12, 14, 18	edges of masks, 164–5	line trick, 20–1
Flash improvements, 191	JSFL, 228–9	outlines, 26–7
JibJab Media, 108–10		
	Pen tool, 17	paint selection, 24–5
masking, 62–3	screensavers, 219	shaping it, 22–3
Star Wars text, 167	shading, 22–3	Shadows, 68-73
Picker tool: IK, 239	Remove Frames, 99	basic shadow, 68-9
"Ping-pong" eyeballs, 10	Repetitive tasks, 79	Drop shadow filter, 70-23
Playback performance, 81, 166–7	Replace Colors, 141, 236	page turning, 154-5
Premiere: Adobe, 9, 145	Reverse Frames, 159	perspective shadows, 72-3
ProgressBar Component, 211	RGB color values, 8–9, 111, 141,	realism, 30–1
Properties panel:	147	texture, 15
AnimSlider Pro, 236	Rotation:	Shape tweens:
Blur filter, 75	body parts, 82-3, 94 5	card flip, 42-3
document setup, 136	Bridge, 259	fire, 174
Edit Envelope window, 187	globes, 52–3	handwriting, 58
syncing, 98-100, 102-3	Rotoscoped effect, 230-5	iris transition, 57
tradigital animation, 127	Rubber band effects, 196	page turning, 155
Property Inspector, 211		tradigital animation, 126–7,
PSD importer, 62-3, 110-11	C	129
	3	Shapes:
\cap		drawing, 4–5
U	Safe colors: video, 140-1	shading, 22–3
	Safe zones: video, 138-9	Shockwave, 130–1
Quality of sound, 182-3	Safety color palette: NTSC, 141	Shortcuts, 229, 248–9, 257, 261
Quick Mask mode, 109	Saturation values, 9	Simple styling, 86–7, 93
Quicktime Exporter, 140, 142,	Save as Template window, 254–5	
144–6, 194	Say, John, 220-1	Sliders: Color Mixer, 8–9
	Scale and Rotate panel, 57, 152	Smoke, 156–9
D	Scenes:	Smoothing, 6, 13, 15, 84
K	sound, 186	Snap:
	video, 142–3	drawing basic shapes, 5
Radial gradients, 10–11	Screensavers, 218–19, 242–3	motion guides, 113
fireworks, 162–3	Script Assist, 260–1	page turning, 154
masking, 53, 164-5	Seek Controller, 147	shading, 20
monkey animation, 94–5	Selection tool:	tradigital animation, 128
motion tips, 74, 84-5		Snow, 176-7
realism, 28–31	Brush tool, 7	Sound, 180-9
smoke, 156–7	distortion, 41	Adobe Soundbooth, 184–5
texture, 15	fire, 175	AS3, 188-9
Rain, 172–3	masking, 54–5	Flash sound, 186-7
Real life, 175	Pen tool, 16–17	lip syncing, 96-7

recording, 182–3	Tablets: Wacom, 6, 148-9, 249
sound effects CDs, 182–3	"Tech Wednesdays", 132
Soundbooth: Adobe, 184–5	Televisions, 136–41
Source CD:	Templates, 254–5
AnimSlider Pro, 236	Text, 76–81
ball motion, 75	blur filter, 80–1
cowboy, 82	effects, 152-3
dynamic sound, 188	fields, 58–9, 79, 153
Easy Palette, 235	flying text, 76–7
extensions folder, 244–5	font, 153, 166-7
Merge Layers extension, 127	motion tips, 76-81
safety color palette, 141	Star Wars, 166-7
screensavers, 219	text tool, 78
walk cycles, 115	Texture, 12-15
Speed, 74–7, 85	Three quarter view, 92, 94, 114
see also Motion tips	Time-saving tips, 246-59
Spiral effects, 170–1	Adobe Bridge, 258–9
Spotlights, 60-1	common libraries, 252-3
Sprite drag methods, 207	find and replace, 250-1
Squash and stretch, 37, 44–5, 125	keyboard shortcuts, 248-9, 257
Stage magnifications, 7, 11, 19	templates, 254-5
Star Wars text, 166–7	workspace layouts, 256-7
Steam, 160-1	Timeline pausing, 208-9
Stigma: flowers, 30-1	TimerEvent, 208
Stiller, David, 189, 215, 245	Tips, 66-85, 224-5, 246-59
Streaming sounds, 186-7	Title-safe zone: video, 138-9
Stretch and squash, 37, 44-5, 125	Toon shading, 20
Strokes, 26-8, 126-8	Trace Bitmap, 18-19, 230-5
Stylized smoke, 158-9	Tradigital animation, 126-9
Subselection tool, 17, 29	Transform Panel, 38, 44
Subtlety, 48–9	Transformation and distortion,
Swap method: lip syncing, 96-8	34–47
Swap Symbol panel, 97	bitmaps, 36-7
SWF files, 113	butterflies, 46–7
SWF2Video, 146-7	card flip, 42-3
Swift 3D Xpress, 240–1	Distort tool, 38-9, 42, 46, 167
Synchronization, 96-103	Envelope tool, 38–41
lip syncing, 96–9	squash and stretch, 37, 44–5,
Sync feature, 100–3	126
video, 142–3	warping, 40–1
System events, 202	see also Free Transform tool
	Tweens see Motion; Shape
' '	2.5D animation, 90-5, 125

l

UILoader Component, 210–11 Updates: mobile devices, 223 User events, 202

Variables: JFSL, 232–4
Vertigo, 170–1
Video, 134–47, 192–9
document set-up, 136–7
editing, 9, 147
Flash video, 196–9
importing video, 194–5
keeping in sync, 142–3
Quicktime Exporter, 140, 142, 144–6
Soundbooth, 184
SWF2Video, 146–7
title and action safety, 138–9
de Visser, Martijn, 198
Vivek, 218

Wacom Cintiq, 149
Wacom tablets, 6, 148–9, 249
Walk cycles, 114–19
Warping, 40–1
WAVE files, 147
Websites, 133, 199, 241
Whistling mouth, 98–9
Williams, Richard, 118
Wimpy FLV player, 198
Wolfe, David, 127, 245
Workspace layouts, 256–7

Yahoo! Super Messengers, 40–1, 66, 106–7 Yard, Todd, 235

LL SOURCE FILES SHOWN are provided to you for exploratory and educational reasons. I know the value of seeing how other people build their source files and how they can often lift the veil of confusion. Keep in mind all of these source files are protected by copyright and can not be used for commercial reasons. In some cases I have used actual photographs of people or images that I shot myself. In some cases the images are from istockphoto.com[®], an ever-growing independent library of royalty-free photographs, vector illustrations, Flash files, and video clips and membership is free.

I have also used images from Adobe® Stock Images which can only be accessed via Adobe® Bridge and features millions of images from several top collections.

PhotoObjects.net is another great resource for royalty-free images and offers several different subscription options.

Design styles

Transformation & distortion

free_transform_vector.fla

evil_mime.fla

card_flip.fla

squash_stretch.fla

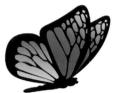

butterfly.fla

Masking

globe.fla

flag.fla

iris.fla

writing_masked.fla

focus_image.fla

spotlight.fla

Motion tips & tricks

witch.fla

mudbubble_boy.fla

hulagirl.fla

8ball.fla

flying text flying_text.fla

keyframer_banner.fla

textblur_filter.fla

cowboy.fla

background_blur.fla

Character animation

2-3D_basic.fla

malien_headturn.fla

monkey_animated.fla

lip_sync.fla

mouths.fla

mouth_loop.fla

holiday_2006.fla

sync_on.fla

hinging.fla

caps.fla

walkcycle.fla

leg_positions.fla

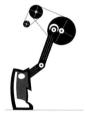

leg_simulation.fla

advanced_walkcycle.fla

anticipation.fla

chicken.fla

looping_background.fla

tradigital.fla

Flash to video

NTSC.fla

NTSC.clr

Yahoo_super_ messengers.fla

SWF2Video trial

SWF2Video Premiere plugin

Animation examples

superbusy.fla

page_turn.fla

smoke_gradients.fla

smoke_shape.fla

smoke_steam.fla

fireworks.fla

soft_reveal.fla

starwarstext.fla

filter_effects.fla

filter_effects_2.fla

vertigo.fla

rain.fla

fire.fla

8

mudbubble_holiday_ 2005.fla

Working with sound

Yahoo_super_ messengers.fla

 $dynamic_sounds_AS3.fla$

Working with video

pbs_btl.fla

cone.fla

Interactivity

event_handling_ AS3.fla

event_handling_ AS2.fla

 $drag_drop_AS3.fla$

drag_drop_AS2.fla

constrained_drag_ drop_AS3.fla

event_handling_ AS2.fla

pause_AS3.fla

pause_AS2.fla

image lorder AS2 ga

image_loader_AS2.fla

Going mobile

FPS-Meter Lite2.mxp

Extending Flash

AutoColor.mxp
CreateMaskingLayer.mxp
CustomZoom.mxp
DefaultColorsMX2004.mxp
Easy Pallette.mxp
EnterGraphCurFrame.mxp
FrameAllLayers.mxp
KeyAllLayers.mxp

Label Jumper.mxp
Rotoscope.jsfl
SkipAround.mxp
SquashAndStretch.mxp
SwapColorsMX2004.mxp
SymbolizeFrames.mxp
ViewLayer.mxp
drawGuide.mxp
frameEdit.mxp

frameExit.mxp

layercolor.mxp libAppend.mxp mergeLayers.mxp MultiSwap.mxp NewAnimClip.mxp TimingChart.mxp toggleGuide.mxp toggleOutline.mxp traceSequence.mxp tween2keys.mxp Apply Motion Tween:

Apply Shape Tween: of I
mudbubble_Pause.mxp
mudbubble_FPSMeter.mxp
BitmapSmoothingMultiple.jsfl
BitmapSmoothingSelected.jsfl
Filter Set Selection.jsfl
Filter Set All.jsfl
Camera.mxp
StageCrop.jsfl

Trial software

Jugglorv22Evaluation.exe CreatorEvaluation.exe